W9-AIE-878

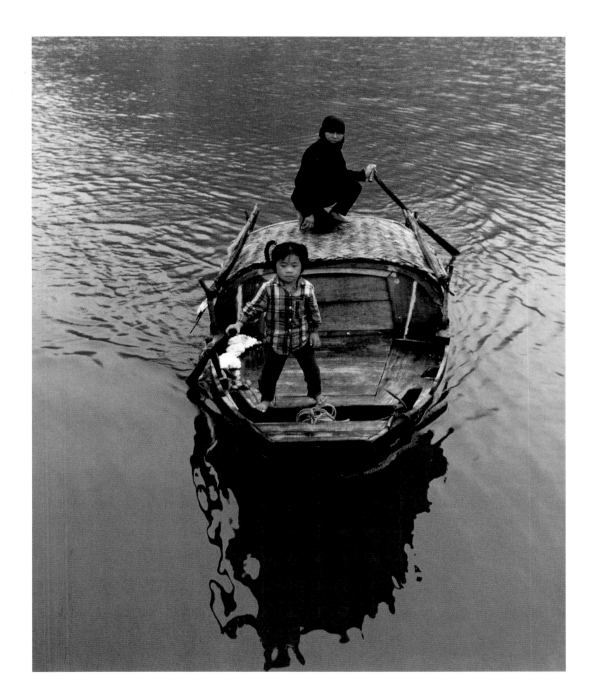

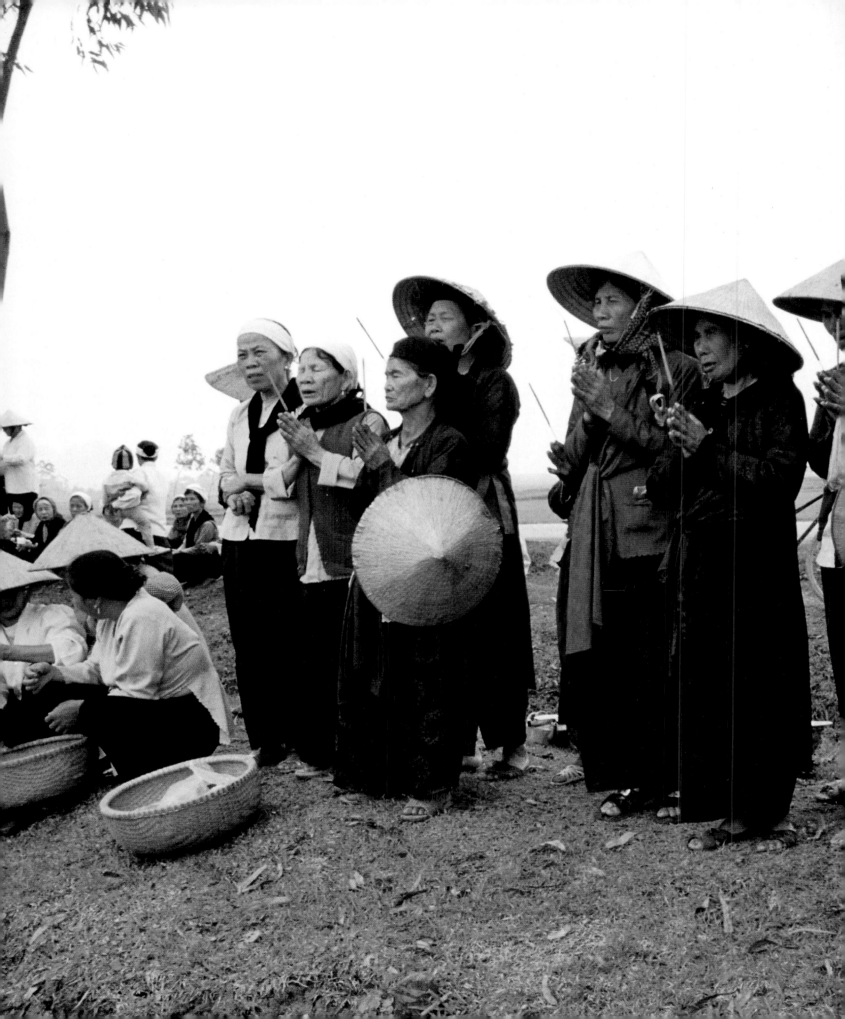

Vietnam

SPIRITS OF THE EARTH

Photographs by Mary Cross
Text by Frances FitzGerald

A BULFINCH PRESS BOOK
LITTLE, BROWN AND COMPANY
BOSTON NEW YORK LONDON

Text copyright © 2001 by Frances FitzGerald
Photographs and captions copyright © 2001 by Mary Cross
Map copyright © 2001 by Anita Karl and Jim Kemp

All rights reserved. No part of this book may be reproduced in any form or by any electronic or mechanical means, including information storage and retrieval systems, without permission in writing from the publisher, except by a reviewer who may quote brief passages in a review.

First North American Edition

"I Have Yet to Become a Prince" by Nguyen Trai. From *A Thousand Years of Vietnamese Poetry*. Copyright © 1974 by Asia Society. Reprinted by permission.

PAGE 1: Coral harvesters, Ha Long Bay.

TITLE PAGE: At this country funeral outside Hanoi, the older women wear brown or purple mourning dresses, which they have sewn themselves. They process in a long line across the narrow paths that traverse the rice paddies. At the burial itself, the women chant with joss (incense) sticks in their hands and then place these burning offerings on the grave. It is important never to bring the sticks of incense home; they must be left at the burial site with the ancestors. To commemorate the date of death, the old women visit the altar in the home of the deceased on the fiftieth day, the one hundredth day, and then annually at death anniversary ceremonies. These events are also attended by the close family members and relatives of the deceased.

CONTENTS PAGE: The broom maker, village of Phuong Trung, Ha Tay Province, just southwest of Hanoi.

Library of Congress Cataloging-in-Publication Data
FitzGerald, Frances.
 Vietnam: spirits of the earth / photographs by Mary Cross;
 text by Frances FitzGerald.
 p. cm.
 Includes bibliographical references and index.
 ISBN 0-8212-2742-4
 1. Vietnam — Pictorial works. I. Cross, Mary. II. Title.
DS556.3 .F57 2001
959.7 — dc21 2001025350

Bulfinch Press is an imprint and trademark of Little, Brown and Company (Inc.)

Designed by Lindgren/Fuller Design

PRINTED IN ITALY

I dedicate my photographs and captions to my six grandchildren, who I hope will continue to learn about the world and will in time be able to help make it a better place.

Daniel, Benjamin, Madeline, Claire, Deirdre, and Theodore

— M.C.

To all my nieces and nephews, who I also hope will continue to learn about the world and to help make it a better place.

Michael, Elizabeth, Paloma, Caitlin, Frances, Ryan, Mikey, George, Amos, Alexander, and Cooper

— F.F.

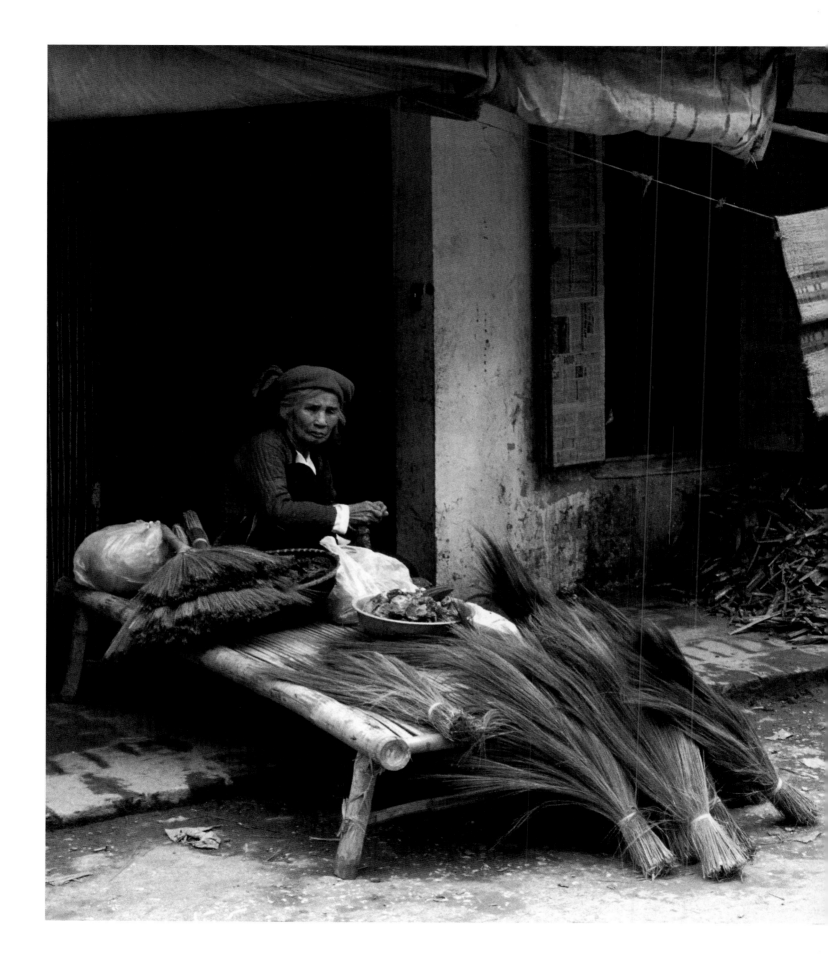

Contents

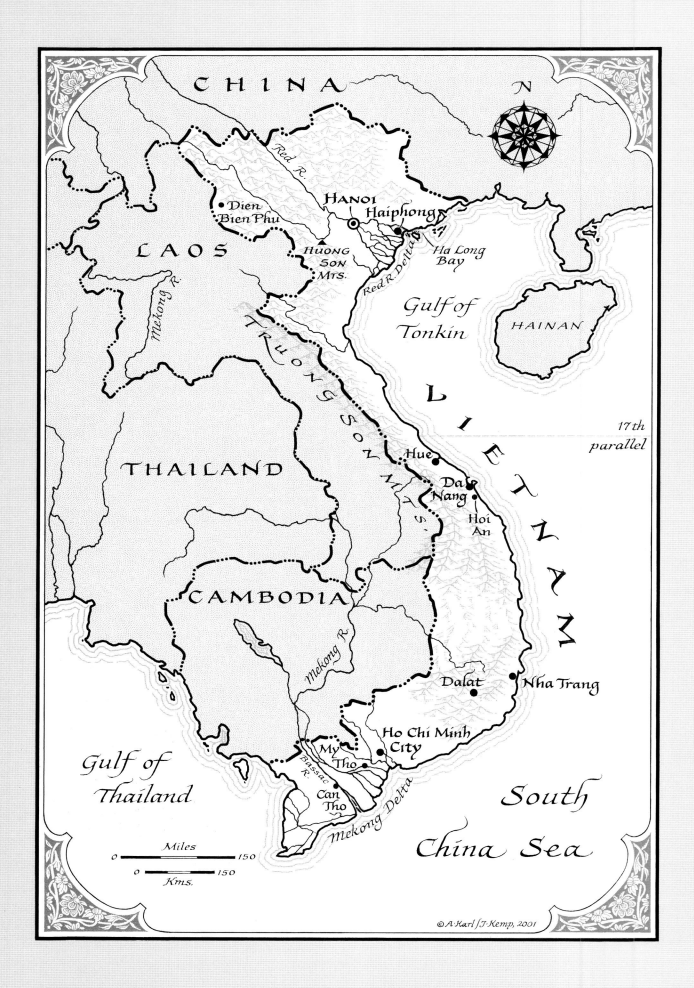

Vietnam: Spirits of the Earth

Having worked as a correspondent in Vietnam at various periods during the war, I returned there in 1993, after an absence of almost two decades. Mary Cross made the first of her several trips to Vietnam in 1996. She had worked in developing countries before and had published books of photography on China, Egypt, and Morocco, but she came to Vietnam with fresh eyes. In the spring of 2000 we traveled the country together. The result is this book. There is no direct connection between the essays that follow and Mary's photographs and captions, but there is a strong correspondence between them, because Mary and I have very similar views of the world.

For the past century and a half Vietnam has been through a succession of profound upheavals, the main ones being the imposition of colonial rule, revolution, and two major wars on its own territory. Nonetheless I devote much of this text to traditional, or precolonial, Vietnamese culture. The reasons are several. For one thing, to understand the new it is necessary to understand the old — the base upon which the new takes shape — and traditional Vietnamese culture is unfamiliar to most Westerners. For another thing, the Vietnamese know a great deal about their own history, and for all the recent upheavals they are just as likely to refer to an eleventh- or fifteenth-century emperor as to any modern ruler. Indeed, they can hardly give street directions without doing so. Third, although colonialism, war, and revolution have altered the shape of the society and the way people think, Vietnam has not changed as much as might be imagined — or as much as the advocates of modernization, Communist and non-Communist, surely hoped.

On my return to Vietnam in 1993 what struck me, after my long absence, was not so much how the country had changed but the extent to which it had returned to itself.

In many ways southern Vietnam looked much like the country I had encountered when I first went there in early 1966, just as the American troop buildup was getting under way. This seemed extraordinary after all that had passed.

During that period of time Vietnam had not only undergone the American war, but in the late 1970s its armies had fought a border war with China and a long, debilitating war with the Khmer Rouge in Cambodia. Then, in the late 1970s and early 1980s, the government in Hanoi, in the flush of its victory over the American-backed government in Saigon, had treated the south as a conquered territory and attempted to collectivize the farmlands and to impose the same command economy that obtained in the north. Central planning and collectivization, however, proved a failure throughout the country in the postwar years; in 1986 the government reversed course, and in a series of reforms known as *doi moi*, or renovation, it created a free market regime.

By 1993 the villages were growing bumper crops of rice. In the north villagers were building new houses. In the south the tin-roofed refugee shantytowns had disappeared and the bomb craters, which in the early seventies had pockmarked the landscape, had been covered over by jungle, filled in, or made into ponds for raising fish. In the city of Hue, in central Vietnam, the citadel, the palaces, and the tombs of the Nguyen emperors had been so completely rebuilt and restored that it was hard to imagine that the bitter, sanguinary, month-long battle for the city in 1968 had ever occurred. Saigon — now Ho Chi Minh City — was once again pulsing with energy, its air thick with the exhaust of cars and motorbikes. In Hanoi, which I had first visited in December 1974, the hiss of bicycles on the wet streets had become inaudible beneath the sound of the rest of the traffic.

Yet while the wounds of war had healed over, I did not see a significant degree of modernization. There had been some industrial development, but in the countryside, where three-quarters of the population live, there had not been much change in the way people went about their lives. In the north rice farmers still moved water from paddy to paddy with baskets. In the poor villages of central Vietnam I saw children with all the signs of vitamin A deficiency that I remembered from the war. In a village near Saigon I had often visited in the sixties and seventies, I talked with a young woman who said she wanted to learn how to use a sewing machine so that she could find employment in one of the new factories or workshops making clothes. Her hopes were high, but she was taking only the first step into the industrialized world, and millions of others in the growing economies of East Asia had already passed her by.

In 1993 many Vietnamese had great hopes that foreign investment would lead to an economic takeoff, and Western businessmen predicted that Vietnam would become the

next Asian tiger economy. But by 2000 the takeoff had still not occurred. Largely because of the economic crisis that hit Vietnam's richer Asian neighbors in 1997, but also because of the remaining legal barriers, the red tape, and corruption, foreign investment had declined, and the GDP growth rate, which ran at 8–9 percent yearly for most of the 1990s, had slacked off to 4–5 percent per annum. In 2000 Vietnam, with its population approaching 78 million, remained one of the poorest and most densely populated countries in the world.[1]

What had happened, though, was that with the adoption of a market economy the government had to some appreciable degree quieted down. These days it no longer exhorts the masses to build socialism or to resolutely struggle against this or that. Its banners, posters, and broadcasts call upon citizens to get their children inoculated, keep the streets clean — and that's about it. In the villages you can walk about all day without hearing a slogan, or for that matter, seeing a government official. In Hue the nineteenth-century Nguyen emperors, whom Communist Party intellectuals used to denounce as defeatists and quislings, are now celebrated in government tourist brochures. More surprising still, the guides at Reunification Palace, or what used to be President Nguyen Van Thieu's residence in the early seventies, speak of its former inhabitant as if he were just another historical figure. The government is there, all right, and quite determined to maintain a one-party state. But the ideology has largely gone.

In its absence the Vietnamese people have filled up both private and public spaces with more or less traditional institutions, practices, and ceremonies, which in the 1970s some foreign observers believed were dying out. In the north villagers have revived the cult of their tutelary genies, the historic guardians of their communities. The rites of ancestor worship are back in a big way, and in central Vietnam families are gathering hundreds of their members, including some who live abroad, for annual celebrations. Buddhism is flourishing, and to a lesser extent so too is Catholicism. In the south people are building new Buddhist temples and shrines apace, and in some provinces Cao Daiism, a syncretic religion that sprang up in the Mekong Delta during the 1920s, has regained its following. Whatever these revivals signify or portend, it is an interesting time to go to Vietnam.

As seen from Hanoi's Long Bien Bridge, hundreds of small wooden river junks are tied up along the muddy banks of the Red River. The boats are maneuvered by a single pole or oar; mats of woven palm leaves offer the only protection from wet weather. ➤

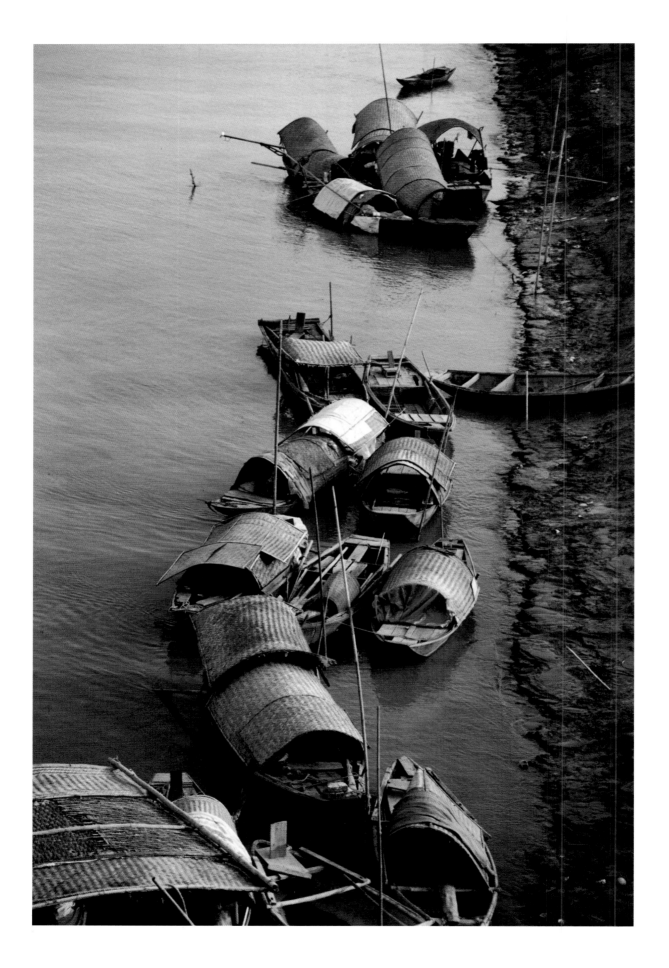

Mountains and Rivers

The Emperor of the South rules over the rivers and mountains of the southern country. This destiny has been indelibly registered in the Celestial Book.

— LY THUONG KIET

A thousand miles long, Vietnam extends in an elongated S from China to the Gulf of Thailand along the South China Sea. Some three-quarters of its total land area is mountainous. In the north two great mountain ranges, which descend from the plateaus of south-central China, enclose the triangle of the Red River Delta. The most extensive of these ranges, that of the northwest, has rugged, heavily forested mountains that reach to a height of more than 8,000 feet. Beginning just south of it, the Annamite Cordillera (or the Truong Son Range), which forms Vietnam's border with Laos, descends south and east, widening at its southern extremity into a plateau known as the Central Highlands. This massive upland system extends to within fifty miles of Ho Chi Minh City, where the vast alluvial plain of the Mekong Delta begins.

The Vietnamese often say their country resembles a bamboo pole supporting a rice basket on each end. The image is apt, for the two great river deltas are connected only by a band of coastal plain, interrupted by mountain spurs and in some places no more than thirty miles wide. It is the more apt because the two deltas are the great rice-producing regions of the country, and the place where most ethnic Vietnamese live.

The mountains, which the Vietnamese traditionally never penetrated, are home to some fifty minority peoples, among them the Tay, the Thai, the Muong, and the Nung.

Because the mountains lack water and the steep slopes erode quickly when cleared, these peoples historically lived a seminomadic existence, hunting and gathering and practicing slash-and-burn agriculture. Many of them are now settled and grow crops on terraced fields, but because of their poverty and their distance from the cities and towns, most still live on the fringes of Vietnamese society and have kept their identity and many of their traditional customs.

As the traveler soon discovers, the three regions of lowland Vietnam are ecologically and otherwise distinct. The Red River Delta, with its chilly, wet winters and its conical limestone mountains, often shrouded in mist, reminds travelers of southern China. Below the Hai Van Pass, which runs between Hue and Da Nang, the climate changes abruptly. Except during the heavy rains of the winter monsoon, the weather is warmer and drier. Central Vietnam, with its backdrop of jungle-covered mountains and its sand beaches stretching for miles, is possibly the most beautiful part of the country, but it is also the poorest, for the rivers plummeting down from the mountains wash the silt straight out to sea. As for the Mekong Delta, it lies full in the framework of Southeast Asia. It is low, lush, vegetative, fertile, a land of interconnecting waterways, paddies, jungle, and mangrove swamps, mysterious because of its lack of perspectives. It is the granary of Vietnam.

The ecological differences between the three regions, as it happens, correspond to cultural differences. The Vietnamese settled each of them at very different stages of their history, and by the time of the French conquest, their settlement of the Mekong Delta was so new that traditional Vietnamese culture can only be said to have existed in north and central Vietnam.[1]

Vietnamese civilization began in the north, and most of its long history is there.[2] Thanks to recent archaeological finds, the Vietnamese can trace their origins to a culture that appeared in the foothills of the Red River Delta three thousand to four thousand years ago. By the seventh century B.C. these peoples had developed a sophisticated Bronze Age culture. Wet rice cultivators who chewed betel nuts and tattooed their bodies with images of sea creatures, they were skilled in the manufacture of bronze tools, weapons, and ritual objects, including enormous, highly decorated drums. The Dong Son culture, as this society is known, took shape on the only lowland path between the Tibetan highlands and the sea, and it is thought to have been a synthesis of cultures coming from Tibet and from the islands of Southeast Asia. The Vietnamese language is

tonal, like the Sino-Tibetan languages, but its syntax and vocabulary have something in common with the old island tongues.

According to ancient legends passed down to today, all Vietnamese are descended from the Dragon Lord Lac Long Quan, a hero who came from the sea, subdued the evil demons, and civilized the people, teaching them how to grow rice. He and his bride, Au Co, a mountain princess of fairy blood, had a hundred children, and one of them was the first Hung king, who ruled the kingdom of Van Lang. According to tradition, the Hung kings, of whom there were eighteen, mediated between the people and the spirit world, and after death became powerful spirits who could be called upon to protect the land.[3]

Vietnamese scholars associate the Hung kings with the Dong Son culture, but the first figure in recorded history was King Au Duong, who founded the kingdom of Au Lac in 257 B.C. At its capital of Co Loa (fifteen miles from Hanoi) archaeologists have found the earthen ramparts of a citadel and several thousand bronze arrowheads. The kingdom had need of an army, for not long after its foundation, the Chinese, who were becoming the most powerful society in East Asia, began to expand to the south. In 111 B.C., shortly after the Han dynasty unified China, the whole of the Red River Delta fell under Chinese control; in A.D. 43, and after a rebellion led by two Vietnamese noblewomen, the Trung sisters, the Han mounted a second invasion and made the delta into a province of China, calling it Giao Chau.

For the next nine centuries Chinese authorities made a sustained effort to transform what they viewed as a semibarbarian society into a civilization on the Chinese model. Their *mission civilisatrice* was a comprehensive project that, as they saw it, would end with the complete assimilation of Giao Chau into the body of the Celestial Empire. By the tenth century A.D. they might well have judged that they had succeeded. The Vietnamese had adopted the Chinese written language, along with Chinese technology; the Confucian classics had become the foundation of the educational system; and at least among the governing elite, Chinese customs and rituals had replaced the more informal local practices. The Vietnamese family structure had become sinicized, and the Vietnamese had embraced the Chinese religions: Buddhism and Taoism as well as Confucianism.

Chinese authorities doubtless persisted in their opinion even when in A.D. 938 Vietnamese aristocrats raised troops and expelled the armies of the declining T'ang

dynasty from the Red River Delta. After all, warlord revolts had occurred many times before in Giao Chau, just as they had occurred in provinces throughout China in times of imperial weakness. But the authorities would have been wrong. The Vietnamese, who had kept their own language, preserved in Chinese characters, as well as many of their old customs, were in the process of taking their independence. In 1010 the warrior lord Ly Thai Tho unified the country, which became known as Dai Viet. He moved the capital to what is today Hanoi, calling the place Thang Long, or Rising Dragon, and established the Ly dynasty. When six decades later the armies of the Sung dynasty descended to reconquer their lost territory, they confronted not the scattered forces of warlords, but an army united under a monarch who called himself the Emperor of the South.

Ly Thai Tho and his successors were Buddhists who ruled through feudal aristocracy, but they established a Chinese-style bureaucracy to help them administer their realm: a bureaucracy whose officials at national, province, and district levels were mandarins chosen by competitive examinations in the Confucian classics on government, ethics, and literature. The country had come to require centralized rule.

For all of its fertility, the Red River Delta is a difficult place to live and to grow rice. Descending swiftly out of the high mountains, the Red River discharges an enormous quantity of water in the summer monsoon season: enough so that without any restraints on its flow it would inundate three-quarters of the delta. Particularly when the typhoons hit, the river poses a major danger to life. From time immemorial the Vietnamese built dikes to direct the flow of water. But only a centralized state with a higher degree of political organization than a feudal state possessed could build the network of broad, high dikes necessary to control the entire river system, plus the canals to distribute the water across the delta. Once built, moreover, the dikes had to be maintained, for breaks in the system would cause floods that would wash away villages and bring famine to the land. With the technologies available, this meant the mass mobilization of labor every few years.

In practice the Ly monarchs and their successors, the Tran, greatly enlarged the dike system and maintained it well. Their success permitted the population to grow and prosper, and that in turn gave the monarchs the legitimacy they needed to preserve the independence of their country from the Chinese. In the thirteenth century the Tran repelled three invasions by the Mongol Yuan dynasty, mobilizing more than 200,000

soldiers out of the relatively small population of the Red River Delta. Only when the Tran dynasty went into decline at the end of the fourteenth century did the Vietnamese resistance falter. The Chinese Ming dynasty occupied Vietnam for twenty years. However, a commoner, Le Loi, and his brilliant strategist, the Confucian scholar and poet Nguyen Trai, consolidated the guerrilla bands that had sprung to life in many areas of the country into an army, and in 1427 they drove the Chinese from the land. Le Loi and his successors ended the remaining elements of feudalism and established the most purely Confucian government the country had yet seen: a mandarinal administration governing a free peasantry. In effect they adopted the Chinese system in order to reject the universalism of the Chinese empire.

In a defense of Vietnamese sovereignty Nguyen Trai wrote: "Our state of Dai Viet is indeed a country wherein culture and institutions have flourished. Our mountains and rivers have their characteristic features, but our habits and customs are not the same from north to south. Since the formation of our nation...our rulers have governed their empire in exactly the same manner in which the Han, T'ang, Sung and Yuan did theirs."[4]

Like all Confucian scholars, Nguyen Trai believed that the way to good government lay in the attempt to replicate the practices of the great Confucian empires of the past. Yet the Le dynasty did not slavishly follow the Chinese model, but took account of indigenous "habits and customs." And where local government was concerned, Vietnam differed considerably from China. For Confucius the family was the model for all institutions, and in China the extended family, or clan, was the primary community and unit of government. Above it was the supra-family of the state, in which the emperor stood as "the Son of Heaven and the father of his people." In Vietnam, where the clans were not as extensive, there was an intermediate institution between family and state: the village. The most important unit of local government, the villages were corporate communities that regulated their own affairs and held land for the common use. Economically almost self-sufficient, the villages paid their taxes, provided labor to repair the dikes, and furnished recruits for the army, but otherwise they had few obligations to the state and a high degree of autonomy. This autonomy was at once the strength and the weakness of the nation, for while the villages could survive the collapse of the state, they could also pull away from it—particularly after the nation expanded beyond the Red River Delta.

Under the Le dynasty the Vietnamese began their March to the South, a pattern of conquest and settlement that more than doubled the size of their country and turned what had been a small kingdom, constantly on the defensive, into a major power in Southeast Asia. The first step was the conquest of Champa, an Indianized kingdom that had established itself on what is today the central Vietnamese coast, roughly from the eighteenth parallel in the north to Nha Trang in the south, in the second century A.D. Champa had long been engaged in hostilities with Vietnam, and over the course of the centuries the military balance had lurched one way and the other. With the strength Le Loi had mustered to defeat the Chinese, the Vietnamese took the Cham capital of Vijaya in 1471 and went on to settle the country, implanting tightly organized civilian communities behind a shield of military villages and penal colonies. They then moved south again. During the seventeenth century they entered the thinly settled plains of the Mekong Delta, pushing all the way to the Gulf of Siam, across the Bassac River, and deep into the kingdom of the Khmer, Cambodia.

Once the Vietnamese had reached the plain of Southeast Asia, they entered into a battle for territory that the Indianized kingdoms of the south had been waging intermittently for centuries. Like the wars of medieval Europe, this battle had gone on through the rise and decline of many kingdoms and cultures. At the time the Vietnamese joined the conflict, the fortunes of the kingdom of Siam were in the ascendant. Though beset by Burmese armies from the west, Siam had driven the Khmer monarchs from their capital at Angkor Wat and was in the process of building an empire out of territories seized from Cambodia and Laos. After a series of engagements with Siam that went on over the course of a century, Vietnam concluded a treaty with Siam whereby the Khmer kingdom recognized the suzerainty of the two greater powers and ceded to each the provinces adjoining their territories. The Mekong Delta became a part of Vietnam.

In the southern delta the Vietnamese settlers found themselves in an environment very different from that they had known in northern and central Vietnam. The Mekong, one of the world's great rivers, originates high in the Tibetan plateau. But long before it reaches Vietnam it drops to 500 feet above sea level, and in its course through the lowlands of Laos and Cambodia, it becomes placid and slow-moving. In its delta the annual overflow is moderate and predictable because in the rainy season some of its waters back up through a tributary to the vast lake of Tonle Sap in Cambodia. In the dry

season the flow from the lake reverses itself, irrigating the delta once again. The gentleness of the river and the mildness of the climate make the Mekong Delta ideal for wet rice farming and a much safer place than the Red River Delta. Rice farmers have no need to build high dikes or to prepare for drought, and thus no need for the level of social and political organization required for survival in the north.

When the Vietnamese arrived much of the delta was marshland, uninhabited except for a scattering of Khmer villages. As the migrants moved in, they dispersed to settle on hillocks in the marshes or along the riverbanks. The pioneer villages quickly lost their fortress aspect and their high degree of internal cohesion. With this adaptation to their new circumstances the Vietnamese began to make the land suitable for rice cultivation. But the delta was enormous and the process of colonization and development slow. By the time the French armies arrived in the mid-nineteenth century, the delta was still fairly empty and undeveloped. The migration to the delta continued, but it did so under French governance and under a system of landownership that changed the social structure as much as did the ecology of the Mekong. As the anthropologist Gerald Hickey put it, the Vietnamese went through a "cultural washout" as they moved from north to south.

The Vietnamese March to the South provided new lands for a growing population, but it made the task of governing the country, with its long, narrow waist, a great deal more difficult. When the Le dynasty went into decline in the sixteenth century, two noble families, the Trinh and the Nguyen, came to the fore, and around 1620 they effectively divided the country between them, the Trinh becoming viceroys of the north, the Nguyen the lords of the newly conquered land to the south. This de facto partition continued until the late eighteenth century, when a peasant rebellion led by three brothers from the village of Tay Son in what is now Binh Dinh Province swept across central and southern Vietnam, overthrowing the Nguyen. The ablest of the brothers conquered the Trinh as well, reunified the country, and proclaimed himself emperor. But after he died, the surviving heir to the Nguyen lords defeated the Tay Son and in 1802 founded a new dynasty, with its capital at Hue.

Earnest neo-Confucians, the early Nguyen emperors had high ambitions to create an empire as glorious as those of the past. Great builders, they constructed roads, bridges, dikes, and citadels. In Hue they established an ultraorthodox regime. Promulgating a new set of laws based on the code of the Ming and the Q'ing dynasties of

China, they built palaces and temples on the model of those in the Forbidden City of Beijing; they cultivated Confucian scholarship and meticulously practiced the imperial rites mediating between earth and heaven. But the court was one thing, the country another.

During the period of internecine conflict warloards had seized peasant lands and bandits had preyed upon the villages. Rather than pacifying the country and redistributing the land, as the early Le monarchs had, the Nguyen paid little attention to the plight of the peasantry. Indeed, they merely added to its burdens with their endless construction projects, prompting local peasant rebellions. Then too the Nguyen did not fully recognize that the European traders, missionaries, and adventurers who had begun to appear in the ports of China and Southeast Asia two centuries before posed a threat of a new kind to Vietnam.

In the seventeenth and eighteenth centuries French missionaries had established a strong presence in Vietnam and converted numbers of Vietnamese to Catholicism. French merchants, on the other hand, had had little interest in the country because its market was tiny compared with that of China. They had moved on, as had the French naval fleets. But in the mid–nineteenth century, when the French joined the British and other European powers in a scramble for colonies to provide raw materials for their growing industries and markets for manufactured goods, Vietnam began to look more desirable. Spurred on by the false hope that one of Vietnam's rivers might prove a route to China — and by their inveterate rivalry with the British — the French occupied Da Nang in 1858 with the intent of marching north and seizing Hue. When their forces were repulsed by the royal armies, they turned south and captured the small but growing commercial port of Saigon. They then moved out across the Mekong Delta, and by 1867 they had put the whole of the south under their control as the colony of Cochinchina. The Franco-Prussian War intervened, but when it was over, they went on the offensive in northern and central Vietnam, taking Hanoi in 1882 and Hue three years later.

Had the Nguyen monarchs been able to mobilize the population, as Le Loi did against the Chinese, and bought enough modern weapons, they might conceivably have made the occupation of their country too difficult and expensive. As it was, revolts in the north preoccupied them, and, lost in the past, they made concession after concession in the vain hope that the French would desist. In many parts of the country local notables

and Confucian scholars raised guerrilla forces to fight the invaders, but separately they could not prevail. In 1885 the French by a treaty with the monarchy divided Vietnam into three parts: the south continued as the colony of Cochinchina, the north became the protectorate of Tonkin, and central Vietnam became the indirect protectorate of Annam, where a puppet emperor ruled over the semblance of government. Later the French combined the three territories with Laos and Cambodia into a federation they called Indochina.

In 1885 "Vietnam" ceased to exist. It took the Vietnamese ninety years and two major wars to put the country back together again.

This peasant woman is crossing a dike on her way to the rice fields near Yen hamlet, in Thach Xa commune, Ha Tay Province. In her left hand she holds a long-handled basket called the single bucket, which is used for irrigation. By long-standing tradition it is the women who weed and cultivate the delicate pale green seedlings.

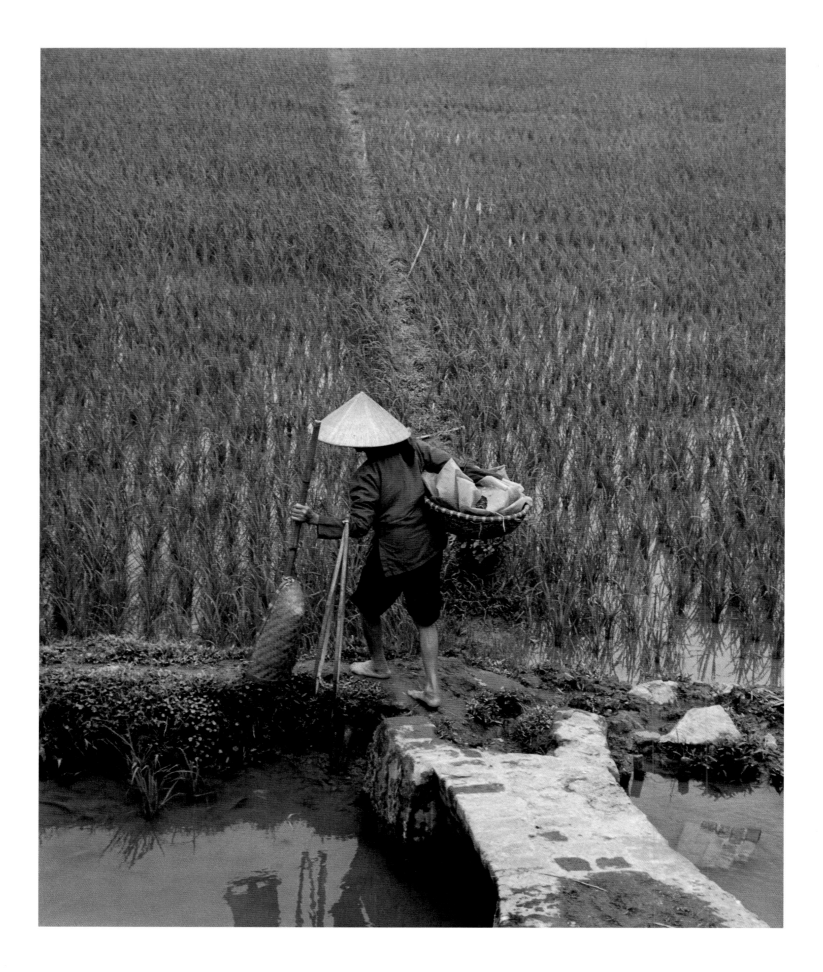

Earth and Water

The last of the Hung kings had a daughter of great beauty. When she came of the age to be married, she had two suitors: Son Tinh, the genie of the mountains, and Thuy Tinh, the genie of the waters. The king promised her to the one who came to him first with wedding gifts. Son Tinh arrived first and took the princess with him into his mountains. Furious, Thuy Tinh assaulted the mountains with his waters, but Son Tinh mastered the waters and forced them to withdraw. Every year at the same time the battle between the two genies takes place again, always ending with the victory of the genie of the mountains.

— AN ANCIENT VIETNAMESE LEGEND

On the floodplain of the Red River Delta the rice land is flat, as though leveled with a rolling pin. From a road that runs along the top of a dike you can look out across an enormous vista of rice fields. In the middle distance there may be a walled village or a mountain, such as those that appear in Sung landscape paintings, rising abruptly out of the plain. Except along the dike itself there are no trees — just rice fields extending as far as the eye can see. In the spring, when the rice is only half-grown, you can make out the small dikes that divide the paddies into a pale green patchwork; the water shines through the rice like the shards of a mirror in the sun. From dawn to dusk there are figures in the landscape: women, perhaps, up to their knees in water, pulling weeds; a farmer netting small fish or crabs; a boy tending his buffalo; men or women moving water from one paddy to another with a rhythmical dip and swing of the straw baskets suspended between them. The road may be lined with oddly shaped towers that are brick kilns, where the squares of earth dug

from the paddies are fired. There are no buildings in the rice fields, not even sheds, for in the summer monsoon the land is flooded, and the waters can rise far up the sides of the two-story-high dike. But there are cemeteries, many with large family tombs.

In Vietnamese *nguoc* means "water," but it also means "the people," "the nation." This is not so difficult to understand, for in Vietnam the image of water is that of the trickle that goes through a rice field and that of the rivers that irrigate the country as a whole. Because the earth is where the ancestors are buried, and because families live for generations in the same place, the people are seen as the water flowing through the permanent land.

It is hard to exaggerate the importance of rice to the Vietnamese.

Wet rice is an extraordinarily productive crop. It produces more grain per unit than any other grain crop; it is far more nutritious than other staples, such as cassava, corn, or wheat; it requires comparatively little seed, and it does not so easily spoil. What is more, the paddies offer almost everything else that is necessary to a balanced diet. In the rainy season they are home to small fish, shrimp, crabs, and snails as well as ducks. In the dry season farmers can raise vegetables in them, and they can use the rice stalks for fuel, for thatching, and to feed the water buffalo. Nothing is wasted, not even the weeds, for these become green manure for the next rice crop.

But for all of its bounteous returns, rice farming is extremely labor-intensive. In fact it borders on horticulture, for without sophisticated machinery the sowing, weeding, and harvesting must be done by hand. In the north the farmers must even germinate the rice seeds and transplant the seedlings into the field one by one. What this means is not just that rice farmers work harder than most other kinds of farmers, but that they live in a more intimate relationship to their land. They know their fields by touch — and the knowledge is not easily abstracted or transferred. In the late 1970s the Vietnamese government undertook a collectivization program in the hopes of making rice farming more efficient and productive. The program had the opposite effect, not merely because it eliminated the profit incentive, but because working in labor brigades, the farmers literally lost touch with their fields. "We were strangers to the land," one farmer later told an American visitor. "Every day a different plot of land. It was like waking up in a strange bed every night."[1]

Rice farmers since the Bronze Age, the Vietnamese became far more powerful than the mountain peoples around them. Rice permitted them to create permanent settlements, to establish a stable social order, and to enjoy something more than a bare subsistence economy. The addition of Chinese technologies and methods of governance permitted them not only to colonize the whole Red River Delta but to advance down the littoral, sweeping other peoples and cultures aside.

Supremely well adapted to their environment, the Vietnamese kept to the lowlands where they could plant rice. With the way open before them, they had little incentive to move up into the Central Highlands and begin cultivating some less productive crop. Their settlements stopped in the foothills of the high plateau. Then, too, they did not venture far out to sea. Their fishing boats plied the coastal waters, but for all their hundreds of miles of coastline they did not build navies or merchant ships to extend their reach across the ocean. Thus until the seventeenth century, when the Vietnamese began to move into the great plain of the Mekong Delta, their nation remained compressed between the mountains and the sea. A small country and relatively isolated, it was a land of rice farmers, artisans, and Confucian scholars.

In precolonial times almost every Vietnamese family was engaged in rice farming. Other occupations, including the growing of other crops, were seen merely as sidelines — as things that could be done when one was not growing rice. The cobbler, the hatmaker, and the silk weaver also grew rice, or, rather they were rice farmers who also made shoes or clothes. In the traditional ranking scholars came first, farmers second, artisans third, and merchants last. In the countryside trading was done exclusively by women, who could take some time from rice farming to buy and sell in the village market or to carry their products to the neighboring villages. Trading was seen as below the dignity of men; thus the Vietnamese left even national and international commerce to overseas Chinese and other foreign residents. For gentlemen the only honorable occupations were rice farming and the study of the Confucian texts: a study that led to the mandarinate and the management of rice farming.

In traditional Vietnam — which is to say the Red River Delta and the coastal plains to the south — everyone was caught up in the seasonal rhythms of planting and harvesting set by the two monsoons. These rhythms were punctuated by rituals. In the villages people made offerings at the beginning and the end of each harvest and prayed for good weather in between. As the mediator with the spirit world, the emperor maintained a temple to the gods of the soil and the grain; at the beginning of each lunar year he presented a ritual offering to the gods and symbolically worked a piece of rice land himself. The emperors of the last dynasty, the Nguyen, celebrated these rites in an outdoor temple, much like that in Beijing, with a round platform, representing heaven, and a square one, representing earth.[2]

In the Red River Delta the growing of rice demanded a national effort. In villages around Hanoi there are still shrines to the Genie of the Mountain and the Genie of the Waters — shrines that testify to the perpetual struggle to keep the flood waters at bay. From the earliest times, maintaining the balance of earth and water involved the whole society. After the Vietnamese wrested their independence from China, the Vietnamese monarchy

took on the responsibility for building and repairing the deltawide irrigation system. This was a major enterprise because the dikes, which ran along the banks of the Red River and its tributaries, were great earthen ramparts fifteen to twenty feet high. Over time they would inevitably develop fissures and, if not properly tended to, would disintegrate in the floods. The mandarins in each district and province had to inspect the dikes with an engineer's eye and raise corvées, or unpaid draft labor, from the villages to repair them. In addition the mandarins had to maintain the irrigation canals and keep stores of rice for use in case of emergency. A dynasty that could not perform these tasks effectively lost its legitimacy with the people — or the Mandate of Heaven. In 1315, a year of dangerous flooding, the emperor Tran Minh Tong oversaw the work on the dikes himself. When a mandarin objected that the king should "practice the great virtues and not concern himself with small things," a court dignitary replied, "When a great flood or drought threatens the country, it is the duty of the king to take care of it directly. That is the best way to practice the great virtues."[3]

Even in the colonial period the mandarins — some of whom were employed by the French — continued to maintain the dikes and to observe the rituals. In her book *The Sacred Willow* Duong Van Mai Elliott tells us that in 1893 her mandarin great-grandfather saved Thai Binh Province from the floods by working day and night on the dikes and praying to the river gods. As an old man he built himself a tomb within a replica of the world, complete with water and a miniature mountain.[4]

The French, however, were not overly concerned with the problems of the ordinary rice farmer, and during the Great Depression and World War II they neglected the dikes and failed to maintain stocks of rice in case of national disaster. In 1944–45 this neglect, bad weather, and the wartime needs of the Japanese who occupied Vietnam led to a devastating famine in northern Vietnam in which about a million people out of ten million starved to death.[5] In August 1945 the Viet Minh, then still a small nationalist guerrilla movement, entered Hanoi, and to the acclaim of huge crowds, their leader, Ho Chi Minh, proclaimed the establishment of the Democratic Republic of Vietnam (DRV). The Viet Minh urged people to plant crops on every inch of available land, even in the urban areas. "An inch of land is an inch of gold," their slogan went. Ho Chi Minh, it was said, led a procession of farmers carrying baskets of soil to the top of the French governor-general's palace and planted rice on the roof. The story may be apocryphal, but it is symbolically eloquent.[6]

After 1954, when the Viet Minh victory at Dien Bien Phu brought an end to French rule in Vietnam, one of the first major undertakings of the new government in the north was to repair the irrigation system and build new dikes and canals, just as the Ly dynasty had done after the first war for independence.[7] Then the government did

something not at all traditional. Faced with the task of creating a modern economy in a land of subsistence farmers, the DRV chose to collectivize the family farms of the north — most of them tiny — in the hopes of creating efficiencies of scale. The program began modestly: hamlets became cooperatives, and extended families "production brigades." This seemed familiar enough, and during the early sixties rice production rose. But along with the American war came larger-scale cooperatives and the specialization of farm labor on the model of a factory system. Rice production leveled off, and after the war, as the government attempted to extend the system to the south, it failed to keep pace with the growth of population.[8]

The farmers put up with extraordinary hardships during the war, but when it was over they became less tractable. They gave their energies to working on their small private plots, and in some parts of the north the cooperatives fell apart. People began to go hungry, and because most of the southern farmers refused to join cooperatives, the government could not extract enough rice from the Mekong Delta to feed the north. In 1981 the government took a first step toward agricultural reform; in 1986, after an internal political struggle, it put the whole process of "building socialism" into reverse and dismantled the cooperatives as well as much of the command economy. The farmers responded quickly, and by 1989 Vietnam was not only feeding itself but had become the third largest rice exporter in the world, after Thailand and the United States. In effect, rice had trumped ideology.[9]

These days farmers in the densely populated Red River Delta just manage to feed themselves on tiny plots. The surplus comes from the less populated Mekong Delta. Driving south from Ho Chi Minh City, you will see an uninterrupted procession of trucks carrying rice from the delta through a series of bustling market towns. The farmers of the south know all about international rice prices and all about research on new rice varietals. Some of them have grown relatively wealthy — in part because when something goes wrong, they complain. In one hamlet I listened to farmers gripe about the weather, the prices, and the farm bureaucracy. One farmer in high dudgeon said, "The government has reversed the whole social order and put cadres first, merchants second, artisans third, and farmers last."

In Vac village, handmade bamboo birdcages and fans are the principal products of a busy cottage industry. All family members participate in manufacturing the delicate cages of split bamboo. ➤

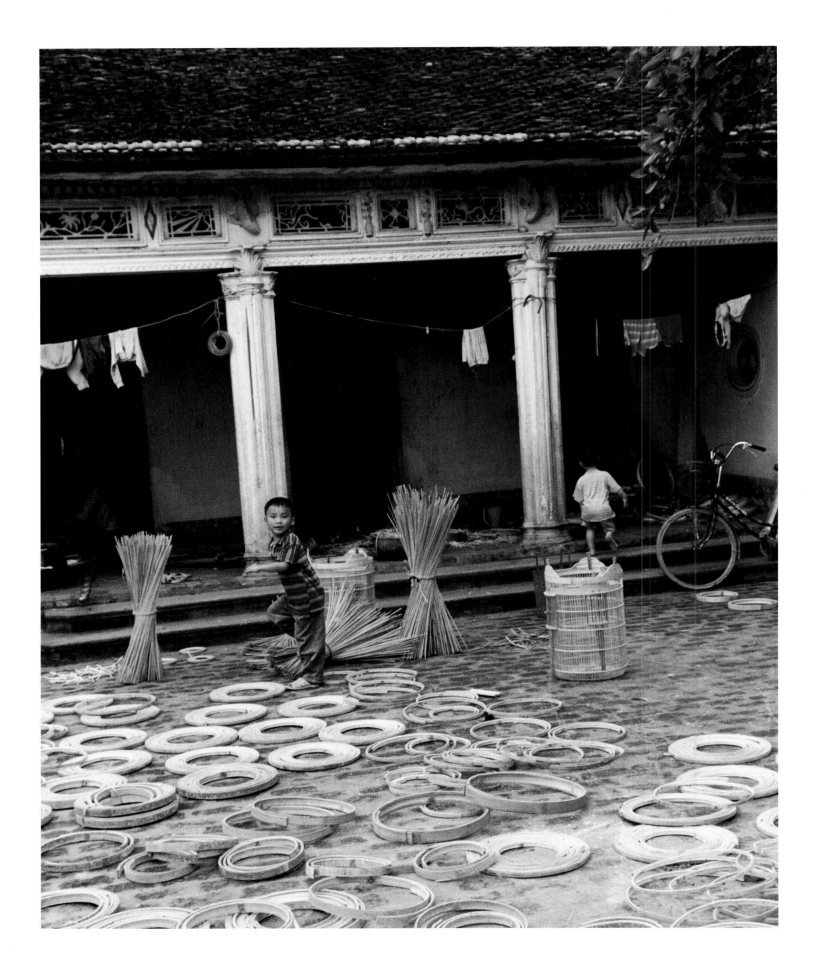

Villages

The mandarin is in a hurry, but the people are not. If the mandarin is in a hurry, let him start swimming and continue his way.

— A VIETNAMESE ADAGE

Most travelers to Vietnam, be they Americans, Europeans, or Asians, are accustomed to viewing the world in terms of centers and peripheries. In Hanoi, the capital for most of Vietnam's long history, they look for historical monuments, as they would in Paris, Rome, or Beijing. But the Vietnamese were not city builders as the Chinese were; their rice-based economy was just too small. Thang Long (Hanoi) and later Hue were centers of government where the emperor had his citadel, his palaces and temples — all of these on a modest scale. In addition each capital had a small commercial quarter, where guilds of artisans catered to the refined tastes of the court. Beyond that, Vietnam was a country of villages: thousands of them scattered out across the alluvial plains.

To the Chinese who came to Vietnam over the centuries these villages appeared inconsequential. Surrounded by trees and thick hedges of bamboo and thorny plants, they looked like nothing more than features of the natural landscape — clumps of greenery that provided some necessary break in the monotony of the flat, rice-growing plain. Looking at these rustic abodes, Chinese who had just arrived in Vietnam would secretly laugh at this poor, provincial land.[1] Yet the village hedges harbored dense settlements and complex societies — societies that, unlike the state, were never made over on the Chinese model. The villages had their own habits and customs and their own sense of

history. The most fundamental expressions of Vietnamese society, the villages were at once the source of Vietnam's irreducible sense of its own identity and of its powers of resistance. And the Chinese were wrong to laugh, for in the tenth century Vietnam broke away from the Celestial Empire, and the many attempts they later made to restore Vietnam to what they saw as its proper place as a province of China always followed the same pattern: their armies would invade and take Hanoi, the emperor would withdraw, and the Chinese would find themselves surrounded and attacked from all sides. In attempting to pacify the countryside, the Chinese would face the problem of how to concentrate their forces in every place at once, for there was no one center to Vietnam, there were thousands.

The traditional villages of the Red River Delta are the keys to Vietnamese culture. Yet these days the old villages are somewhat difficult to find, for the main roads, most of them built by the French, go from city to city and town to town, leaving the villages aside. In recent years these roads have become corridors so built up with houses, shops, and small business enterprises that it is hard even to catch a glimpse of the landscape beyond. From these corridors one might gain the impression that the modern world has passed the villages by. But from an airplane you can see that these settlements still dominate the countryside and command their rice fields like fortresses. And from the heights of a dike you can see that within their hedges — or the brick walls that have in some areas replaced them — they are a hive of small courtyards with tile-roofed houses and gardens.

In precolonial times the villages were largely autonomous. Each had its own subsistence economy, maintained its own local dike system, adjudicated disputes among its members, and administered itself. The empire was centralized and authoritarian, but its powers were limited, for by statute as well as custom the villages acted like corporate persons in its regard, paying taxes, raising corvée labor, and supplying a contingent of soldiers. The mandarins did not deal with individuals or families; they dealt with villages, which, once they had discharged their collective obligations, were free to govern themselves. "The law of the emperor yields to the custom of the village," ran one well-known adage. When a dynasty went into decline and allowed the dikes to break and bandits to roam the land, a village might withdraw behind its bamboo hedges and withhold its taxes and its labor. Conversely, if a village failed to meet its obligations, the dynasty might cut its hedges down. In the colonial period the French dealt with rebellions in this way, for the penalty was serious. As the French geographer Pierre Gourou wrote in the

1930s, the hedges were not just a protection for the village but a sacred boundary, and without it "the village feels as uncomfortable as a human being would were he undressed and marooned in the midst of a fully dressed crowd."[2]

Separated from each other by expanses of paddy land and surrounded both physically and symbolically by hedges, the villages were closed communities. Some of them cooperated, or engaged in friendly rivalry, with their neighbors, but generally their relations with each other were formal, and strangers did not easily gain entrance. The only opening in the hedges was a narrow brick gate, often highly ornamented and well guarded. This was the face the village presented to the world.[3]

Traditionally the heart of the village was the *dinh*, or communal house, which served as the meeting place for the council of notables, the sanctuary for the guardian spirit of the village, and the place where the village charter from the emperor was kept. Like the family, the village was both a secular and a sacred polity. The word for this polity was *xa*, and in the original Chinese orthography the character *xa* was composed of two roots, or radicals, the first meaning everything that refers to the spirits and the second meaning everything that is earthly. Together the two characters signify "spirit of the earth" and give the idea of individuals coming together to worship the spirits — and specifically the patron genie of the village.[4] Each year the village held festivals celebrating the spirit of the dinh with rites that symbolized, and helped to maintain, the ties that bound the members of the village together and linked the village to the state, to nature, and to the supernatural world. Membership in a village was thus of transcendent importance. As the anthropologist Neil Jamieson tells us, a bride on her journey to the groom's village would take talismans to ward off the evil spirits, because in passing between villages the individual was outside of culture, existentially isolated and exposed. To leave the village was to leave society and its links with the larger forces of the universe.[5]

Village societies were — and are today — made up of extended families, or clans, but the village was a community that incorporated and transcended them. Individual families owned land, but the village itself was a major landlord. The proportion of the land held in common varied considerably: in some villages it was less than 10 percent, in others over 25 percent. The village notables redistributed this land every three years or so to members of the commune. Precedence was normally given to former soldiers, to those who worked for the commune, and to the poor, but if there was enough land, others got a share. In addition villages dedicated a piece of land to the cult of the guardian spirit, the rents from which paid for the dinh festivals. The villagers therefore resisted selling land

to outsiders, and when a family from the outside acquired land within a village, it could take generations before its members were accepted as full members of the commune.[6]

Each family was a hierarchy, with rankings from the eldest male of the senior branch on down to the youngest girl in the most junior branch. The village was also a hierarchy, but not just one of birth or seniority in one of the clans. Adult males could attain status and move up through the rank-ordered positions by educational achievement, virtue, and contributions to the welfare of the village. Who became a notable was of some political and economic consequence, but for the most part the ranking determined symbolic issues, such as how individuals were addressed by others and where they would sit at village feasts. This ranking was a matter of great moment to everyone — or at least to the men. Describing the village he grew up in in the 1920s, the Marxist scholar Nguyen Khac Vien wrote, "After the ceremonies honoring the village guardian spirit, the head, beak and crown of the sacrificial rooster had to be set aside for the highest-ranking notables. Heaven help anyone who took a piece for himself!"[7] Traditionally wealth in itself did not confer status, generosity did — and the richer a family was, the more it was required to contribute to achieve higher status. In effect the village exacted a tax on prestige, consisting of persistent social and economic demands. Because the amount of land within an established village was inelastic, a family, it was said, could not remain wealthy — or poor — for more than three generations.[8]

Village societies were, however, more diverse and complicated than the ranking order would suggest, for they included a number of voluntary associations, where people came together as equals in the pursuit of shared interests. Many villages had their own specialized handicraft industries, and the artisans would often organize themselves into a guild. Every village had a Buddhist pagoda, temple, or shrine and an Elderly Women's Buddhist Association to take care of it. In addition there were mutual aid societies into which each household would contribute a small sum each month to save up for marriages, funerals, and other occasions that demanded sudden large outlays of resources. On top of that there were a great variety of social clubs: associations for the Confucian literati, clubs for wrestlers, singers, bird breeders, students of the same village scholar, even associations for people born the same year. Each of these societies had its own meetings and banquets, and many of them owned land, whose income covered their expenses. The villages, Pierre Gourou wrote, had "a strenuous social life" hidden within their bamboo walls. In the village of Dinh Bang he counted eighty public or semipublic feasts in a year.[9]

The traditional village had, in other words, an abundance of what the sociologist Robert D. Putnam calls "social capital."[10] These village arrangements made for a disciplined, public-spirited society; at the same time, as one villager told me, they encouraged conformity and conservatism at the expense of creativity and entrepreneurship. Vietnamese village society was more lively, spontaneous, and informal than its Chinese counterpart, yet status and "face" were important, and villagers tended to regard outsiders with distrust.

Since the late nineteenth century the villages of the north have gone through a series of profound upheavals — as well as three major wars. By monetarizing the economy, replacing the limited, ritualized Confucian state with an activist administration, and levying taxes on individuals at rates that were exorbitant for subsistence farmers, the French quite inadvertently dealt a body blow to the internal organization of the villages and created great disparities of wealth. In 1945 the Vietnamese revolution swept away the decayed apparatus of village government, and in 1954–56 the new government carried out a brutal but effective land reform program. Collectivization followed, along with modern health, education, and social welfare systems. Then came the American war, and a decade or so after it, an abandonment of the collectives and a return to family farming.

As a result of all these events, the villages are hardly as they were before. For one thing, their political autonomy has long gone, and so has much of their distance from the social and cultural life of the rest of country. Within the villages, government and Communist Party officials transmit national policies and manage the administration, and government-sponsored organizations for women, youth, and veterans play civic roles. Still, some features of village life have not changed — and a surprising number of others have undergone revivals in the wake of the economic reforms of the 1980s.

Finding the entrance to a village is sometimes a puzzle, for some of the old villages now belong to larger administrative units,* and the gates of the old villages often bear no relation to the modern roads. But then, within the gates there is a world quite different from the one outside: a labyrinth of lanes and alleyways, too narrow for cars, flanked by hedges or brick walls. Walking through the village you soon find yourself lost in blind alleys or on paths that wind about in an apparently arbitrary fashion. Through

* Because the Viet Minh appropriated the old terms, these new units are often called *xa* — whereas people speak of their old villages as *lang* or *lang xa*.

the gates in the walls you can see houses set in small courtyards or gardens. The village is a honeycomb in which each household maintains its privacy.

Traditionally the plan of the village was established by geomancy. It was, for example, thought that the breath of the dragon ran in underground channels, so that digging in certain places might bring on catastrophe.[11] Though the villages are no longer planned in this way, past practices account for some of the twists and turns in the paths. Some villages have houses built in the old style, with a courtyard flanked by wings where the cooking and washing are done, or where chickens and doves take roost. But even in houses of modern design an altar to the ancestors invariably dominates the front room. These days the biggest buildings are usually schools or government headquarters, but every village has a dinh as well as a Buddhist pagoda or shrine, and in all the villages I visited in 2000 the dinhs had been rebuilt or refurbished during the 1990s. A Chinese-style "tent" structure, the dinh, or communal house, typically has four sloping tile roofs turned up at the corners and supported by heavy wooden pillars. Inside are three bays, with the main altar in the center and a side altar on the left. Typically the dinh faces south onto a courtyard, beyond which there is usually a pool and a large shade tree, perhaps a banyan. In effect the dinh has much the same plan as a large and refined traditional house. But then private houses and dinhs are simply temples of different dimensions.[12]

From medieval times on, most villages had their own particular handicraft industry, and this is still the case. Driving along the roads you can often see the raw materials stacked up by the roadside: plywood for those that make toothpicks or matches, bundles of reeds or straw for those that weave mats or baskets. Some of these industries are new, but some villages continue to produce the same handicrafts they did centuries ago. Bat Trang, for example, just outside Hanoi, has long been famous for its blue-and-white pottery, Chuong, in Ha Tay Province, for the *nom* leaf covering for conical hats. Each village jealously guards the secrets of its craft and respects the secrets of others — with results that sometimes baffle foreign development experts. Chuong, for example, does not make the bamboo structure for its hats. It imports them from a distant village, though the technology is not complex and bamboo grows well near Chuong. In the past these industries developed in a haphazard fashion. One entrepreneurial villager would make a commodity — say a certain kind of silk or a bronze vessel shaped in a certain way — and if a market for it developed, his neighbors would copy him, and eventually everyone in the village would produce the same thing. This is still true today. In one

village I visited in 1993 a young woman, a mother of three small children, had managed to contract with a Japanese company to produce baskets of a traditional design, giving employment to half the households in the village.

Dong Ho, in Hai Duong Province, is a village that has long been well known for its colorful woodblock prints, whose motifs represent sacred animals, legends, and scenes from traditional village life. On our way back to Hanoi from the But Thap Pagoda, Mary and I stopped in to see how the printing was done. Passing through a narrow gate in the village wall, we found ourselves in what was clearly a prosperous settlement. The lanes were paved in concrete, and there were many new stucco houses with fruit trees and flowers in their tidy courtyards. Following signs for a print workshop, we came to a house with bronze plaques on the walls testifying to government and UNESCO support for the perpetuation of this ancient folk art. But it was a Sunday, and the workshop was closed. Walking on through the village, we discovered that only two families made these prints and that what the village really did was to make the paper offerings that the Vietnamese burn for their ancestors. In the courtyards families were hard at work cutting and pasting colored paper and fashioning it into imitations of things people want their ancestors to have in the afterlife, such as shoes, umbrellas, and appliances. Each household had its specialty. One man, a veteran who had fought in South Vietnam and Laos in the sixties, invited us into his house to see the paper dress shirts he and his wife and children were making. The village, he said, had taken up this enterprise fifteen years before, when the government instituted the free market system, and since then it had prospered.

In a small shop near his house we found an array of the paper goods made in the village. A number of them seemed to me quite as interesting and imaginative as the traditional prints, notably the two-foot-high bicycles and motorbikes with all their gears and spokes represented. The village did not make the imitation Benjamin Franklin $100 bills that were the most popular offering in Hanoi that season, but it did make paper cell phones.

The government, we discovered, had for a long time frowned on paper offerings. The official reason was that the burning of paper creates air pollution, but this seemed implausible. Surely the real reason was that burning imitation luxury goods and American money for the ancestors appalled the puritanical old revolutionaries. Ben Franklin, of course, might have hated this Veblenesque ritual just as much.

A few village industries — though perhaps not more than a few — have in recent years become major business enterprises. The village of Dong Ky, in Bac Ninh Province,

for example, has used its ancient woodworking skills to produce inlaid furniture for an international market. Importing mahogany logs from Laos, its family-owned shops, equipped with mechanical lathes, sell furniture to Thailand, China, and Taiwan. Some of the shops employ fifty or sixty workers and have revenues of hundreds of thousands of dollars a year. Three- and four-story houses have sprouted up amid the traditional court-yard houses, giving the village, with its winding pathways, the look of a medieval town. The manager of one family business, a young man with an executive air about him, greeted us in his showroom and explained the business, how he had coped with the Asian economic crisis of 1997 and what he was doing to fill the needs of an expanding Taiwanese market. Later he took us back to the family compound, where his father, whom I will call Mr. Vu (for some reason I never quite got his full name), gave us tea in the main house before the tablets to his ancestors.

A man in his seventies and patriarch of a subclan — the fourth of seven branches — Mr. Vu said that the family had come from China fourteen generations ago, and that while woodworking was traditional in the village, his great-grandfather, who had built the house, had been a well-known Confucian scholar. Confucian values, such as loyalty and honesty, were of enduring importance, he said. We gathered that Mr. Vu had sent most of his sons off for professional education in Hanoi and that it was his sixth son who managed the business. While his daughter-in-law, clad in fitted blue jeans, came in and out on errands, he told us that what the village needed was a sonogram for the clinic and a mechanized plow that could service its 200 hectares of rice land. He praised the dynamism and creativity of the younger generation, but when I asked him whether he thought the country was going in the right direction, he said that the country should be moving more toward communism, as Ho Chi Minh had wanted.

Whether he was thinking about the economic disparities that have resulted from the dynamism of families such as his, I could not tell, but certainly disparities now exist. At the doorstep of a shop not far from his house we came upon a young woman who was sanding down a piece of inlaid wood. She was sixteen, she said, and every day she bicycled seven and a half miles from her village to work for eight hours so that she could take back 9,000 dong (about 70 cents) to her parents and her five younger sisters and brothers. She hadn't much hope of advancement, she said, because the skilled jobs were reserved for the artisans of Dong Ky.

Outside the residential quarter of the village, on a hillside above a canal, a wrestling tournament was in progress in a small open-air stadium. High school athletes

from Dong Ky were competing with wrestlers from a neighboring village, and the crowd was cheering and groaning with the fortunes of the local boys. The tournament was one of the events in the spring festival celebrating the tutelary genie of Dong Ky.

In March, and then again after the summer monsoon, travelers in the Red River Delta will see processions of people in blue, red, and yellow robes making their way along the dikes carrying silken banners and parasols. In the middle of these processions, behind musicians playing ancient stringed instruments, gongs, and drums, the young men will be carrying the red-and-gold throne of the village genie. The processions, which are the main event of the village festivals, can be seen even on streets in Hanoi, a reminder that the city has grown to encompass dozens of villages.

In the past the village festivals had numerous functions. They not only reinforced village solidarity, but they were occasions for villages to cement their alliances with their neighbors or to compete with them. They were also occasions when intervillage marriages could be arranged—and lovers could tryst. Often they would go on for a week, and there would be major feasts with pigs and even bullocks killed; there would be gambling, and much rice wine would be consumed. The festivals are far more decorous these days and far less expensive, but most of their traditional functions are at least symbolically represented in the festival activities.

In the village of Quang Ba, beyond the West Lake of Hanoi, we found a group of people preparing for the spring festival at the dinh. The village, which had once grown flowers, had in the past couple of decades been built up and transformed into a residential neighborhood in which many foreigners lived. One of the chief organizers of the festival, Mr. Vu Hoa My, a man in his sixties dressed in city attire, introduced himself in French and showed us around. The dinh, a fine example of traditional architecture, just recently restored, had a lacquered and gilded altar decorated with flowers and miniature orange trees in blue-and-white pots. Mr. My explained that the guardian spirit was Phuong Hung, a king who had led an uprising against the Chinese in the eighth century, and that the village had charters from seven emperors and from the present government.

On the steps of the dinh was a new stele, inscribed with the names of those who had contributed to the most recent restoration of the building and the amount they had given. Mr. My proudly pointed to his own name and the sum of 1.7 million dong ($1,200). When I asked if he was a businessman, Mr. My said no, he had been the chief of the Hanoi region in the Ministry of Agriculture and the head of the Party in the

district. Later he told me that he wasn't at all sorry to see the tall buildings encroach on the rural landscape of his youth, for he had built three of them himself, and he earned a good living from renting out two of them to foreigners. Mr. My was in high good humor.

The courtyard of the dinh gave onto a stone terrace with a square pool. In a small shrine beside the pool was a bust of Ho Chi Minh with joss, or incense, sticks burning in front of it. "We can't keep the two spirits in one building." Mr. My laughed. The bust commemorated Ho Chi Minh's visit to the village in 1962, when, as Mr. My remembered it, Ho, seeing that some of the children had an eye disease, had persuaded the villagers to dig clean wells, over objections that the gods of the earth might be disturbed by the digging.

At Mr. My's invitation we came back on festival day just as the procession returned to the dinh, pennants flying, musicians making a great noise, and a beautiful cloth dragon billowing out above it. The procession, we gathered, had gone to the village pagoda to collect pure water — the dew of the morning — for the dinh. A couple of hundred people dressed in their holiday best had gathered to greet its return. After the genie's throne had been ceremonially replaced in the dinh, a group of elderly men in blue Chinese-style robes said prayers before the altar. Families came forward out of the crowd with trays piled high with rice, vegetables, fruits, and cooked chickens. Leaving a symbolic morsel on the altar, they asked the genie to bless their meal and went outside to have their holiday photographs taken. Afterward, amidst a genial hubbub, the entertainment began. The village chess masters set up a human chess game in the courtyard with high school students dressed in robes representing kings, queens, knights, and pawns; the students sat on chairs and moved from square to square as directed. The play was fast, but one of the queens, who was hardly moved at all, got bored and read a movie magazine through most of it. Meanwhile ducks were let loose in the pond, and little boys competed to capture them by maneuvering long-handled nets or simply by diving in and grabbing them. In a field behind the dinh men huddled around rings in which spurless fighting cocks struggled more or less energetically to force their opponents out of the ring.

At the simple luncheon Quang Ba held for neighboring villagers and assorted other guests, Mr. My told us that the dinh festivals had not always been celebrated in the same way. During the French and the American wars there had been no colorful processions, just a few people coming to pray at the dinh. Then too, on coming to power in 1954, the government had complained that the traditional festivals were full of superstitions, and

that people had spent too much money on the feasts. But now, he said, the government encourages the festivals. It prohibits the bad customs — like drinking and gambling — but it favors the ceremonies and traditional games because they remind people of their history and of their civic duties. The festivals, he said, help to renew family ties and to create strong communities.

Buried within Mr. My's explanation was the fact that for thirty years the government actively discouraged (without actually banning) the cult of the tutelary genie, understanding it as a remnant of the "feudalist" past.

Vietnam never had a cultural revolution as China did, but from 1954 until the reforms of 1986, the Party had attempted to remold the northern villages into socialist societies. Under the French regime the money economy had benefited some, but the high taxes had left many farmers landless; the councils of notables fell into the hands of the larger landowners and those who could buy dinh titles from the French. In the land reform of 1954–56, a Maoist-style operation in which the poor were encouraged to denounce their richer neighbors as "wicked landlords," the land was redistributed and the village elites replaced by revolutionary councils run by Party cadres and in many cases made up of the poorest families.[13]* Later the government collectivized the land and merged the villages into larger administrative units. The locus of power shifted to the local government offices, and for many years the dinhs were seen as symbols of the old elites and their expensive competition for status. As for the village charter, the Party saw it as the attachment of the villages to the discredited Nguyen emperors.[14]

When the cooperatives began to break down in the late seventies and early eighties, the villagers began to pressure the government to recognize the historic value of their dinhs and pagodas. Then, after the economic reforms of 1986, when they were able to make a little money from farming and trade, they began to refurbish the dinhs themselves and once again to make offerings to their tutelary genies. This was not just matter of nostalgia or sentimentality, for at the very same time the peasants resurrected the social — and sometimes the physical — boundaries of their old villages and formed credit associations along traditional lines. According to anthropologists, the villagers were

* The land reform, carried out with Chinese advisers at a time when the new government was heavily dependent on China, sowed hatred and fear in village societies, and several thousand — possibly as many as 10,000–15,000 — people were executed or otherwise died. Ho Chi Minh halted the campaign in its second year and admitted that many "errors" had been committed and would be rectified. The government never used Maoist methods again.[15]

readjusting to the return of family farming and the need for voluntary cooperation among households, and the dinh ceremonies helped this process along. These days Party members as well as people from the families of the old notables and people who are now prospering in business belong to these communities, and all of them, it seems, participate in the ceremonies.[16]

By the end of the 1980s the government had come to see the dinhs in a new light; the Ministry of Culture gave a number of them landmark status and contributed funds toward their restoration. Later the government gave its official blessing to the resurrection of the dinh festivals and processions.[17] "When we collectivized, we said the festival was feudalistic. Now we bring the festival back and call it 'traditional,'" one villager told an American at the time.[18]

In effect the government had discovered the value of village traditions in holding the society together and the need to relegitimate itself on traditional grounds. Mr. My did not mention patriotism, but that is surely a part of it. After all, many of the village guardian spirits are legendary heroes who had fought the Chinese, and, at least in Dinh Bang village, in Bac Ninh Province, new heroes have joined the old ones in the dinh pantheon.

The village of Dinh Bang, long famous for its wealth, has one of the most beautiful dinhs in the country: a huge structure that evokes a tribal longhouse, with a curving roof that sweeps from a great height almost to the level of its elevated wooden floor. From its main entrance a wide wooden stairway ascends to the altar and a worshiping hall supported by sixty ironwood columns, all finely carved with fruit, flowers, and sacred animals. Begun in 1736, the dinh took three generations to complete.

On festival day the dinh was crowded with people. The rain fell heavily, and the ceremonies were delayed. Walking around the sanctuary, I found in one room a series of bulletin boards with a pictorial history of the village since the 1940s. The commune, it appeared, had been a center of the Vietnamese resistance during the French war; sitting astride a strategic route into Hanoi, it had served as an important base for the Viet Minh guerrillas. In 1954 the French had tried to pull the dinh down with tanks, but the ironwood columns were too strong for them. Later that year the first Vietnamese national assembly met in the dinh. During the American war the commune served as a site for the antiaircraft batteries protecting Hanoi. In this section of the exhibit there were maps of the artillery emplacements, graphs showing the number of tons of rice sent to the south, photographs of villagers — including a group of young women — who had gone south to fight and the names of the 123 who were killed.

Back in the main hall a hamlet chief—an army veteran who had marched into Saigon with his division in 1975—read an annotated, scholarly history of the dinh over a microphone. When he finished, people milled about; women talked in groups and little boys ran hither and yon. An elderly man offered me a seat on the bench beside him, and in what remained of the French he had learned in his youth, he recounted the history of the village from the Ly dynasty on.

Still, not everyone in the dinh was focused on the past. The ceremonies eventually began, and as I watched the blue-robed old men presenting jars of rice wine and joss sticks to the altar, a young man in ceremonial regalia came up and welcomed me to the festival in student English. He hoped, he said, to go into business and to travel abroad.

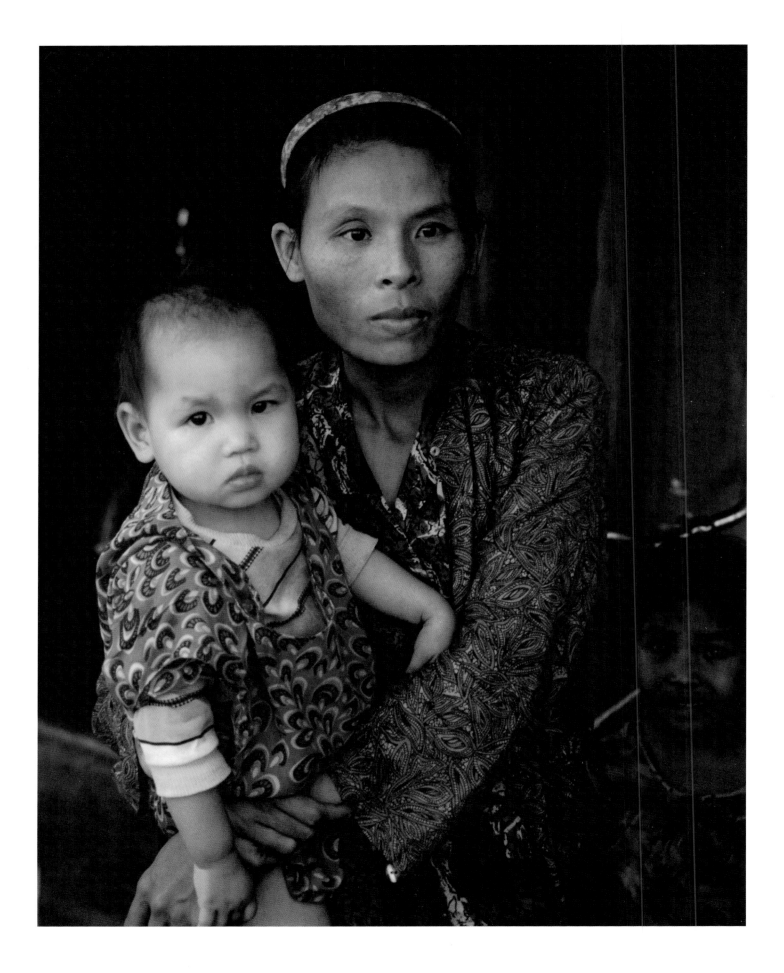

Families

As a bird has a nest, so people have ancestors.

— VIETNAMESE SAYING

Central Vietnam was the region hardest hit by the American war. Driving from Da Nang to Hue on my first trip back to Vietnam, in 1993, I somehow expected to see the rusting bodies of tanks, the tin shacks of the refugee encampments, and the scars from the bombing and shelling on the sides of the mountains. But except for a line of bunkers in the midst of a paddy field, there was no sign the war had ever occurred. The landscape looked much as it had before the arrival of the American troops — except for one thing. Along the road there were cemeteries with new family tombs, freshly plastered and painted in pastel colors, tombs much larger than those I remembered, and larger — or so it seemed — than many of the houses along the road.

When I returned seven years later, Route 1 outside Hue had become a bustling commercial highway lined with stores, repair shops, and houses. New houses had sprung up in the villages as well, some of them with highly decorated spirit screens in front of them. But the dinhs, even those the Ministry of Culture had designated as historical monuments, lay in varying states of disrepair. "It's hard to raise money for the dinhs," the elderly guardian of one of them told me. "People take very good care of their clan houses, but the dinhs are lost in these large communities."

In central Vietnam — at least south of the seventeenth parallel — the villages do not have the cohesiveness they do in the north. Whether this is a recent or a historical development, they are today little more than administrative units. Here the family is all.

Just as the dinh guardian said, the most impressive buildings in the countryside near Hue were the houses that people had built or repaired in honor of their ancestors. Walking around one village — as it happened the home village of Le Duc Anh, the president of Vietnam in the early nineties — we found a splendid new house, completely unoccupied, that the members of a clan had built for the ancestral altar and for family gatherings on the death anniversaries of their forebears. Just next to it was a beautiful traditional house, with ironwood columns and a sloping tiled roof. The woman who lived there told us that it was the house her deceased husband had inherited from his father. "It's his house," she said, pointing to a picture of her father-in-law. "He was the principal of the village school." While we drank tea, her husband's sister arrived from Hue, and the two women talked about the repairs they were preparing to make on the house and the family tombs. Relatives in the United States, they told us, had contributed two-thirds of the cost.

On a road just north of Hue we came across a lineage hall: a shrine built in the 1990s by a branch of the imperial Nguyen family, containing the family's ancestral tablets and a genealogical chart tracing the family back fifteen generations. Lineage halls were, I knew, a feature of traditional society, but I had never seen one before. Just opposite the Nguyen hall was another one, also of recent construction, this one honoring a branch of the Do family.

The caretaker of this shrine, Mr. Do Van Le, showed us a book, privately printed in 1998, which traced the family back twelve generations to the ancestor who had come here from Thanh Hoa Province in the north five hundred years ago. In 1977, by his account, a member of the family had found a record of the first seven generations compiled by a Confucian scholar in 1875. He had the text translated from Chinese characters and added information about the succeeding generations. Subsequently the family had appointed a board of editors to do the remaining work.

According to Mr. Le, most of the Do family had lived in this district until the American war, when there had been a partial diaspora. Some members now lived in Hue, some in Saigon, some in California. In central Vietnam many families had been ideologically or as a matter of circumstance divided by the war, and the Dos were no exception. In the 1960s and 1970s much of the family had sided with the American-backed Saigon government, and many of the men had served in its army, the ARVN (the Army of the Republic of Vietnam). But some had fought on the other side, with the National Liberation Front, known to Americans as the Viet Cong. Mr. Le's eldest brother, for example, had joined the

guerrillas and had been killed in the U Minh forest. But Mr. Le spoke of the war as if it were ancient history. What pleased him, he said, was that as many as 250 members of the family came back for reunions, including a number from the United States.

Listening to Mr. Le, I remembered a family reunion I had attended in central Vietnam a quarter of a century before.

In 1973, after the Paris Peace Accords were signed and a tenuous cease-fire held, a press colleague and I went to a village a few kilometers west of Da Nang that I had visited several times during the war. In the midsixties it was a rich village. Its several hamlets nestled in groves of trees had fine brick houses, and out in the rice fields there were well-tended family tombs. But the Viet Cong guerrillas often went there and sometimes used it as a staging area for mortar attacks on the Da Nang airport or attacks on military convoys going out of the city. So in the years after the American troops arrived, it became a virtual free-fire zone. Most of its inhabitants fled, and eventually the village was razed. Its houses, tombs, and paddy dikes were bulldozed and its trees chopped down. But the fighting had eased around 1970, and by the spring of 1973 the countryside was once again emerald green with the first rice crop.

Walking off the road to what had been the center of a hamlet, my colleague and I found a few thatched shelters erected on the old brick foundations and terraces. In front of one of these shelters some forty people were gathered around a long table covered with dishes of fish, meat, rice, fruit, and sweets. A family composed of old men, women, and children — the younger men having gone off to war — was celebrating the death anniversary of an ancestor four generations back. The patriarch, a man in his eighties, who had been burning joss sticks in front of the family altar, welcomed the two of us and asked us to join the group at table. We demurred, but he insisted.

After some questions about who we were and what we were up to, the elderly men, all in traditional dress, told us that the village had been a battleground during the French as well as the American war. In 1952, they said, French legionnaires — Moroccan troops, as it happened — assembled all the people of the village and shot down 227 of them in cold blood. Then, to my surprise, the men began to talk not as victims but as participants in the struggle, now three decades old. "This was always a strong resistance zone," one of them said. "That is why the French killed so many people. The liberation forces came back here in 1962, and we have had no Saigon government administration since that time." Another man said that he had spent three years in the political prison on Con Son Island in the 1960s; others said they had sons there now. A man in brown robes, who

seemed to be the authority in political matters, said he had been jailed five times, the last time just recently, when the flag of the National Liberation Front was raised over the hamlet. From his smile I gathered that he had put the flag up himself.

While the men were talking in this way, an ARVN officer in dress uniform with a major's bars pulled up to the house on a motorcycle. My colleague and I looked at him apprehensively. But the major simply dismounted and with some apologies for his lateness took a place at the table. The patriarch acknowledged his arrival, and the men went right on talking about their exploits in the resistance against the French, the Americans, and the ARVN.

Puzzling over this experience later, I began to think that the key to the extraordinary resilience of these people — and to the reception of the ARVN officer — was the fact that the family was celebrating an ancestor four generations back.

In traditional Vietnam the basic social unit was the family — not the nuclear family but the extended family, or clan, which included the dead as well as the living. In northern and central Vietnam these clans were often extensive, for they maintained their ties over many generations. Families often kept genealogical records going back seven or more generations through the male line: the father, the father's father, and so on.[1] Every year at the death anniversary of each of the ancestors, including the wives in this line, the family would gather to make a formal offering to the departed. A large and well-to-do patrilineage might have several dozen ritual gatherings a year of varying sizes and celebrate at least some of them with a feast.[2] In central Vietnam, as in the north, even poor peasants normally belonged to a large and highly articulated society, and the "simple peasant" might well have connections that an outsider would not suspect. Then, too, because of family ties, even the formally uneducated had a great sense of history. Bound to their rice fields, Vietnamese farmers rarely traveled beyond their own district. Their dimension was time rather than space: a vertiginous time through which they navigated as easily as airplanes through their medium.

In traditional Vietnam individuals were so deeply embedded in the family they half-disappeared into it. Indeed, within the family there was no word for "I." Individuals referred to themselves in terms of their relationships to other family members. A man, for example, would speak of himself as "your nephew," "your older brother" and so forth, depending upon the person he was addressing. Even a mature adult would speak of himself as a "child" when speaking with an elderly parent. This is still the case today, though the etiquette governing modes of address has become simpler.

The cement of this family was filial piety. Children were taught to obey, honor, and respect their parents; more than that, they were made to feel that they owed them a moral debt so enormous that it could not be repaid. Children were supposed to obey their parents' every wish and to try to please them at all times and in every way, lightening their burdens, making them more comfortable, and fulfilling their aspirations. Children were brought up on stories of exemplary filial behavior: the child who slept next to his parents uncovered so as to attract the mosquitoes away from them; the child who sat next to his mother's grave in thunderstorms because his mother had been afraid of lightning.[3] Then, a child's obligations did not stop with his parents; they extended to older siblings, uncles and aunts, grandparents, and so on in varying degrees. In effect children grew up in a web of social obligations that had to be fulfilled regardless of personal preferences, and a network of protocols for dealing with all the other members of the patrilineage. Growing up in such an environment, the individual found a sense of identity primarily in his membership and position in the family.[4]

What children received in exchange for service to their parents and the deference they showed them was not just the prospect of becoming parents and elders themselves, but the sense of connection — permanent connection — to a web of nurturance and protection. At family gatherings each member of the clan, no matter what his status in the larger world, would find his place in front of the altar and at the feasting table according to his own birth rank and feel at ease there. Thus the ARVN officer easily and naturally found his place among his Viet Cong relatives. At stake, after all, were not just the living but the dead and the generations to come. As all understood, the officer and the patriarch alike were holding places at that table for others. Over time individuals would die — that went without saying — but if the family survived, its members had a lifeline from the past to the future. Describing ancestor worship, two French scholars wrote, "Thanks to the rites, the Vietnamese believe in the dead, whereas Westerners believe only in death."[5]

For traditional Vietnamese the ancestors were present in the particular place where they lived and died. Indeed, as far as the living were concerned, the ancestors owned the land and the houses they had passed through; the living merely acted as trustees for them and for the future generations. In that place they watched over their descendants, protected them from harm, and shared their joys and sorrows. They also rewarded virtue, censured bad behavior, and gave advice when asked.[6] At Tet, the lunar new year, family members gathered before their ancestral altar and called their ancestors back to them. Tet was, and is, a time of rejoicing and the most important national holiday of the year.

In precolonial times, the family had an added significance, for like all of those within the scope of the Confucian world, the Vietnamese viewed the family as a microcosm of the whole society. As a father governed his family, served as a model of proper conduct, and observed the rites, so the emperor as the "father of his people and the Son of Heaven" had to do likewise for his mandarins and the country at large. The family and the state were everywhere congruent: both were moral and spiritual as well as social systems; the disciplines were in both cases the same, and both were seen as a part of the natural order of things. The goal of both the father and the emperor was to create harmony within the society and between the society, nature, and the supernatural world by conforming to the Way (Tao), or the order of the universe. Within this crystalline structure of the microcosmic and macrocosmic family, every individual had his place and his obligations. In this society there was no word for "I." The word *toi*, which people today use for the first person singular when speaking to people outside their family, originally denoted "subject of the king."

The imposition of French colonial rule thus came as an earthquake to the Vietnamese, for it removed not only their government but their connection to each other and to the heavens. The larger family was gone, and what the Vietnamese had seen as the order of nature was profoundly called into question. So too was the Confucian education system, which was the way of gaining knowledge of the "natural" laws and the wisdom to govern effectively. A number of Confucian scholars, including Ho Chi Minh's father, recognized that immediately and sent their children off to French schools. The microcosmic families survived, but they survived within what the Vietnamese saw as a broken society that could never be put together in the same way again. Yet in a sense nothing demonstrated the continuing power of the idea of a national family better than the Vietnamese revolution.

In the 1930s and 1940s the Communists were far from the only political group in Vietnam attempting to build support for an anticolonial struggle. That they succeeded while others did not had much to do with the considerable fit between Marxism and Confucianism — that and the way Ho Chi Minh adapted Marxism to the Vietnamese landscape.

Confucians looked to the past, Marxists to the future, but both believed that there were laws governing history and a single correct order of human relations; both put their emphasis on the society as a whole as opposed to the individual, and on collective duties and obligations as opposed to individual rights. Economically the Confucians had an egalitarian bent (in an agrarian society, great wealth could be gained only at the expense of others), but politically they, like the Marxists, believed that as a result of education and training some were better qualified than others to say how the laws of history worked and

how the society should be governed. The similarities between the two ideologies struck Ho Chi Minh immediately when, thanks to Lenin's declaration of support for anticolonialism, he first read Marx seriously in 1921.[7] But Marxism was just an ideology, and Ho, who had spent his childhood immersed in the Confucian texts, saw what had to be added.

At a training institute he established in Canton in the mid-1920s and later on in the maquis, Ho Chi Minh taught his cadres that success depended on their ability to practice the "revolutionary virtues," among them generosity, modesty, uprightness, courage, prudence, and respect for learning. This was a course of instruction Lenin had not thought to teach, but then the Confucians understood social relations as an ethical system, and the virtues Ho taught were those of the Confucian gentleman. To his cadres and later to the Vietnamese people, "Uncle Ho," with his gentle manners and his simple way of life, appeared as a model of the virtues he espoused.

"Uncle"—*bac* in Vietnamese—was an honorific Ho Chi Minh had acquired in the maquis during World War II. Ho had structured his Communist Party on the Soviet model; unlike the Soviet leaders, however, he never took on the role of general secretary but withdrew himself from the day-to-day operations of the politburo, to act as its senior adviser and guide. To Westerners "uncle" seemed merely a term of endearment, but to the Vietnamese it had very specific meanings. For one thing, it signified that Ho — and by extension his government — was not going to be a father responsible for disciplining his children, nor was he going to take the place of the distant, ritual emperor separated from his people by high walls. Then, too, *bac* is not just any uncle but specifically the eldest brother of the father: that is, the uncle charged with overseeing the ancestral rites and creating continuity between one generation and the next. Thus the revolution was to have some continuity with the past, and Vietnamese society was to be a family again.

Among those Vietnamese who joined the revolution and fought the French and the American wars, many did have a sense of joining a new national family. The songs and poems of the guerrillas spoke explicitly of brotherly love and solidarity within the family of the revolution.[8] In addition, many hoped that communism would have the answers to national development and to social harmony within the society as a whole. But a family must be fed, and when collectivist methods failed, many within and without the Party lost faith in communism and in its promise of a macrocosmic family.

In the north today the most obvious remnant of the old family feeling lies in the way people honor the memory of Ho Chi Minh. The government has, of course, encouraged the cult, but the fact is that for most northern Vietnamese Ho Chi Minh's death in

1969 meant that Ho had moved up a rank from uncle to revered ancestor and from president of the country to become a guardian spirit, like the Hung kings and the emperors who maintained Vietnamese independence from the Chinese.

The family feast I attended in central Vietnam in 1973 had seemed to me a natural resumption of tradition — a simple exhalation of the breath after all those years of war. By contrast the appearance of lineage halls and scholarly reconstructions of five hundred years of history in the year 2000 gave pause. These branches of the Do and the Nguyen had been grand families in the nineteenth century, but they were hardly the only ones to do scholarly research on their origins. In fact, most of the people we talked to in the villages around Hue could tell us how many patrilineages there were in the village and where their ancestors had lived in the sixteenth century. What was the reason for this?

Anthropological studies of north Vietnamese villages in the early 1990s showed that in the region that had most fully supported the revolution, and the region where the revolutionary government had held sway from 1954 on, the decline and the subsequent revival of the extended patrilineages and their rituals had proceeded in tandem with the advance and the retreat of collectivization.[9]

During the period of building socialism from the 1950s through the 1970s, Party officials in the north discouraged elaborate family ritual practices and banned expensive feasts. Weddings were held in village offices, with the youth organization providing the entertainment; funerals were simplified; lineage halls were neglected; and death anniversary gatherings were small. Ancestor worship was not banned, and most families had altars with tablets or photographs of the deceased, but the ceremonies were so low-key that at least some foreigners were persuaded that ancestor worship was gradually dying out.[10] The reasons for this were several. The Communists disliked the waste and status competition involved in the traditional family feasts, and equipped with their own version of what was scientific, they looked down upon many of the old rituals as antiquated and superstitious. Beyond that, however, the extended families represented a set of obligations and power relationships that officials considered disruptive of communal unity and competitive with the cause of the national family. In the north in particular the network of families within a village could put considerable pressure on the local cadres to serve local interests by bending the rules.[11]

However, as the government began to reverse the collectivization process and rice farmers were able to earn a little money, the surplus went immediately into spending for family rituals as well as into other religious rites. The villagers argued the money was theirs, not the state's, and to the surprise of some government economists, the spending

fueled further increases in the production of rice and other consumer goods. Eventually the government abandoned its sanctions. Patrilineages revived, lineage halls were rebuilt, and by 1990 life-cycle rites were celebrated with feasts that had not been so lavish or well attended since the era before World War II.[12] According to one anthropologist, the dynamic involved was quite simple: when the household regained its role as the primary production unit, kinship ties became more important as a source of assistance in various domains, and the ceremonies, feasts, and gift exchanges reinforced kinship relations.[13]

But in central Vietnam there was surely something more going on. Of course, central Vietnamese farmers did not have villages to rely on as the northerners did. Still, families like the Do and the Nguyen had not simply renewed their local ties after a decade of collectivization. Rather they had gone to considerable scholarly effort—one they had not made since the French arrived in the nineteenth century—to discover their roots in the distant past. In doing so they had created clans that encompassed large numbers of people, some of them living as far away as California. But perhaps that was just it. Central Vietnamese families had been torn apart by two wars and geographically dispersed. The effort to put them back together again seemed so great as to be artificial, but it was proportionate to the trauma of the many war deaths and separations. To what extent the efforts to reconstruct these lineages will succeed in binding together the geographically—and culturally—dispersed family members remains to be seen, but certainly they have brought some Vietnamese Americans back home.

Neatly dressed in formfitting white *ao dais*, book bags tucked in bike baskets, four university students pedal home for lunch from morning classes at the university in Can Tho.

Ao dais are close-fitting tunics worn over trousers. They are the female outfit of choice in Saigon and are seen throughout the Mekong Delta. Suntanned faces and arms are not considered fashionable. Hats are universally worn in towns and cities to protect women from the sun's powerful rays. For cycling, a large number of urban women wear long gloves as well. The face covering shown here is a protection against exhaust fumes and dust.

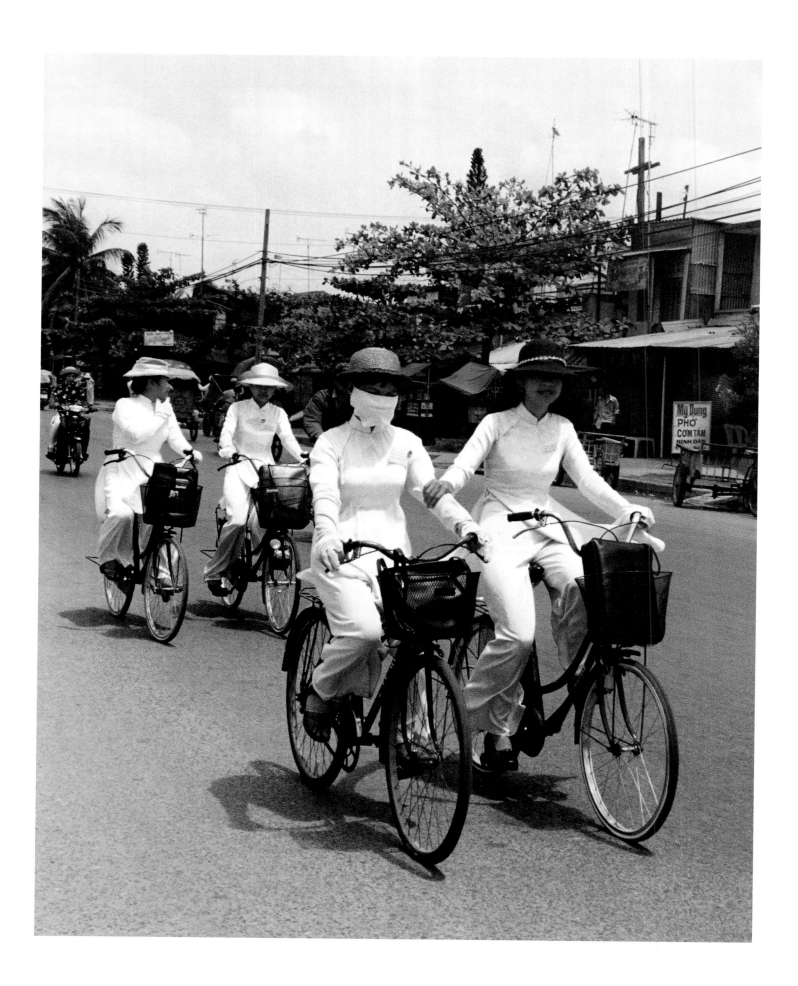

Women

Did the fairy midwives have a falling out
and somehow misplace her maidenhead?
.
Well, fine. It's really okay. Since her whole life
she'll never have to hear "daughter-in-law."

— HO XUAN HUONG

The revival of village and kinship ties and the rites that undergird them may provide security in a changing world, but it raises questions about the nature of the society that is coming into being. One of the questions is surely what it will do to the status of women. But then the status of women has always been a matter of some contestation in Vietnam.

The traditional Vietnamese family was patrilineal. That is, women had no place in the family genealogies, though their spirits were venerated to the fourth generation. It was also patriarchal. Women were supposed to submit to their husbands and eldest sons with the same selflessness with which they served their fathers. Marriages were arranged, and the bride went to live with her husband's family, where she served his parents and vied for her husband's affections with her mother-in-law. (In song and story the most fraught relationship of all.) Well-to-do men often took second wives or concubines, and if the first wife objected, she had no legal recourse. Still, Vietnamese women had a far higher status in the family than did their Chinese sisters. Under the legal code the Vietnamese inherited from the T'ang dynasty when they took their independence from

China, women had hardly more rights than children and were entirely dependent on their male relatives. However, in Vietnamese medieval law, enshrined in the Hong Duc code of the late 1400s, women could inherit land and, if they had no brothers, could serve as trustees of the ancestral cult; further, a wife had property rights under the code, and children could not claim their inheritance until both parents were dead. The Vietnamese support of property rights for women was, it appears, unique in the history of East Asian classical civilizations.[1]

In many areas, but particularly where women were concerned, there seems to have been a good deal of tension between Confucian orthodoxy and indigenous traditions. In the Confucian tradition men were supposed to be morally and otherwise stronger than women. Yet Vietnamese women worked with their men in the rice fields, and many were skilled artisans. Furthermore, Vietnamese folklore was filled with tales of strong women leaders. The Trung sisters, for example, who fought a last-ditch battle against the Chinese invaders in the first century A.D., were not only venerated but turned into goddesses.[2]

Within the family this tension was in part resolved by a division of labor unique to Vietnam. Women were excluded from the realm of education and government, but in the realm of trade, small business, and family finances they reigned supreme. In a sense this was perfectly orthodox, for in the Confucian tradition men were supposed to be benevolent, disinterested, and concerned with the public good, and trade was seen to be amoral and self-interested. This is why in the classical order of the professions scholars came first and merchants last. However, in China the status of women was so low that they were not entrusted with trade, and when in the sixteenth century trade became profitable in the vast empire of China, Chinese businessmen reinterpreted the classical texts to raise the status of business and to extend Confucian ethics to their profession.[3] In the much smaller economy of Vietnam men clove to the classical paradigm. Concerning themselves with honor and prestige, they acted as heads of state and foreign ministers of the family, while women, concerned with household finances, acted as "the ministers of the interior."[4] Thus in Saigon during the 1960s and 1970s the generals' wives, acting as bankers and commodity traders, moved millions of dollars through their informal channels, making sure that their cousins and cousins' cousins would be well taken care of when the Americans got tired of upending their cornucopia of money and goods upon the country.

Another sign of the tension between Confucian orthodoxy and the actual power of women in Vietnam lay in the uses of the two major village institutions: the dinh and

the Buddhist pagoda. The dinh was for the most part a men's house, where the elders performed Confucian-style rituals and competed for prestige; the pagoda, though staffed by a priest, was the place where women repaired, for in Buddhism all souls are equal. A woman with a calling to renounce the world could become a nun, and every village had an Elderly Women's Buddhist Association, whose members worshiped at the pagoda on the first and the fifteenth day of every lunar month and helped with the upkeep of the temple. In addition to statues of the Buddha and the goddess of mercy, Quan Am, who gave particular help to women and children, the village pagodas often had statues of a child-guardian deity, or mother goddess, to whom elderly women offered their grandchildren for nominal adoption and protection against evil forces. Sometimes the pantheon included other female deities, such as the Jade Queen of the Immortals or the Dark Maiden of the Ninth Heaven, with powers to lift curses and heal the sick. The Confucian literati frowned upon these cults.[5]

Confucian values were strong when the state was strong, for then mandarins had more influence over the villages, and Confucian teaching was widely disseminated by village scholars waiting to pass their exams. Conversely, when the state was weak — when it became corrupt or lost control to insurgents — the Confucian order weakened. This was the case in the eighteenth century, when the Le dynasty went into decline, and peasant rebellions broke out. Toward the end of that period a woman poet, Ho Xuan Huong, shocked the literary establishment by satirizing the court, corrupt Buddhist monks, polygamy, and the whole notion of male superiority in poems that were at once erudite and full of witty sexual innuendos. Little is known about Huong's life, except that she was the daughter of a concubine who became a concubine herself, but she is regarded as one of the country's leading poets.

The status of women changed very little under the French colonial regime, but a great deal thereafter. Polygamy was outlawed and so were child marriages. The Vietnamese revolutionaries were ideologically committed to gender equality, not just because equality was their standard but because women traditionally concerned themselves with the household economy to the exclusion of the public domain. The Viet Minh, and later the government in Hanoi — as well as the American-backed governments in Saigon — introduced universal literacy and opened the whole education system to women. Holding with classic socialist theory that drawing women into work in the public economy was the path to their liberation, the government encouraged women to work in all sectors of the economy, including the government. During the wars women played important

roles, some of them taking the place of the absent men, others joining the war effort. The regular army was for men only, but in the guerrilla struggles women participated in political organizing and even in combat, some of them as leaders. One famous Viet Cong sapper team, whose skill at blowing up military fortifications gained the reluctant admiration of American officers in II Corps, turned out to be composed entirely of women. Another woman, Nguyen Thi Dinh, rose to become the deputy chief of the southern liberation forces. The poet Ho Xuan Huong, who once wrote that if she were a man she might have done heroic deeds, surely would have applauded.

After the war equality of opportunity for women was established in principle, though not everywhere in practice. By 1989 adult literacy rates were 93 percent for men and 84 percent for women, and there were no major differences between men and women in the extent of schooling. By then women had taken a major share of the jobs in all occupational categories, the lowest being 33 percent in the managerial/administrative sector. Men, however, continued to occupy the best-paying jobs and the positions of greatest authority.[6] Interestingly enough, when village industries were collectivized, men took the top jobs from women because working for a public enterprise allowed them to maintain their Confucian dignity.[7] In addition they took most of the Party leadership roles in the villages, and as Ho Xuan Huong might have complained, the members of the politburo could often have been mistaken for the clan elders at an ancestral gathering.

The move away from socialism and return to household economies did not, it appears, reverse the gains made for women and children, but then the changes the Party had made in family life had been something less than revolutionary. In the 1990s the ritual practices in the northern villages suggested that while some things had changed since the 1950s, some things had not. Women regularly attended the dinh ceremonies, though they did not officiate at them. At funerals the ritual steps symbolizing subordination and gender inequality had been eliminated: children no longer walked on rough canes during the procession, and daughters and daughters-in-law no longer lay in the courtyard in the path of the coffin.[8] However, the male elders continued to take first place at all family gatherings and village ceremonies. In general well-educated young people had far more freedom than previous generations had had, but in the villages parents continued to have a major say about whom their children should marry, and the brides of eldest sons normally went to live with their in-laws.

That not everything had changed was surely demonstrated by the revival of institutions and rituals particular to women. The Elderly Women's Buddhist Associations, for

example, had largely survived the period of collectivization, and in the late 1980s many of them developed into the strongest and most disciplined organizations to be found in their villages. Some now have members in their forties and are attracting even younger women to the pagodas.[9] The government had never objected to these associations, but officials had strongly condemned the cult of the mother goddess, the child-guardian deity, who was believed to keep children in good health. "There is no such thing as a Mother Goddess in Buddhism. It is a superstition," one directive read.[10] The government also anathematized the cult of the queen-goddesses and the shamanistic rites associated with them. But in the late 1990s these cults were flourishing once again, and in the cities as well as in the villages. On an island in the Perfume River, Mary and I watched a mother and her grown daughter burn joss sticks before an outdoor altar and then dance themselves into a trance. They were thanking the goddesses for lifting a spell cast by a deceased aunt that had made the mother ill. When they had finished, the young woman took off the silk robes she had worn over her blue jeans, made sure she had the keys to her motorbike, and prepared to go back to her job as a hairdresser.

At the Tu Hieu Pagoda, a few kilometers north of the city of Hue, a community of monks gathers at 11 A.M. for their midday meal of rice and vegetables. The meal always begins with a ceremonial blessing in which the fingers of the devout men are arranged in a ritualized fashion. Their day is punctuated by long periods of prayer, which are interspersed with arduous physical labor. The French called the site La Pagode des Eunuques because it was endowed by eunuchs of the Nguyen dynasty. Having sired no descendants, the eunuchs wished to ensure that continuing prayers would be offered for their souls on their journey into the afterlife. ▶

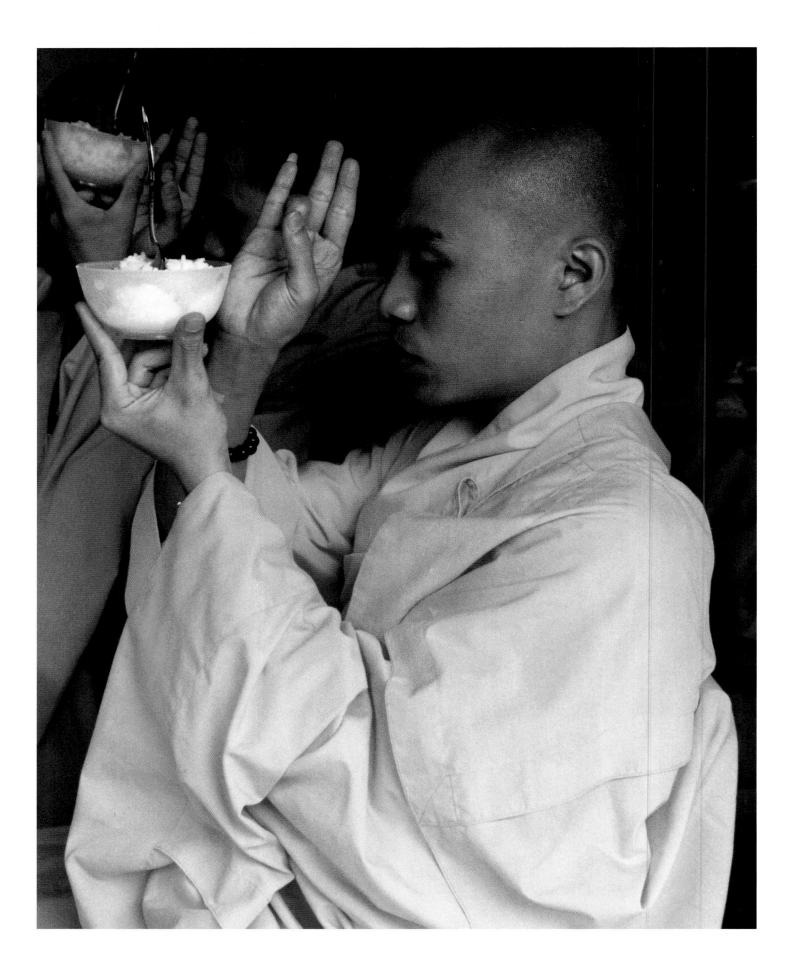

Buddhism

I have yet to become a prince or a duke,
But my head is already gray.
I will leave my house as if parting from an inn,
Trade honors, fame for an angling rod.
Unfettered, light and easy,
My mind is like Buddha's: who needs more?

— NGUYEN TRAI

Possibly the most remarkable development in Vietnamese cultural life over the past decade or so is the revival of Buddhism throughout the country. Since 1989 a large number of the historic Buddhist pagodas have been renovated or rebuilt, and at least ten of them have become major pilgrimage sites and tourist attractions for the Vietnamese.

In the north the most popular of these is the Perfume Pagoda — or rather the complex of ancient temples and shrines in the Huong Son Mountains, forty miles south of Hanoi. Each year hundreds of thousands of people hire boats at Te Tieu village and go by river through the gorges of these misty green hills — a retreat for holy men since time immemorial — to worship at the shrines set deep in their limestone grottoes.

In Hue the seventeenth-century Thien Mu Pagoda, with its seven-story octagonal tower overlooking the Perfume River, is mobbed with visitors every day. Famous for their learning, its bonzes, or brothers (monks and priests), are also famous for their political independence. In the 1960s monks from Thien Mu played an important role in the

protests against the regime of Ngo Dinh Diem and the subsequent military juntas in Saigon. Among treasured relics of the pagoda is the Austin motorcar that conveyed the venerable bonze Thich Quang Duc to his death by self-immolation in 1963. Since 1975 the pagoda has on occasion been a focus for protest against policies of Hanoi. These days, however, the bonzes hardly have the time to think, much less meditate, so inundated are they with pilgrims and tourists.

In the southern city of My Tho the Vinh Trang Pagoda, built in 1849 by a bonze from Hue, has become a major pilgrimage center for the Mekong Delta. On the fifteenth day of every lunar month thousands of visitors come to admire the temple's exuberant, colorful facade and to worship in its sanctuaries. The pagoda has a school of Buddhist studies, and with donations from its devotees it helps to support many of the smaller pagodas in the province.

A traveler visiting Vietnam these days would be puzzled to hear anyone ask whether the Vietnamese were really Buddhists. Yet Western scholars and journalists have posed that question intermittently from the colonial period on and sometimes answered it in the negative. A Jesuit priest who studied the many forms of Vietnamese religious life in the 1930s wrote that the number of Vietnamese who understood Buddhism as "a philosophy, a conception of man and the world" was "totally nugatory" and that the true religion of Vietnam was "the cult of the spirits." Similarly, two French Marxist sociologists who studied Red River Delta communes in 1979 divided Vietnamese simply into Catholics and non-Catholics — uncertain how else to classify them. In a book published in 1998 an American observer quoted the Jesuit priest's conclusion as the final word on the subject of Vietnamese Buddhism.[1]

What these observations reveal is the difficulty Westerners have often had comprehending the religious multiplicity of classical East Asian civilizations. Yet little is more important to an understanding of these societies. In Vietnam, as in China, the philosophical traditions of Confucianism, Taoism, and Buddhism not only coexisted but complemented each other, in the sense that each had its own particular function in the life of the society. Traditionally all Vietnamese were Confucians, Buddhists, *and* Taoists — not to mention ancestor worshipers and animists who believed in the spirits of trees, rivers, and mountains. Which tradition rose to the surface depended on the circumstance or the issue involved. Possibly most Vietnamese could not explicate the eightfold path, but they certainly understood the Buddhist conception of "man and the world" and how it contrasted with the Confucian conception of the same.

For the Vietnamese, as for the Chinese, Confucianism was a ritualized way of life, a prescribed set of social relations and method of governance. Confucian doctrines focused on the welfare of the whole society rather than on that of the individual, and on roles rather than on subjective states. In Confucianism the emphasis was on ethics and duty toward others at the expense of individual feelings. Male-oriented, hierarchical, and canted toward the past, it prescribed a single right way of doing things — learned from the study of the classical texts — which would lead to harmony in the society and between nature and the heavens. Buddhism, by contrast, had no prescription for social organization and no cosmology; its focus was squarely on the individual and his existential plight in the cycle of life and death. A spiritual discipline, it showed a way beyond the suffering of existence, caused by cravings and attachments to the world, through right conduct, mindfulness, and meditation. The path to the ultimate transcendence of Nirvana was open to all.

Mahayana Buddhism came to Vietnam in the second century A.D. and established itself during the period of Chinese rule. The first Vietnamese dynasties — the Ly and Tran — relied upon Buddhist monks as advisers and built great monasteries. Eventually, however, the emperors adopted the Chinese mandarinal system to administer the country. At that point the Buddhist brotherhoods made a very particular accommodation with the Vietnamese state. Accepting the Confucian order as a political and social system, they maintained their claims to a greater universality: Confucianism was a social order defined by culture and history; Buddhism was a faith relevant to all times and to all people, no matter what their circumstances. Not just a means of living in the world, it was a Way for all to transcend the limitations of the society and the self to reach a higher truth. In Buddhism all men — and all women — were equals: equal in moral responsibility and equal in their capacity for achieving salvation. Rather than an alternative to the Confucian system, Buddhism became a complement to it, offering the Vietnamese an internal life — a soul, a personal identity — outside the conventions of society and a morality that lay beyond the Confucian system of duties and obligations.

At the village level Buddhism melded with Taoism and with a variety of folk beliefs and practices, from the cult of the mother goddesses to rites designed to bring good fortune, as, for example, the issuing of amulets to protect houses from harm. Nonetheless the intellectual and philosophical traditions of Mahayana Buddhism were taught in the major monasteries, the teaching often refreshed by contacts with centers of Buddhist learning abroad. In fact, during the 1930s and 1940s, when anticolonialist sentiment was

on the rise, a number of bonzes went abroad to study and returned to set up teaching centers in Hanoi, Hue, and Saigon.

"The Vietnamese are Confucians in peacetime, Buddhists in times of trouble," an old adage goes. More precisely, Buddhism came to the fore when the Confucian state went into a decline. When the state crumbled, the monasteries became the most important institutions outside the village, and Buddhism filled the ideological vacuum, giving the Vietnamese a moral and intellectual center apart from the official religion.

In modern history the most dramatic demonstration of the power of Buddhism in Vietnamese life came in the spring of 1963, when the Diem regime in Saigon was self-destructing. The Catholic Ngo Dinh Diem and his brother Ngo Dinh Nhu had alienated the country people, demoralized the army, and divided Catholics from non-Catholics in the cities. Rather than to conciliate their city opponents, they attacked anyone they perceived as a threat. On May 8 their police fired into a crowd of Buddhist demonstrators, killing nine people. In the second week of June the Venerable Thich Quang Duc seated himself in the lotus position in the midst of a busy intersection in Saigon and immolated himself by fire. To the Vietnamese this ultimate gesture of protest was a call to a morality that transcended personal loyalties and to a brotherhood that went beyond factional divisions. From that day on university students and many other middle-class city people who up until then had been politically quiescent went en masse to the pagodas of Hue and Saigon to pray and then to join demonstrations led by the bonzes. In a sense they responded by becoming Buddhists.

The Diem regime was soon dispatched by an army coup, but the Buddhists, following the pattern that had held throughout Vietnamese history, did not replace it. For the next three years the generals vied for power, and coup succeeded coup. The Buddhists continued to demonstrate, but bonzes and their supporters never built a political organization, much less the basis for a regime that could command the support of those South Vietnamese who did not want a Communist government. In the early 1970s, after the American troops withdrew and the war slacked off, huge new pagodas sprouted up around Saigon. Their appearance should have been a warning to American policymakers, for what they signified, beyond the fact that many in Saigon had made money during the war, was that the very people who had the most at stake in building a government and contributing to the war effort were instead looking to their own salvation. In effect they signified that the American efforts to shore up the Saigon regime were unlikely to succeed.

In the north the revival of Buddhism in the late 1980s followed upon almost a half-century of quiescence: decades in which the priests left the villages and many of the pagodas and shrines fell into disrepair. In that period the Communists denounced many Buddhist folk practices, and beginning in 1954 the government put numerous restrictions on the monasteries. (All of them had to belong to a government-controlled National Buddhist Association.) More important, perhaps, most northern Vietnamese supported the revolution, wanted to learn what this new scientific religion of Marxism had to offer, and for many years were preoccupied by the French and then the American wars. Until the late 1970s only the Elderly Women's Buddhist Associations visited the pagodas regularly. But with the evident failure of collectivization and the decline of the cooperatives in the 1980s, attendance increased and villagers began to petition the government to recognize the historic importance of their pagodas as well as their dinhs. The Ministry of Culture acquiesced. Beginning in 1989 it gave many pagodas throughout the country the equivalent of landmark status and began to contribute to the cost of renovating them. At the same time, the government lifted some of the restrictions it had put on the monasteries and on the folk practices it had labeled superstitious.[2]

In the north priests returned to the village pagodas and once again celebrated the annual Buddhist rituals and assisted at family rites. In the south new pagodas sprang up in the villages, and private prayer houses were built by the well-to-do. In the 1990s, after the government had dropped all of its restrictions on travel and people had some money to spend, northerners and southerners alike began making pilgrimages to the major pagodas in their regions, conferring a particular landmark status on some of them.

In the north the Ba Chua Kho Pagoda, in Ha Bac Province, runs a close second in popularity to the Perfume Pagoda complex. Dedicated to the eleventh-century empress who provisioned her husband's troops for war against the Chinese, this temple, not far from Hanoi, has enjoyed a phoenixlike revival in recent years. Neglected during the 1950s, it fell into a state of disrepair; it was then enclosed within an army base and virtually destroyed in the war. In the 1990s the Ministry of Culture, bowing to popular demand, rebuilt it almost from the ground up. The government justified the expenditure on the grounds that it was a national historical monument, but for its visitors the main attraction is the reputation of the provident empress for conferring prosperity and good fortune upon her devotees.

Apart from holidays, weekends are the times most people have for visiting the pagodas. But arriving at Ba Chua Kho at ten A.M. on a Friday morning, I found the parking lot already filling up with buses and cars. In the booths in front of the pagoda steps

scribes were writing out prayers in Chinese characters for their customers, and vendors of fruit, sticky rice, joss sticks, and paper offerings were doing good business. At one of the booths a woman from the Ministry of Health in Binh Dinh Province, who had been called to Hanoi for a meeting on malaria control, was ordering a tray piled high with an arrangement of fruit, flowers, and gilded paper offerings to take to the goddess on behalf of herself and some of her coworkers. She was, she said, building a house and needed help with the financing. When I asked if she had thought of asking the goddess for help with malaria control, she glared at me and turned away. The goddess, I gathered, concerned herself with private, not public, affairs.

The main sanctuary of the pagoda was crowded with people and with the trays of offerings they had left before the altar. Going in through a side door, I found myself pressed against a wall next to a young woman in a fashionable black leather jacket and jeans. On the wall was a government poster — ubiquitous in pagodas — enjoining people to practice religion and eschew superstition, a distinction the author did not even try to define. In front of us a group of men were handing around a cup with three antique coins and taking turns throwing the coins: heads you get your wish, tails you don't. After some conversation, the young woman told me she had come to the pagoda because she wanted a boyfriend. Sure, she said, she was making an effort, but a little good fortune always helps.

Ba Chua Kho is one of those eclectic pagodas in which Buddhism has melded with folk traditions, Taoism, and the worship of a legendary hero — in this case a heroine who was a great provider. The Phu Tay Ho Pagoda, on the West Lake of Hanoi, dedicated to Princess Lieu Hanh, is similarly eclectic, and filled with people — most of them women — making offerings and asking for something specific. In the courtyard I encountered a family from Haiphong. A middle-aged couple with three daughters and a son-in-law, the family had just come from Ba Chua Kho, and according to one of the daughters, the quest was for two more husbands. However, the family was in a holiday mood and clearly enjoying the outing.

At the orthodox Mahayana temples, many of them of great age and beauty, the atmosphere is more subdued. In the north the ancient Thay Pagoda in Ha Tay province, built into the lee of a limestone mountain, and the nearby Tay Phuong Pagoda are both very popular, though neither is as beautiful as the less-frequented pagoda at But Thap. On weekdays most of the visitors are women from Buddhist associations traveling together on buses from one temple to the next. Quiet and serious, they listen intently as the local guide explains the history and the religious significance of the sculptures, carvings, and

musical instruments. Some ask questions about the iconography, and at the main altar they stop to light joss sticks and pray.

On weekends the crowds swell with family groups, busloads of civil servants and factory workers, and groups of young people from the cities. What kind of quest these people are on is more difficult say. Certainly they are exploring their country—a luxury they have never had before—and watching them examine the shrines and grottoes, I could imagine them simply as museumgoers, except that some of them, too, stop to pray.

The Tu Hieu Pagoda, five miles outside Hue, doesn't have crowds of visitors; it is a teaching monastery where young monks follow a rigorous schedule of meditation, instruction, and work. It is the home pagoda of Thich Nhat Hanh, a bonze who left Vietnam in 1966 and has since become a well-known teacher in France. While we were there, three well-to-do couples from the north—the men dressed in suits, the women in *ao dais* and pearls—came in with sizable gifts of rice and cooking oil. The abbot received the group ceremoniously and gave its members his blessing. From their reverential attitude I assumed that these people had some connection to the monastery, but as they left one of the women told me that they had come because they had seen the pagoda on television.

What accounts for the revival of Buddhism in Vietnam over the past fifteen years? The answer is not easy to come by, for the pagodas are so diverse, yet in all of its aspects the revival seems to have something to do with freedom and with a sense that something is missing.

With the economic reforms of the late 1980s the government essentially told its citizens, "The system isn't working, so we're breaking it up and you're pretty much on your own." On the most basic level that meant that people had to take economic risks—a novelty for most people in the north. In temples such as Ba Chua Kho the Vietnamese are taking out the spiritual equivalent of insurance policies on their houses and businesses. It's not that they entirely trust these policies, but they are doing what they can to hedge their bets, and since for the Vietnamese everything has a spiritual dimension, they would doubtless continue to pay these premiums of flowers and fruit even if they had earthly insurance policies.

With the economic reforms the government not only freed up the economy, it loosened the ties of the macrocosmic family and withdrew from its claim to represent a complete moral and social system: that is, a complete replacement for the Confucian regime. In fact the system had already broken down by the mideighties, and everyone knew it. In the villages people worked to rebuild their local communities, and reconstructing the Buddhist rites was a part of the effort. But Vietnamese farmers, along with

city people and townsfolk, live in a larger society as well. In many countries in certain periods of history, multitudes of people made pilgrimages to shrines long distances away. Whatever they intended to accomplish, the pilgrims saw something of the larger world and along the way developed a sense of spiritual community with their fellows: a community that transcended local boundaries and regional differences. In Vietnamese Buddhism, pilgrimages were a part of the traditional pattern when the Confucian state was on the wane. In this case, of course, the government has not disappeared or gone silent; it has a good deal to say about the society through the school system, the media, and the law. But having ceased to be a family, it hasn't much to say about spiritual matters — and on questions such as how a city girl should find a husband it has no answers at all.

Silk Robes and Cell Phones

Paper cell phones for the ancestors, shrines to Ho Chi Minh, a young man in traditional silk robes talking of a future in business, a lineage hall built with money from Silicon Valley, a health bureaucrat in a Communist government making offerings of fake Benjamin Franklin hundred-dollar bills to an eleventh-century empress?

Contrasts between the traditional and the modern exist in every society, including our own, but in most societies the change is in one direction. The remarkable thing about Vietnam is that it is going back to tradition and forward at the same time. More precisely, it is reclaiming and refashioning some of its traditions in order to move on.

To the eye of a foreign visitor the revival of traditional culture is most striking in the countryside. It is less obvious in the cities, but it is happening there as well. In the midst of a traffic jam in Da Nang I saw two men dropping scraps of gold paper out of the back of a truck. What they were doing, I eventually realized, was laying a trail for the spirit of a family member to find its way from the cemetery back home.

In fact there are differences between city and country people, as there are between those who are well educated and those who are not, but the differences are often of degree rather than kind. This is not so surprising, because cities are relatively new to the Vietnamese. Hanoi, for example, had a population of only 125,000 in 1931 — and only 300,000 in 1954 — but it is now a city of two million people. What this means, of course, is that most city people are recent immigrants from the countryside and not so far from their roots in village culture. Furthermore, there is no sharp division between the rural and urban areas — there is still a flower-growing village within Hanoi's city limits — and there is a great deal of coming and going between city and countryside. Market women come

into the cities with their produce; families go back to their home villages for Tet and other celebrations; around Hanoi doctors often go back to their home villages to treat the sick after retiring from their city practices.

In the cities you don't see the elaborate family ceremonies you do in the villages, though they surely exist. But tradition is not just a matter of religious beliefs and practices. It involves attitudes toward life and the way people think about each other. In Vietnam the pull and tug of tradition is in the language itself, creating a dilemma for city people every time they meet someone new.

Ever since the revolution of 1945 the Party and the government have encouraged people to refer to themselves as *toi* (the word that represents the Western first person singular) when talking with nonfamily members, such as coworkers, fellow students, and so on. But to the Vietnamese that word *toi*, which originally meant "subject of the king," still has a formal, cold sound to it, so, after a few moments of conversation, the speaker will often revert to familial terms, calling himself "child" or "elder brother" or "uncle," depending upon the person he is addressing, and by implication adopting that person into his family. One problem with this is that, since the family is hierarchical, this familial language has no word to indicate that the other person is of equal status. Another is that it introduces familial warmth into all relationships, including those that should be businesslike or ruled by impersonal standards. One small businessman explained this very concretely to me. "I always call myself *toi*, when I speak to my truck driver," he said, "but he always wants to call me *anh*, 'elder brother,' as a sign of respect but also so that on occasion I will allow him to bend the rules." He added: "I understand this, because when I get a traffic ticket driving my motorbike, I sometimes send my wife to the police station to deal with it. She can call the policeman 'elder brother' and perhaps gets off with a lesser fine than I could in her place."

In the villages, as in the cities, the revival of traditional practices does not mean a return to the past. People may resurrect their dinhs and lineage halls; they do not therefore reject government schools, clinics, and agricultural extension programs. Similarly, the warm language of family membership and the colder one of individuality and equality coexist. Nor does the revival of some of the old ways mean that people are not looking to the future. To the contrary, it has helped people adapt to the new economy. The Vu family, for example, has built a sizeable furniture-making business in part by reweaving its extended family ties.

What is happening is that the Vietnamese are engaged in a process of cultural construction using some of the most disparate pieces of their experience. All societies do

this, for all of us are making our way between the past and the future, often unconscious of what we are keeping and how we have changed (and imagining, as we avoid walking under ladders, our cell phones in our ears, that our behavior is all of a piece). But because of the upheavals Vietnam has gone through in the past hundred years, the materials the Vietnamese have to work with, like the layers of rock thrown up by a volcano, have particularly high contrasts — at least as seen from the outside. The entrepreneurial Mr. Vu, for example, spoke of a return to Confucian values and the communism of Ho Chi Minh. Thus the process of cultural construction, whether conscious or not, is a remarkably creative enterprise in Vietnam.

Notes

Full publication information on the works cited may be found in the Bibliography, on page 72.

INTRODUCTION
1. U.S. Government, *The World Factbook*, 1999.

MOUNTAINS AND RIVERS
Epigraph: Truong Buu Lam, *Patterns of Vietnamese Response to Foreign Aggression: 1858–1900*, p. 47.
1. Neil L. Jamieson, *Understanding Vietnam*, p. 6.
2. Portions of this chapter are based on my earlier work on Vietnam, *Fire in the Lake*.
3. For modern accounts of the origins of Vietnam, see Keith Weller Taylor, *The Birth of Vietnam*; Nguyen Khac Vien, *Histoire du Vietnam*, pp. 13–24; and Jamieson, *Understanding Vietnam*, pp. 6–7.
4. Truong Buu Lam, *Patterns of Response*, p. 56.

EARTH AND WATER
Epigraph: Nguyen Khac Vien, *Histoire du Vietnam*, p. 21.
1. Lady Borton, *After Sorrow*, p. 219.
2. Nguyen Khac Vien, *Histoire du Vietnam*, p. 28; Le Thanh Khoi, *Le Vietnam*, p. 352.
3. Nguyen Khac Vien, *Histoire du Vietnam*, p. 29.
4. Duong Van Mai Elliott, *The Sacred Willow*, pp. 19, 29.
5. David G. Marr, *Vietnam 1945*, p. 104.
6. Paul Mus told me this.
7. Nguyen Khac Vien, *Tradition and Revolution in Vietnam*, pp. 83–87; Hy V. Luong, *Revolution in the Village: Tradition and Transformation in North Vietnam, 1925–1988*, p. 195.
8. John Kleinen, *Facing the Future, Reviving the Past*, p. 110; Ngo Vinh Long, "Reform and Rural Development: Impact on Class, Sectoral, and Regional Inequalities," pp. 166–173; Mark Selden, "Agrarian Development Strategies in China and Vietnam," p. 223.
9. David Wurfel, "*Doi Moi* in Comparative Perspective," pp. 23–29; Hy V. Luong, "Economic Reform and the Intensification of Rituals in Two North Vietnamese Villages, 1980–90," pp. 262–267; Ngo Vinh Long, "Reform and Rural Development," pp. 262–267. The first reform came from the ground up. In 1977 one cooperative in Haiphong City secretly began making production contracts with individual families. The district Party secretary discovered it and decided it was not contrary to the Party line. By 1980 the entire province had adopted this new system, and in 1981 the Central Committee in Hanoi made it national policy. For a few years rice production rose. (See Wurfel, pp. 23–24.)

VILLAGES
Epigraph: Pierre Gourou, *The Peasants of the Tonkin Delta*, p. 304.
1. John T. McAlister and Paul Mus, *The Vietnamese and Their Revolution*, pp. 49–50.
2. Gourou, *The Peasants of the Tonkin Delta*, p. 304; McAlister and Mus, *The Vietnamese and Their Revolution*, p. 53; Hy V. Luong, "Economic Reform," p. 96.
3. Gourou, *The Peasants of the Tonkin Delta*, p. 293; Jamieson, *Understanding Vietnam*, p. 28.
4. McAlister and Mus, *The Vietnamese and Their Revolution*, p. 117.
5. Jamieson, *Understanding Vietnam*, p. 26.
6. Ibid., p. 29; Hy V. Luong, "Economic Reform," pp. 56–57; Gourou, *The Peasants of the Tonkin Delta*, pp. 380, 385, 392.
7. Nguyen Khac Vien, *Tradition and Revolution*, p. 39.
8. Jamieson, *Understanding Vietnam*, p. 31; Gourou, *The Peasants of the Tonkin Delta*, p. 312; McAlister and Mus, *The Vietnamese and Their Revolution*, p. 33.
9. Gourou, *The Peasants of the Tonkin Delta*, p. 317. See also Jamieson, *Understanding Vietnam*, pp. 34–35; McAlister and Mus, *The Vietnamese and Their Revolution*, p. 145; and Hy V. Luong, "Economic Reform," pp. 58–60.
10. Robert D. Putnam, *Bowling Alone*.
11. Gourou, *The Peasants of the Tonkin Delta*, pp. 296–297.
12. Ibid., p. 359.
13. Kleinen, *Facing the Future*, pp. 98–107.
14. Ibid., p. 272; François Houtart and Genevieve Lemercinier, *Hai Van*, p. 176.
15. Edwin Moise, *Land Reform in China and North Vietnam*, pp. 222, 252.

16. Hy V. Luong, "Economic Reform," p. 289; Kleinen, *Facing the Future*, pp. 165, 183–184, 190.
17. Hy V. Luong, "Economic Reform," pp. 273, 287; Kleinen, *Facing the Future*, p. 163.
18. Borton, *After Sorrow*, pp. 194–195.

FAMILIES
1. Alexander Barton Woodside, *Vietnam and the Chinese Model*, p. 44.
2. Jamieson, *Understanding Vietnam*, pp. 23–24.
3. Ibid., pp. 16–17; Nguyen Khac Vien, *Tradition and Revolution*, p. 33.
4. Jamieson, *Understanding Vietnam*, p. 23.
5. Paul Mus, *Ho Chi Minh, le Vietnam, l'Asie*, p. 166.
6. Jamieson, *Understanding Vietnam*, p. 24.
7. William J. Duiker, *Ho Chi Minh*, p. 75.
8. Jamieson, *Understanding Vietnam*, pp. 254–256.
9. See Kleinen, *Facing the Future*, and Hy V. Luong, "Economic Reform."
10. Gareth Porter, *The Politics of Bureaucratic Socialism*, pp. 36–37. Some families put pictures of Ho Chi Minh in place of pictures of their ancestors.
11. Kleinen, *Facing the Future*, pp. 128–130, 150; Hy V. Luong, "Economic Reform," pp. 275–277, 285–288.
12. Ibid., pp. 275–281; Kleinen, *Facing the Future*, p. 150.
13. Hy V. Luong, "Economic Reform," p. 289.

WOMEN
Epigraph: In John Balaban, trans., *Spring Essence: The Poetry of Ho Xuan Huong*, p. 59.
1. Woodside, *Vietnam and the Chinese Model*, p. 45.

2. Ibid., p. 46.
3. Timothy Brook, "Profit and Righteousness in Chinese Economic Culture," pp. 27–45.
4. Jamieson, *Understanding Vietnam*, p. 27.
5. Ibid., p. 36; Hy V. Luong, "Economic Reform," p. 272.
6. U.S. Government, *The World Factbook*, 1999; Joan Kauffman and Gita Sen, "Population, Health, and Gender in Vietnam: Social Policies Under the Economic Reforms," pp. 233–258.
7. Hy V. Luong, "Capitalist and Noncapitalist Ideologies in the Structure of Northern Vietnamese Ceramics Enterprises," pp. 202–203.
8. Hy V. Luong, "Economic Reform," p. 282.
9. Kleinen, *Facing the Future*, p. 166; Hy V. Luong, "Economic Reform," p. 272.
10. Houtart and Lemercinier, *Hai Van*, p. 176.

BUDDHISM
Epigraph: Nguyen Ngoc Bich, ed., with Burton Raffel and W. S. Merwin, *A Thousand Years of Vietnamese Poetry*, p. 72.
1. Houtart and Lemercinier, *Hai Van*, p. 174; Robert Templar, *Shadows and Wind: A View of Modern Vietnam*, pp. 261–262.
2. Hy V. Luong, "Economic Reform," pp. 271, 287–289; Kleinen, *Facing the Future*, p. 166. The government, however, continues to keep a sharp eye on the monasteries of southern Vietnam that in the 1960s and 1970s played a role in politics. In the past decade it has arrested leading bonzes when their monasteries became the focus for local protest movements or when the social institutions of these monasteries gained too much power.

Bibliography

Balaban, John, trans., *Spring Essence: The Poetry of Ho Xuan Huong*. Copper Canyon Press, Port Townsend, Wash., 2000.

Borton, Lady, *After Sorrow: An American Among the Vietnamese*. Viking, New York, 1995.

Brook, Timothy, "Profit and Righteousness in Chinese Economic Culture." In Brook, Timothy, and Hy V. Luong, eds., *Culture and Economy and the Shaping of Capitalism in East Asia*. University of Michigan Press, Ann Arbor, 1997.

Dang Van Nghiem, *Ethnic Minorities in Vietnam*. Gioi Publishers, Hanoi, 1993.

Duiker, William J., *Ho Chi Minh*. Hyperion, New York, 2000.

Elliott, Duong Van Mai, *The Sacred Willow: Four Generations in the Life of a Vietnamese Family*. Oxford University Press, New York, 1999.

FitzGerald, Frances, *Fire in the Lake: The Vietnamese and the Americans in Vietnam*. Atlantic–Little, Brown, Boston, 1972.

Gourou, Pierre, *The Peasants of the Tonkin Delta*. vol. 1. Human Relations Area Files, Inc., New Haven, Conn., 1955.

Hickey, Gerald, *Village in Vietnam*. Yale University Press, New Haven, Conn., 1964.

Houtart, François, and Geneviève Lemercinier, *Hai Van*. Zed Books, London, 1984.

Hy V. Luong, "Capitalist and Noncapitalist Ideologies in the Structure of Northern Vietnamese Ceramics Enterprises." In Brook, Timothy, and Hy V. Luong, eds., *Culture and Economy: The Shaping of Capitalism in Eastern Asia*. University of Michigan Press, Ann Arbor, 1997.

—— , "Economic Reform and the Intensification of Rituals in Two North Vietnamese Villages, 1980–90." In Ljunggren, Borje, ed., *The Challenge of Reform in Indochina*. Harvard Institute for International Development, Harvard University Press, Cambridge, Mass., 1993.

—— , *Revolution in the Village: Tradition and Transformation in North Vietnam, 1925–1988*. University of Hawaii Press, Honolulu, 1992.

Jamieson, Neil L., *Understanding Vietnam*. University of California Press, Berkeley, 1993.

Kauffman, Joan, and Gita Sen. "Population, Health, and Gender in Vietnam: Social Policies Under the Economic Reforms." In Ljunggren, Borje, ed., *The Challenge of Reform in Indochina*, Harvard Institute for International Development, Harvard University Press, Cambridge, Mass., 1993.

Kleinen, John, *Facing the Future, Reviving the Past*. Institute of Southeast Asian Studies, Singapore, 1999.

Le Thanh Khoi, *Le Vietnam: Histoire et Civilisation*. Les Editions de Minuit, Paris, 1955.

McAlister, John T. Jr., and Paul Mus, *The Vietnamese and Their Revolution*. Harper and Row, New York, 1970.

Marr, David G., *Vietnam 1945: The Quest for Power*. University of California Press, Berkeley, 1995.

Moise, Edwin, *Land Reform in China and North Vietnam: Consolidating the Revolution at the Village Level*. University of North Carolina Press, Chapel Hill, 1983.

Mus, Paul, *Ho Chi Minh, le Vietnam, l'Asie*. Editions du Seuil, Paris, 1971.

—— , *Sociologie d'une guerre*. Editions du Seuil, Paris, 1952.

Ngo Vinh Long, "Reform and Rural Development: Impact on Class, Sectoral, and Regional Inequalities." In Turley, William S., and Mark Selden, eds., *Reinventing Vietnamese Socialism: Doi Moi in Comparative Perspective*, Westview Press, Boulder, Colo., 1993.

Nguyen Khac Vien, *Histoire du Vietnam*. Editions Sociales, Paris, 1974.

—— , *Tradition and Revolution in Vietnam*. Indochina Resource Center, Berkeley, California, 1974.

Nguyen Ngoc Bich, ed., with Burton Raffel and W. S. Merwin, *A Thousand Years of Vietnamese Poetry*. Knopf, New York, 1975.

Nguyen Vinh Phuc, *Historical and Cultural Sites Around Hanoi*. Gioi Publishers, Hanoi, 2000.

Porter, Gareth, *The Politics of Bureaucratic Socialism*. Cornell University Press, Ithaca, N.Y., 1993.

Putnam, Robert D., *Bowling Alone: The Collapse and Revival of American Community*. Simon & Schuster, New York, 2000.

Selden, Mark, "Agrarian Development Strategies in China and Vietnam." In Turley, William S., and Mark Selden, eds., *Reinventing Vietnamese Socialism:* Doi Moi *in Comparative Perspective.* Westview Press, Boulder, Colo., 1993.

Taylor, Keith Weller, *The Birth of Vietnam.* University of California Press, Berkeley, 1983.

Templar, Robert, *Shadows and Wind: A View of Modern Vietnam.* Penguin, New York, 1998.

Truong Buu Lam, *Patterns of Vietnamese Response to Foreign Aggression: 1858–1900.* Monograph Series, no. 11, Southeast Asia Studies, Yale University, 1967.

U.S. Government, *The World Factbook, 1999.* http://www.odci.gov/cia/publications/factbook/index.html.

Woodside, Alexander Burton, *Vietnam and the Chinese Model: A Comparative Study of the Nguyen and the Ch'ing Civil Government in the First Half of the Nineteenth Century.* Harvard University Press, Cambridge, Mass., 1971.

Wurfel, David, "*Doi Moi* in Comparative Perspective." In Turley, William S., and Mark Selden, eds., *Reinventing Vietnamese Socialism:* Doi Moi *in Comparative Perspective.* Westview Press, Boulder, Colo., 1993.

Since the introduction of *doi moi*, or governmental economic reform, the citizens of Vietnam have started small private businesses whenever and wherever they can.

On Hanoi's Underbridge Street, adjacent to the Long Bien Bridge, the facade of an eighteenth-century Buddhist temple still stands. Once the religious center of an agricultural village, the small pagoda was swallowed up by the expansion of Hanoi. The shop on the right serves *pho*, a rice noodle soup, the favorite breakfast in Vietnam. Hanoi is famous for the most delicious noodle soup in the country. ►

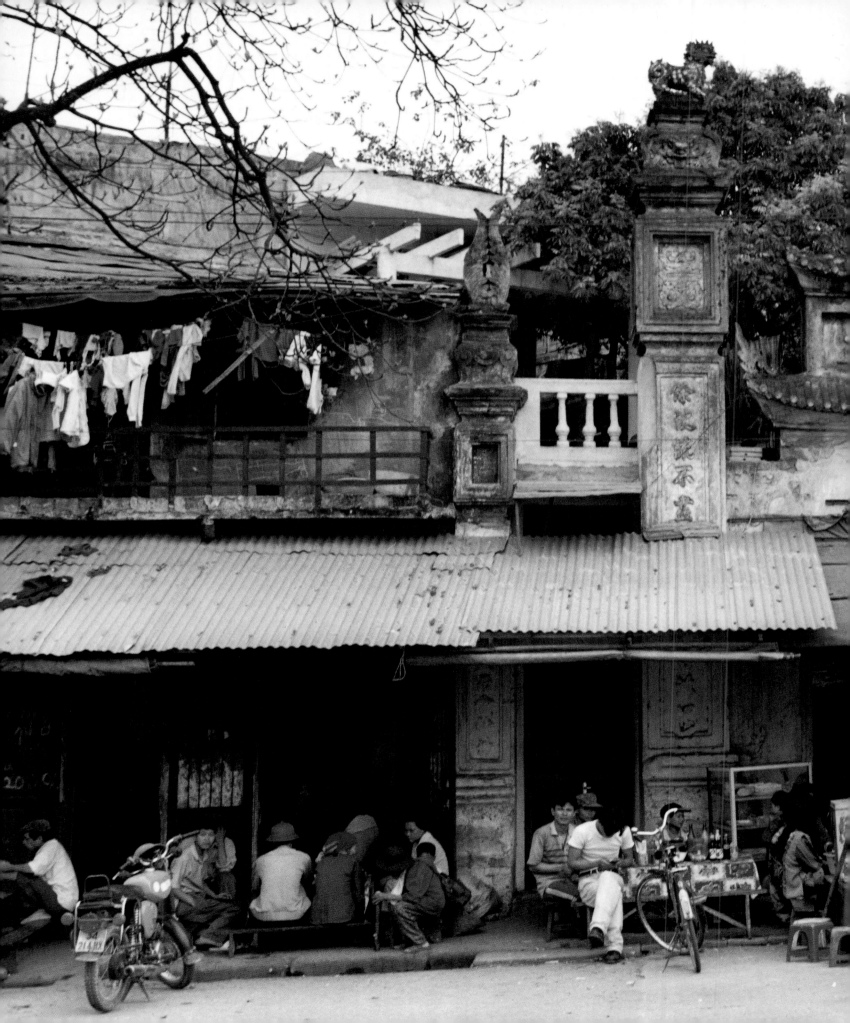

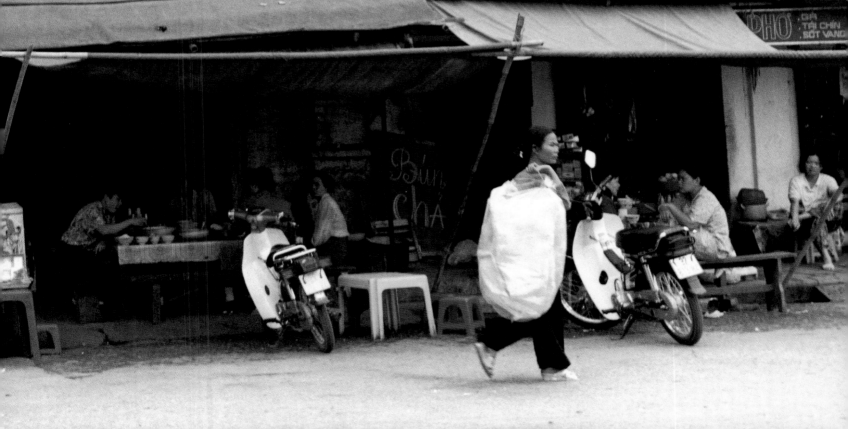

The North

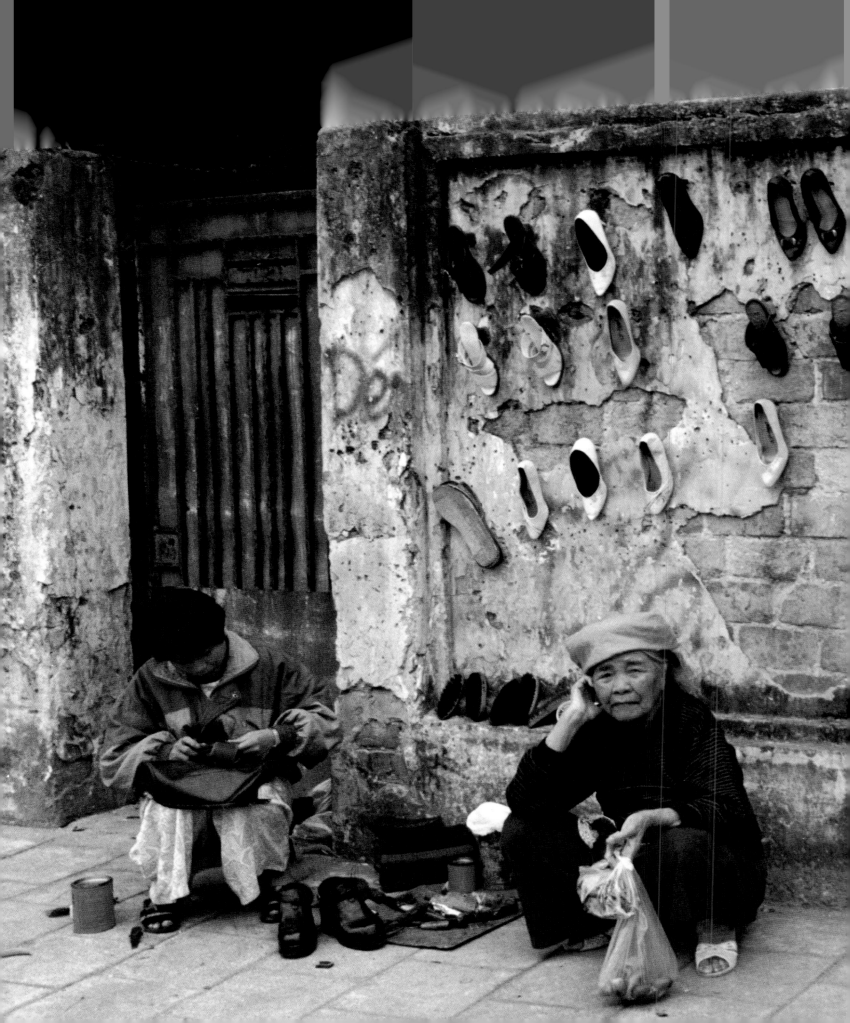

In a Hanoi neighborhood, displaying repaired high-fashion shoes on a wall is an excellent way to keep track of both right and left shoes and to advertise the talents of this young entrepreneurial shoe repair woman.

Southwest of Hanoi the Yen Vi stream wends its way through a landscape of karst outcroppings to the limestone cliffs of the Huong Son Mountains. Here a complex of shrines and temples known as the Perfume Pagoda is built into the steep and rocky hills. At high festival time in March and April the entire fleet of small rowboats is filled to overflowing with devout Buddhist pilgrims, often traveling together from the same home pagoda. They pray for fertility, a respite from suffering, and purification of their spirits.

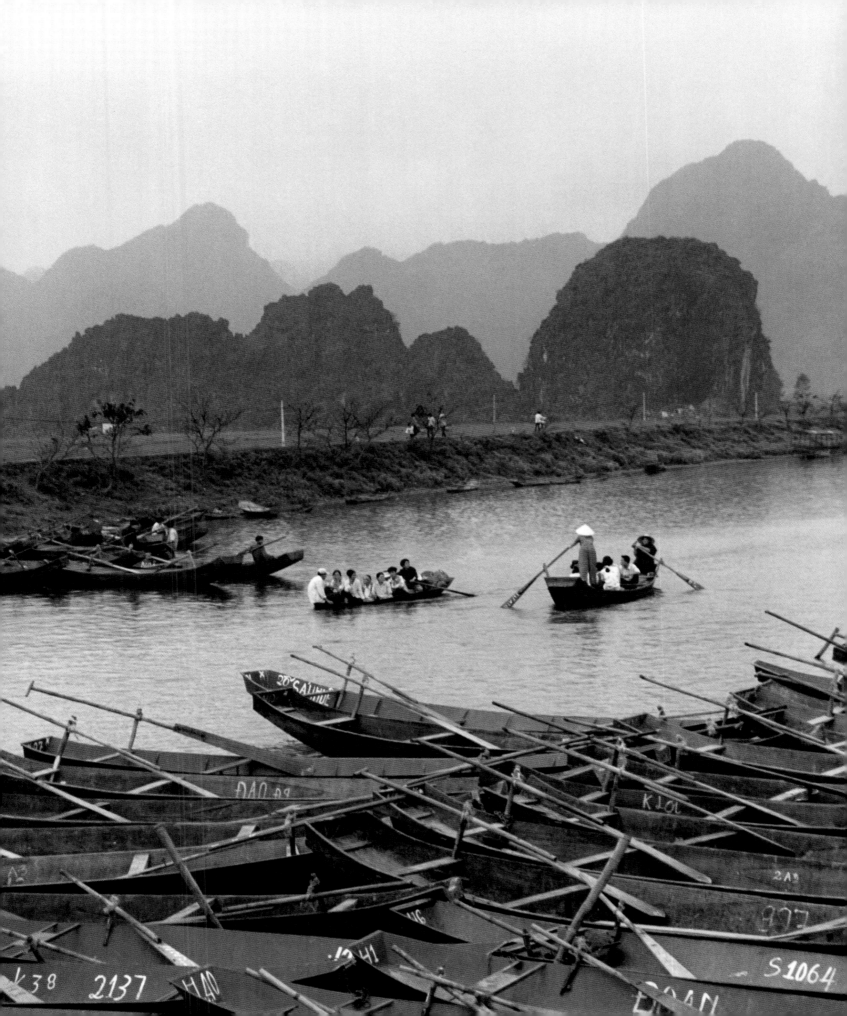

Soldiers ride to work across the Long Bien Bridge toward Hanoi. Some one hundred years ago the French spanned the rushing currents of the Red River with this great metal structure, whose pilings were sunk more than one hundred feet beneath the surface of the water.

Strategically important as the rail and road link between the interior and Haiphong harbor, this bridge was a favorite target for U.S. bombers during the American war. It remained standing but has been repaired in several sections. The bridge is now used only for bikes and motorcycles. While rails still run down the middle of the bridge, trains have not used this track for many years.

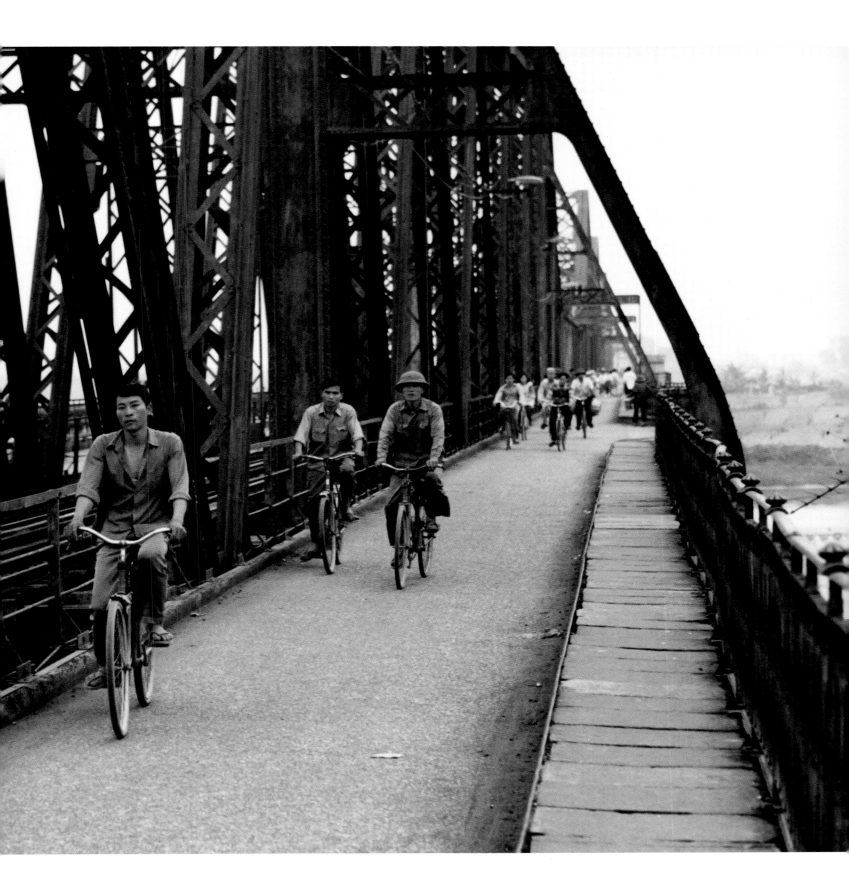

In Haiphong, as in all Vietnamese cities, the cyclo, a man-powered three-wheeled pedicab, is often the chosen means of transportation. Rich and poor alike take advantage of the low fares. For a Vietnamese a ride might be 5 cents (U.S.), whereas an American visitor pays $1. A large number of cyclo drivers were formerly soldiers in a now downsized Vietnamese military.

On upscale cyclos a top can be raised in rainy weather and plastic sides snapped on. The rather inelegant cyclo at right is being put to use for the owner's private transport of household goods.

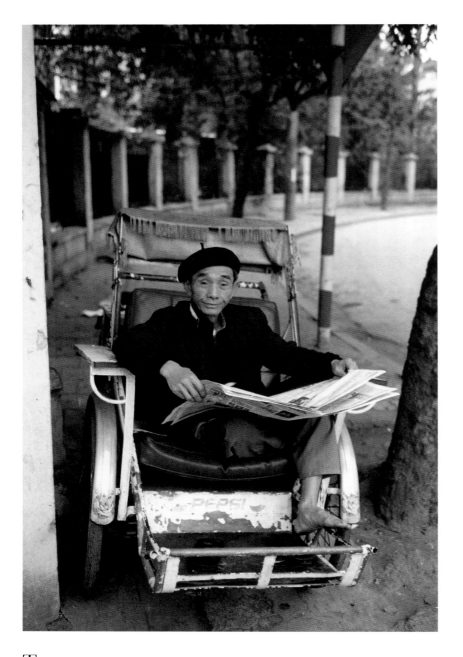

This urbane driver is the owner of an up-market cyclo. It is well cared for and boasts decorative flower motifs as well as small Pepsi-Cola ads. The jaunty black beret is a legacy of the French. In northern Vietnam, as in Paris, berets were very much in fashion in the first half of the twentieth century.

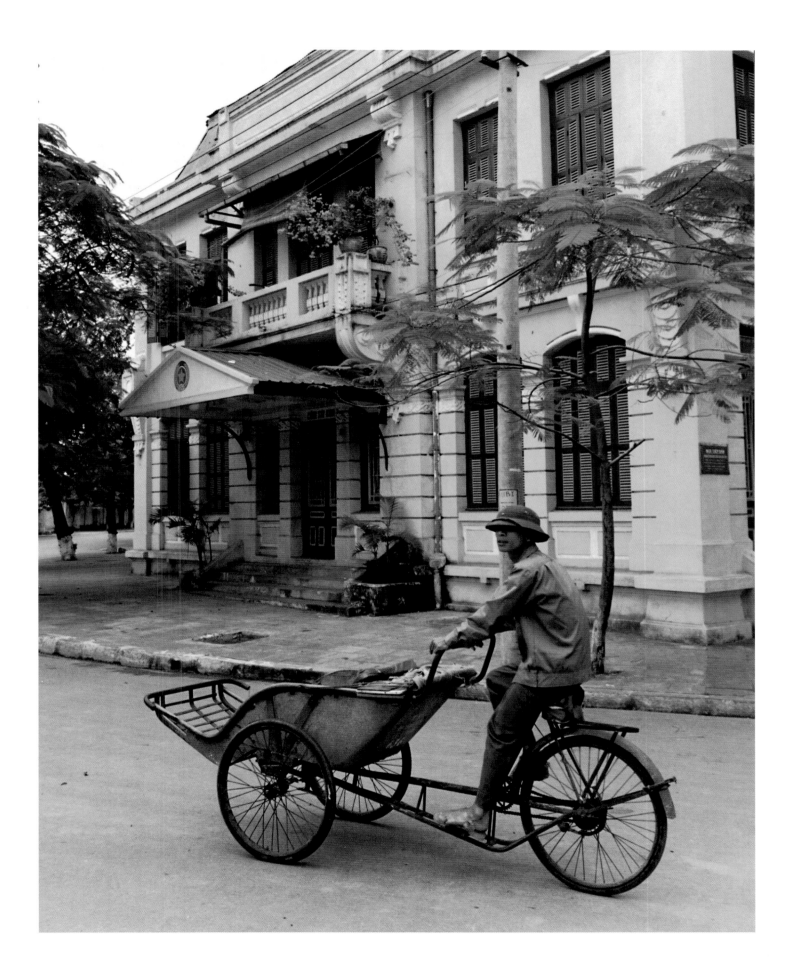

In Hanoi the traffic is dominated by swarms of motorbikes. The brand of choice is a Honda Dream II. Every day hundreds of motorcycle accidents take place along Vietnam's highways and twenty-five or more Vietnamese are either killed or suffer permanent brain damage. This is an enormous casualty rate for a country with just 8,500 miles of paved roads. Safety experts worry that only 3 percent of riders wear protective helmets. Helmets are not considered fashionable by Vietnamese youths, who not only have become conscious of the speed of their vehicles but also like the way they look on their motorbikes.

Handsome colonial buildings built by the French are now occupied by Vietnamese ministries, as shown by the nation's red flag emblazoned with a yellow star.

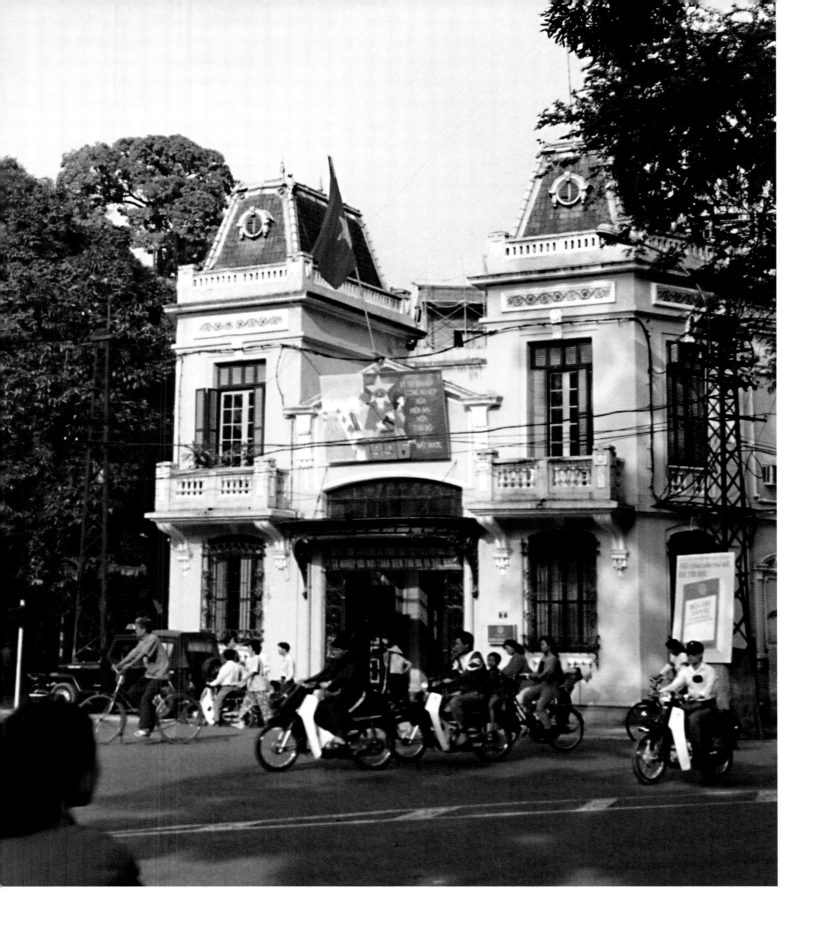

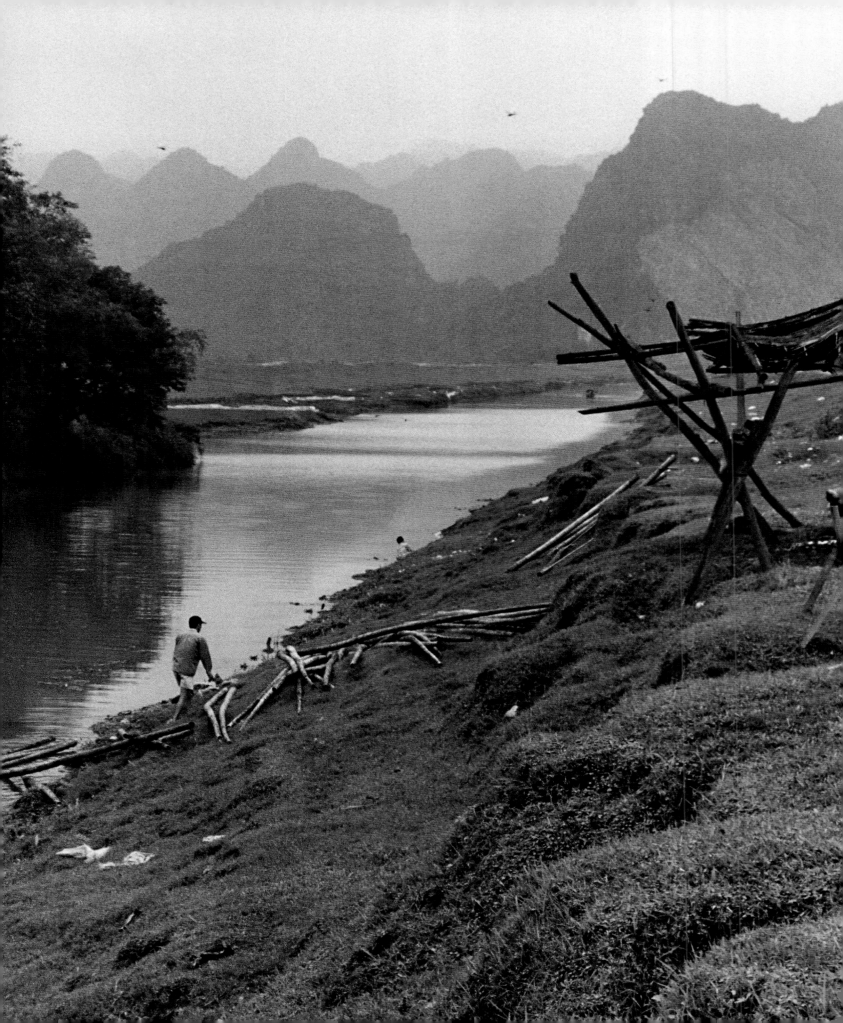

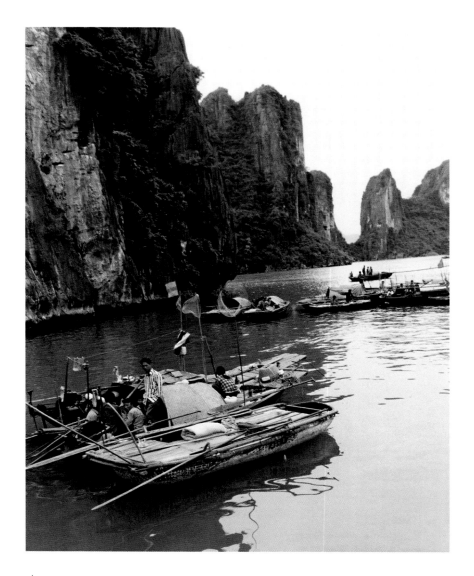

At Ha Long Bay more than three thousand limestone islets rise out of the murky green waters of the Gulf of Tonkin. A widely told legend holds that the outcroppings were created by an enormous sea dragon whose all-powerful tail slashed the ground with such force that mountains rose from the sea.

A community of fishermen who ply the salty waters of Ha Long Bay cluster together for companionship. These small boats are their permanent dwellings. A dog, several children, and even extra relatives may be living aboard these tiny craft.

A branch of the Yen Vi stream, making its way from the Huong Son Mountains.

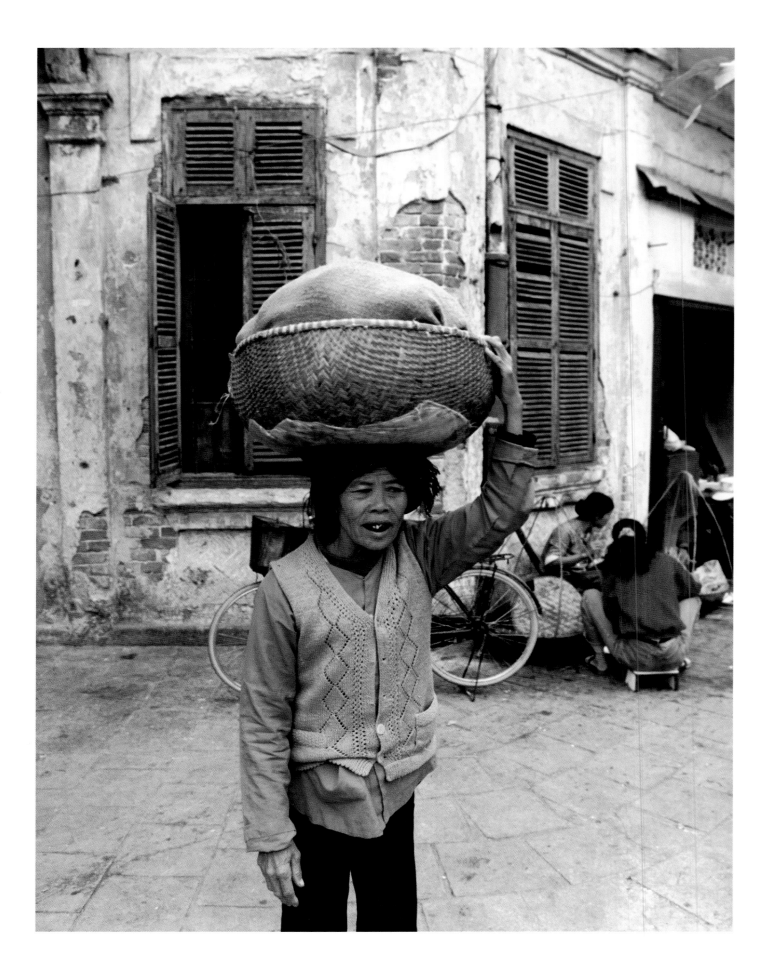

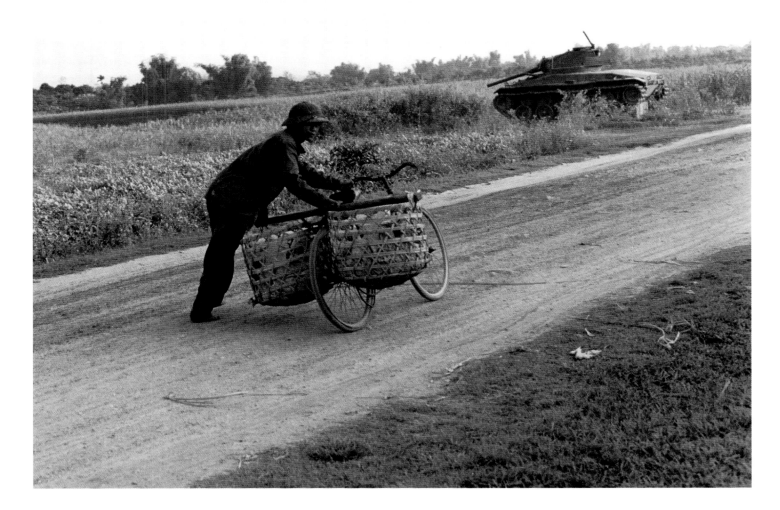

Part of a balancing act, freshly baked French bread is wrapped in cloths to ensure freshness on its way from the bakery to a restaurant. Behind the delivery man a group of fruit and vegetable vendors squat on tiny stools. By decree of the prime minister, most Hanoi sidewalks are not to be occupied between 7 A.M. and 6 P.M., but the entrepreneurial Vietnamese pay little heed to these ordinances.

The battle of Dien Bien Phu in 1954 marked the end of French domination of Indochina. As a reminder of the Vietnamese victory, a French tank has been left along a road on the outskirts of the dusty town.

Once strategically important, Dien Bien Phu was a central trading point on the caravan network that connected South China, the Red River Delta, and Thailand. The town lies only twelve miles from the Laotian border, in the Muong Thanh valley.

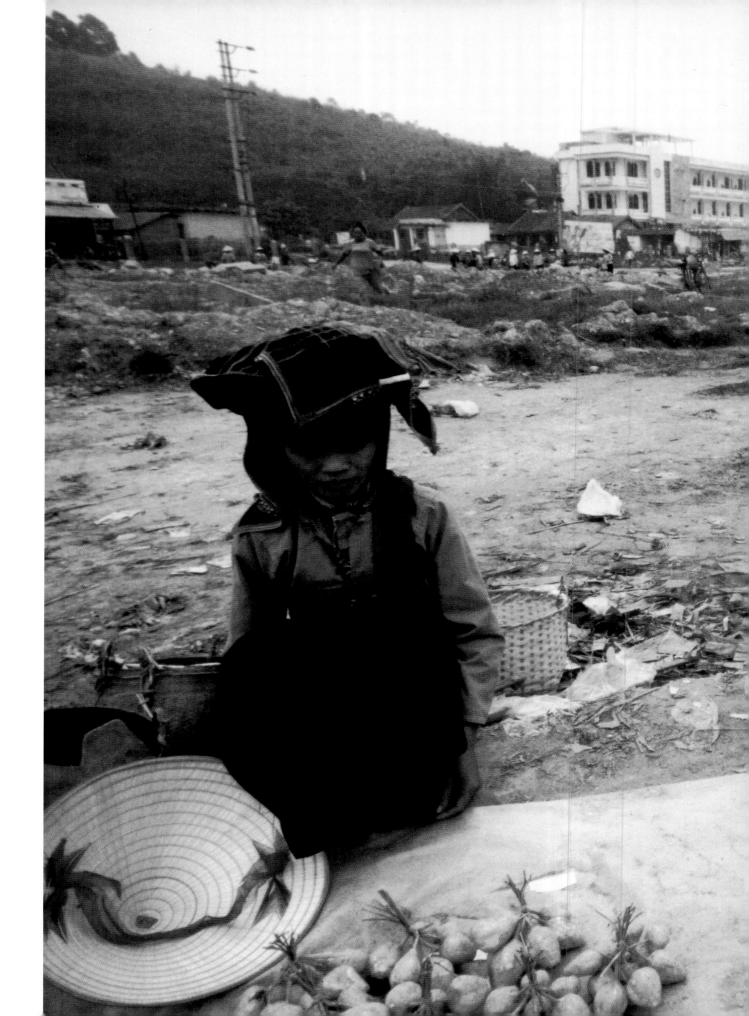

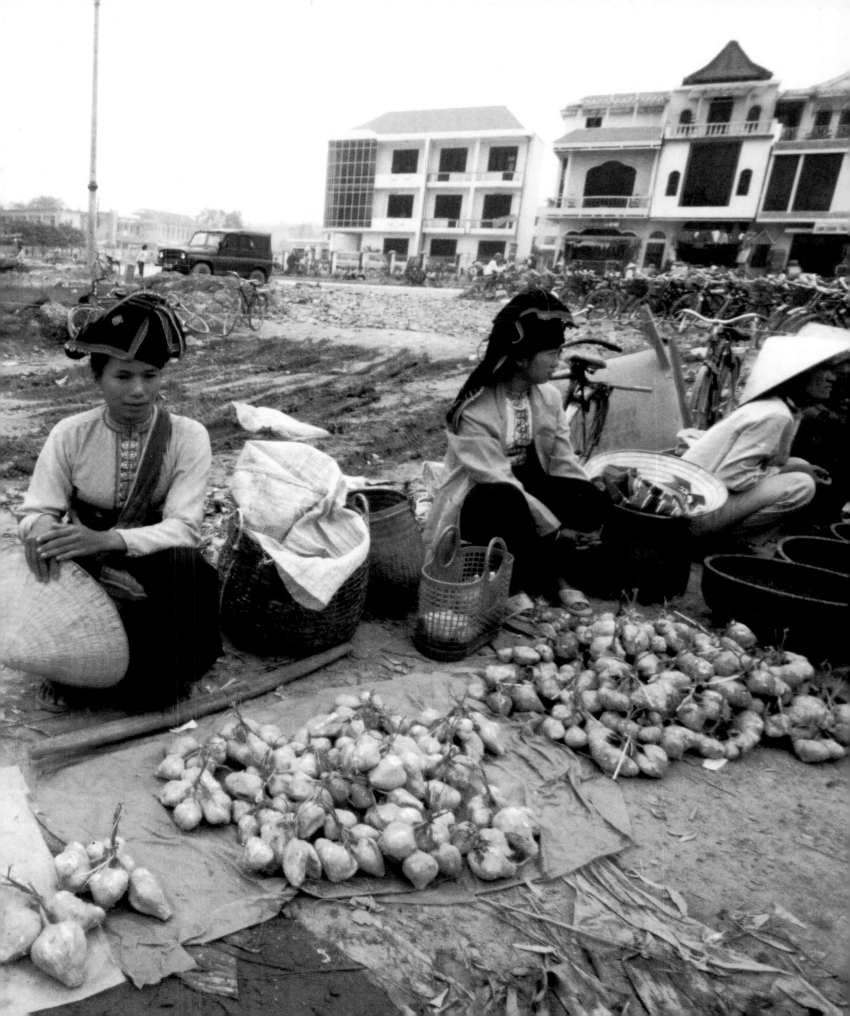

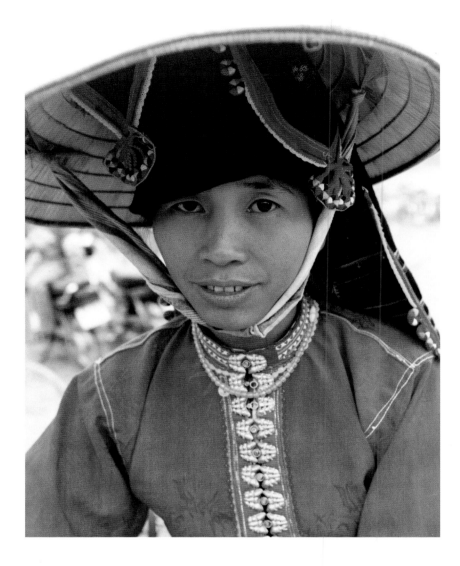

At the morning market each day in Dien Bien Phu, tribal people come down from the highlands to sell vegetables or fruit they have grown or animals they have raised. Because of its remote geographical location, it seemed unlikely that Dien Bien Phu would become an area of great population growth. Nevertheless, ambitious new construction encircles this small, dusty market town in northwestern Vietnam. Dien Bien Phu has recently become the provincial capital of Lai Chau Province, and many of its newest buildings are slotted for government use. As a result, civil servants and the support system of shops and suppliers necessary to service them are moving in both from Hanoi and from the former provincial capital. This new surge in population has created a heavy demand for housing. Fast-moving land speculators have made a killing buying and selling land to the government and to private developers in an area that fifty years ago was regarded by the French as an impenetrable and impregnable valley.

Women of the Black Thai tribe selling root vegetables at the daily market in Dien Bien Phu. Despite their extreme poverty, adult women of the Black Thai tribe wear traditional silver clasps on their jackets as everyday attire. Some of the silver comes from melted-down coins that date from 1930s French Indochina. Like many residents of the Western Highlands, the Black Thai live in tall houses covered with thatched roofs and built on log pilings.

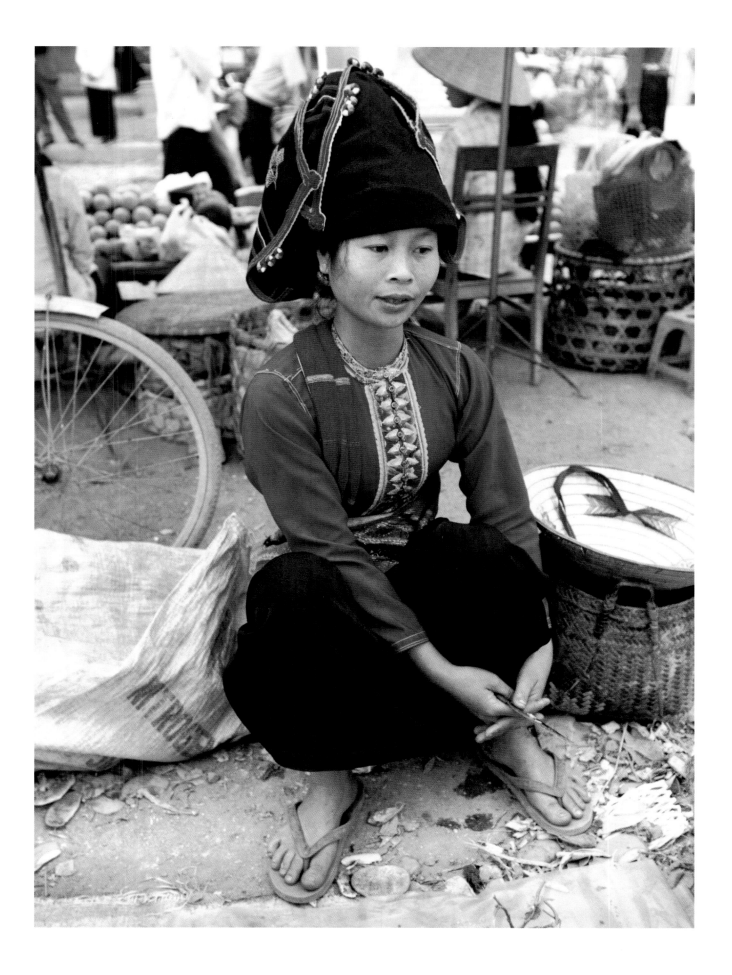

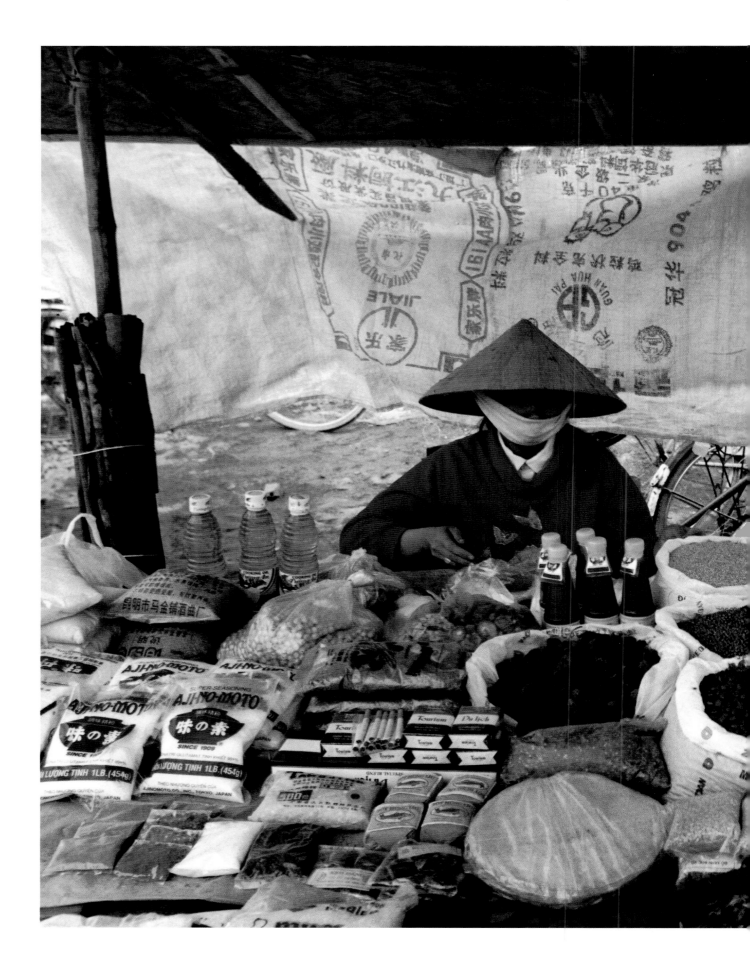

A wide choice of food products is offered for sale at Dien Bien Phu's daily market. Even in this isolated section of the country, only a dozen miles from Laos and perhaps thirty-five miles from the Chinese border, the packaging is printed in four different languages: Vietnamese, Chinese, English, and Japanese. Culinary offerings range from locally made vermicelli to a choice of *bot canh* (a shrimp powder used as a base for fish soup), dried funghi, dried crustaceans, mung beans, Vietnamese hot sauce, and, always for sale, Japanese Asino-Moto, which is MSG.

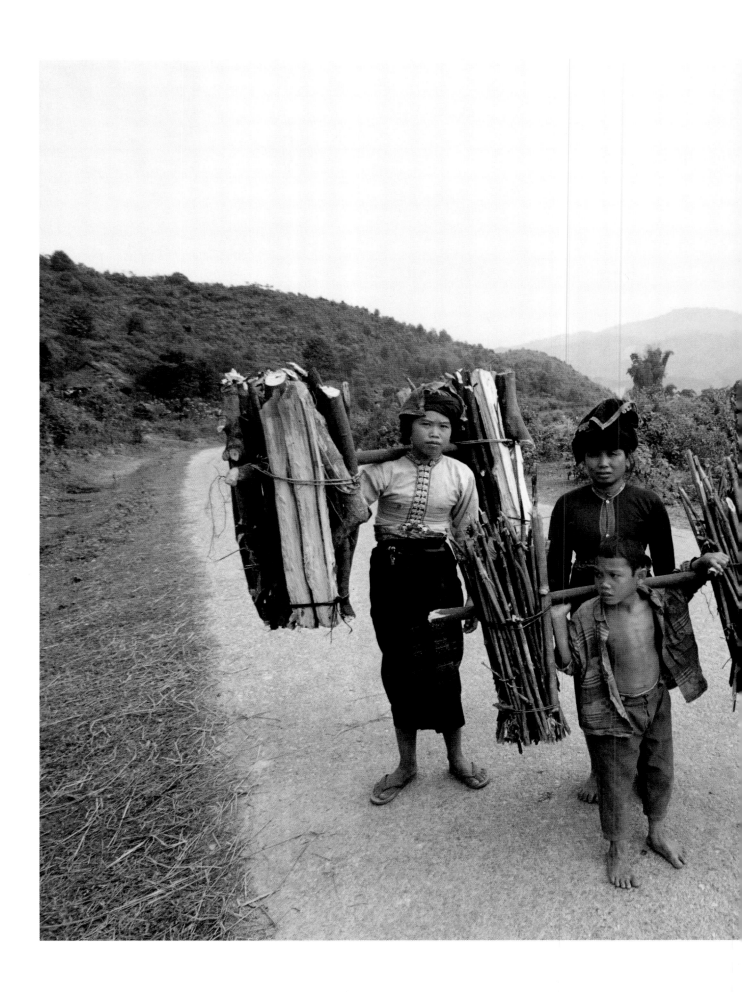

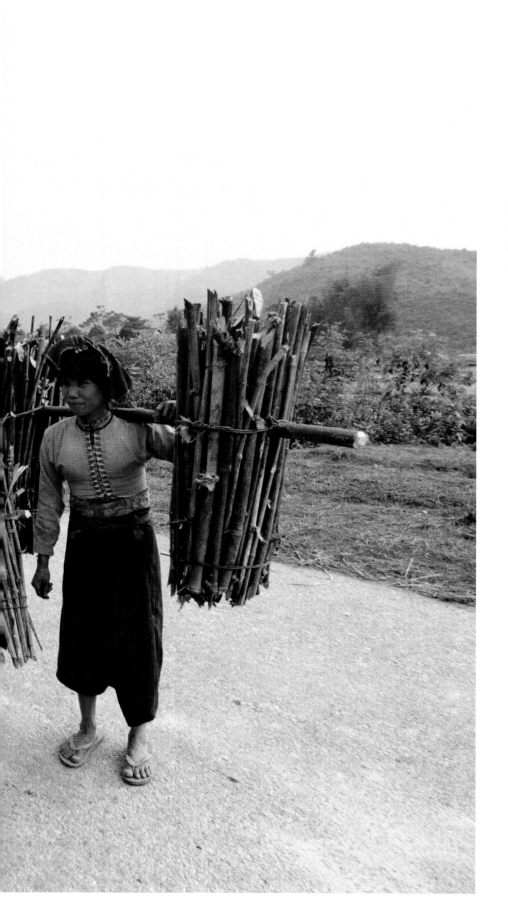

The Black Thai of the Western Highlands are identified by the color of the women's skirts. Each day Black Thai women and children, laden with heavy bundles of wood cut from hillside forests, trudge to the morning market in Dien Bien Phu. They walk seven or eight miles a day. Each woman will receive a sum equivalent to 30 cents (U.S.) for her efforts. In general the mountain people have annual incomes lower than those of most ethnic Vietnamese.

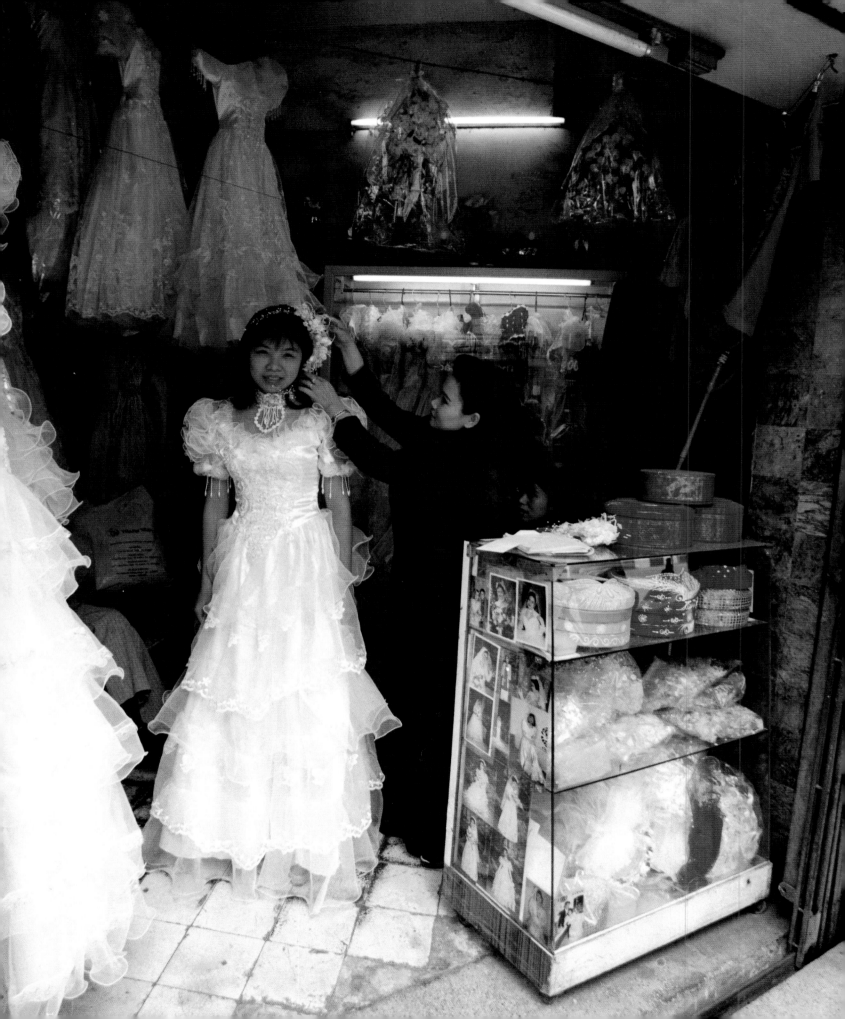

According to the revised marriage and family law of June 2000, the minimum marriage age is twenty years for men and eighteen for women. The minister of justice recently stated that men need more time to become socially mature than do women.

Vu Thu Hien plans to marry in ten days' time. She tries on a wedding dress at the shop of Thanh Nhan on Hanoi's Hang Bong Nhoum Street. The shop has dresses in all colors for sale or rent. Ruffles are popular in Vietnam. These high-style dresses are appropriate for weddings as well as for other ceremonies. This bridal dress rents for $40 (U.S.) per event. "Please pay in advance."

To the right, in the glass case, is a display of traditional Chinese-style red lacquer wedding boxes overlaid with yellow dragon and phoenix designs. Bought and paid for by the groom's family, these boxes are important parts of the Vietnamese wedding ritual. On the wedding day, tea, two bottles of rice wine, and sweet cakes are placed inside the boxes, along with two small cups. Members of both families drink rice wine from the cups as they stand before the ancestral altar. Also for the ceremony there are smaller wedding boxes containing two gold rings, one each for the bride and groom. Two earrings and a necklace that are to be placed on the bride by the groom's mother will be held in another tiny box. An additional box containing betel leaves and areca nuts is required for a wedding in Vietnam. Even in Vietnamese weddings overseas where betel and areca are not available, a simulation of the leaves and nuts will be painted on paper.

In Hanoi's old quarter, Bao Nguyen meticulously copies photographs of Vietnamese mandarins — or any other person. His depiction of American film stars of bygone years gives the impression that some of his customers today may be former G.I.s, or it just may be that the Vietnamese have become fans of classic American films. In Vietnam the art of black-and-white portraiture was still fashionable in the 1960s.

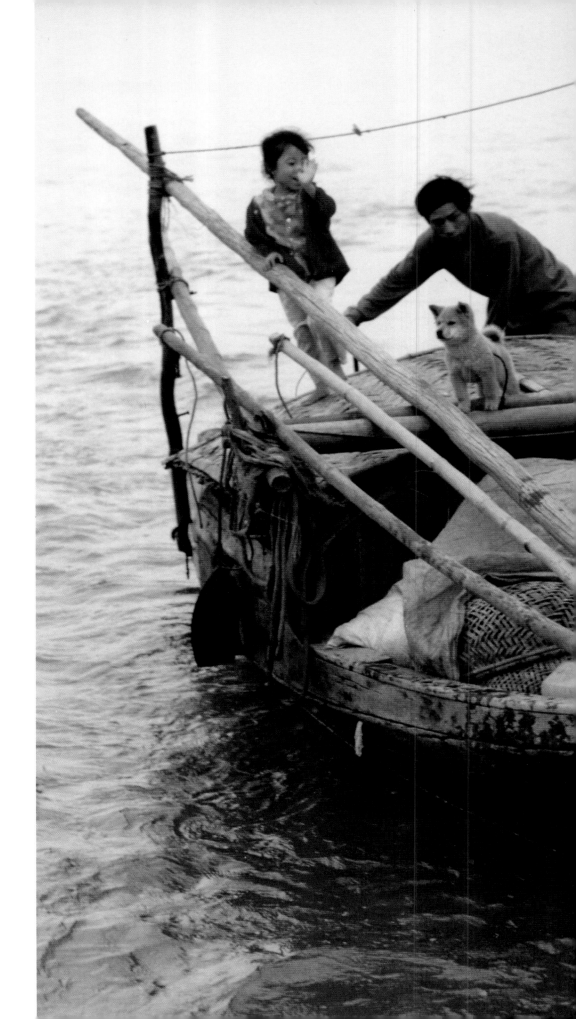

In Ha Long Bay boat dwellers, accustomed to life on the water, never seem to fall overboard. This sampan is home to a Vietnamese family of four and a fluffy dog.

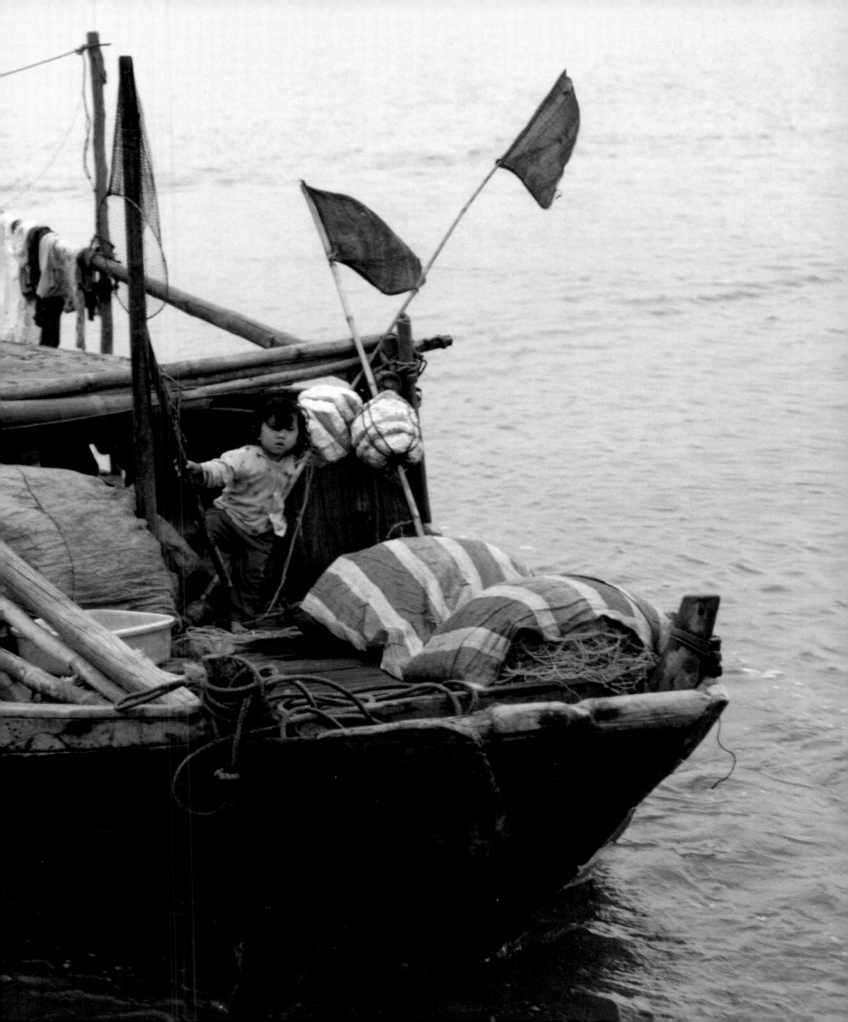

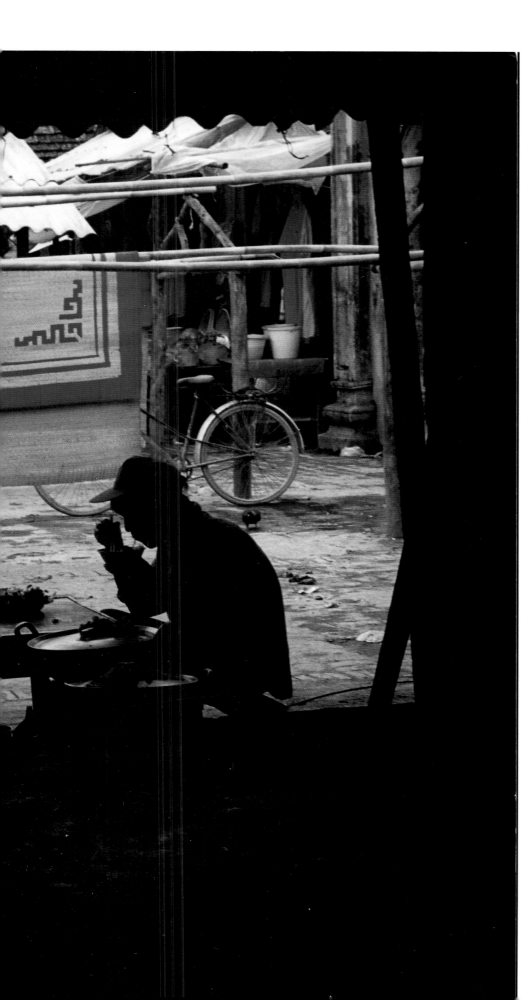

Red-and-tan prayer mats hang on a wall in a small village market in Chuong, near Hanoi. The village of Chuong is renowned for its conical hats and brooms of excellent quality.

For centuries the Vietnamese have been ingenious in the art of transporting goods. The burden carried by the young cyclist is not an oversized glazed doughnut but rather a huge collection of handwoven baskets that she carries perfectly balanced on either side of her bicycle. She will offer them for sale on a street corner in Hanoi, a dozen miles distant.

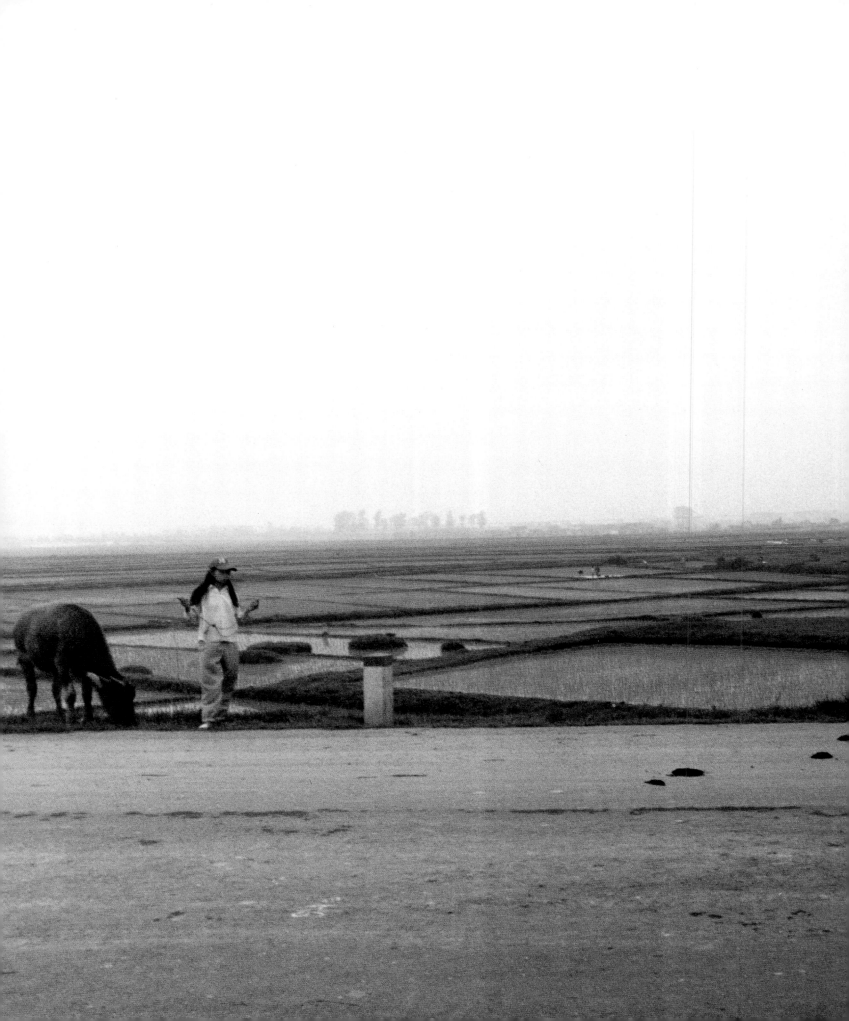

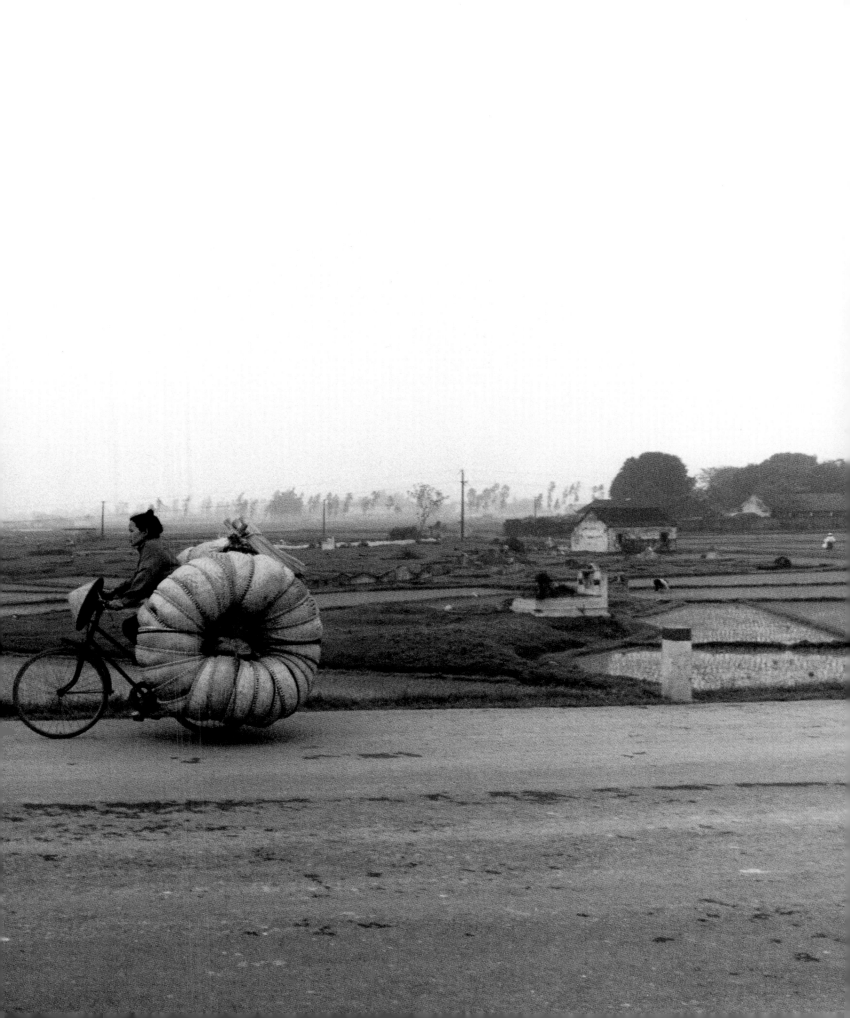

The weaving of split bamboo baskets has become a thriving cottage industry for this northern Vietnamese family living in Yen hamlet, Thach Xa commune, Ha Tay Province. The mother and father are also farmers and weave baskets to supplement their small incomes. Baskets are used for washing rice, carrying vegetables, and drying beans. The grandmother, wearing a pink plastic comb as an adornment in her hair, supervises the grandchildren and watches over the basket production. Both the sleeping and the cooking areas of the house open onto a central courtyard, where most family activities take place in good weather. Yen hamlet is adjacent to the Tay Phuong Pagoda, which attracts thousands of Buddhist pilgrims each year.

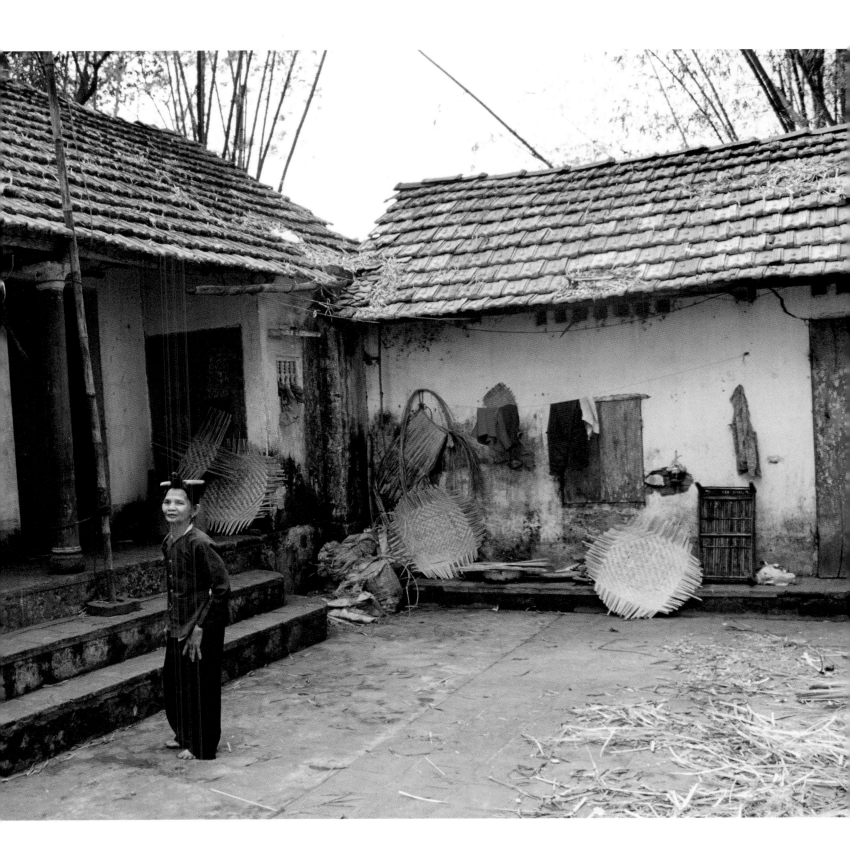

In Vietnam, especially in the north, snake wine is believed to be a beneficial tonic for fatigue. Athletes and workers drink it to increase energy. Older Vietnamese will sometimes have a cup of the wine before meals to stimulate their appetites. They may have another before bedtime to ensure a sound sleep.

The recipe: place five or seven snakes (always an uneven number) in a solution of rice alcohol for 100 days. The wine is then ready for drinking. The first round is the strongest and purest; as rice alcohol continues to be added, the mixture becomes diluted and loses its power.

Their children grown, their husbands dead, these women spend much of their day tending a Buddhist pagoda in northern Vietnam. They are members of the local Elderly Women's Buddhist Association. Traditional Chinese writing on the pagoda wall reads, "Green mountains and trees embody all gods and spirits."

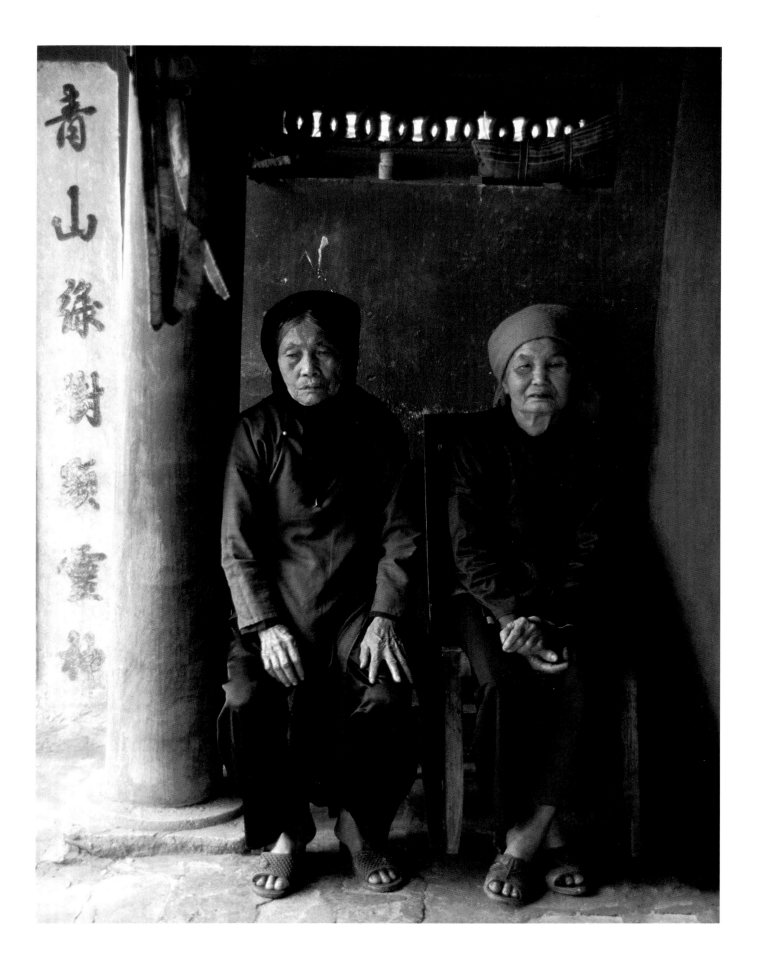

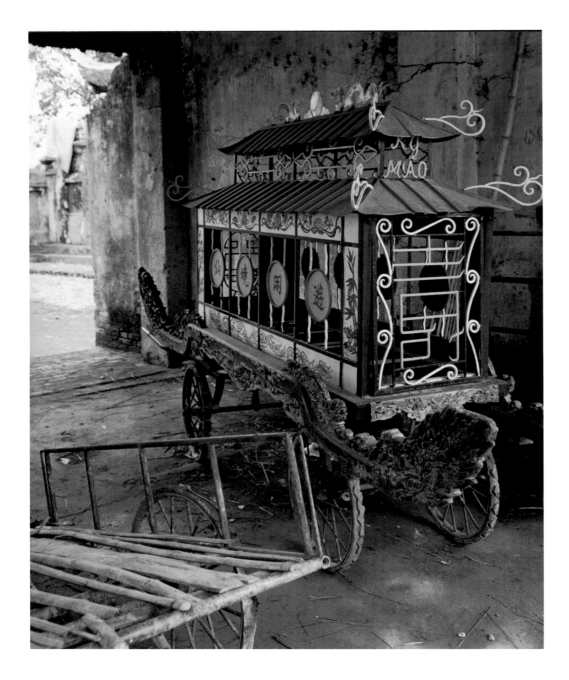

Elaborately decorated hearses are still pre-ferred by a tradition-conscious older generation. Chinese in style, hearses of a design similar to this one are found at country funerals throughout Vietnam. Two ferocious carved dragons support the body of the deceased. "Ky Mao" indicates that the departed was born in the lunar Year of the Cat.

Near Hanoi's Hoan Kiem Lake (Lake of the Restored Sword), the golden sun of early morning illuminates the facade of a colonial building that blends nineteenth-century French architecture with Asian motifs. The building now houses the Institute of Pharmaceutical Medicine.

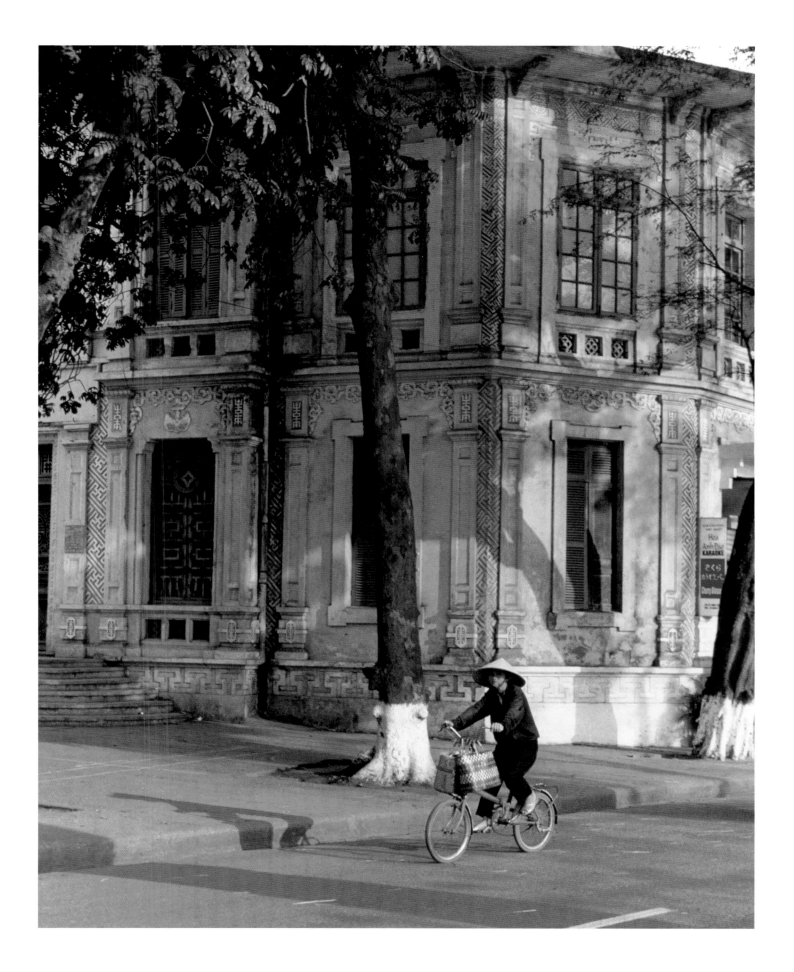

In the heart of Hanoi, at 25 Hang Bai Street, Hanoi's oldest girls' school, Dong Khanh, was built by the French in 1917. Now co-educational, this handsome colonial building serves as two separate schools. In the mornings it is named Truong Vuong Junior High, and in the afternoons the name changes to Nguyen Du Junior High School. More than two thousand students attend each separate half-day session.

On the lower portion of the building hundreds of special locations for parking student bikes are clearly marked (7A, 7B, 7C). Over the past several years, Vietnamese bicycles have frequently been replaced by lighter, cheaper, better-made Chinese models. A porous Chinese border allows easy violation of import bans on bicycles.

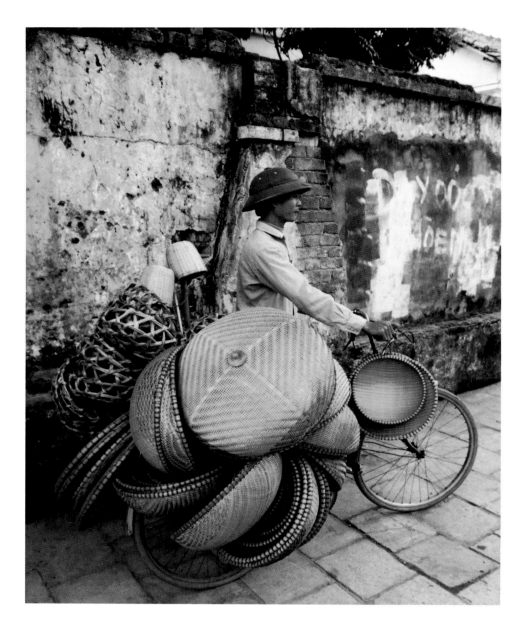

A number of country villages outside Hanoi are known for weaving handmade baskets, many of which are bought by city dwellers. This young man who has pedaled twenty miles into the city will offer the baskets for sale directly from his bike. The baskets were made by members of his family. For each basket his family will receive from 30 to 50 cents U.S.

Traditionally the *dinh*, or communal house, was the heart of the village. It was the place where the council of notables met and where ceremonies honoring the guardian spirit of the village were held. From the 1950s through the 1970s the dinhs were neglected, but with the move from socialism to the market economy, they have once again become important ritual centers, and the village festivals have been revived. Here elderly women from the village of Dinh Bang assemble to watch the ceremonies of the most important local feast day, which is held annually on the fifteenth day of the second lunar month.

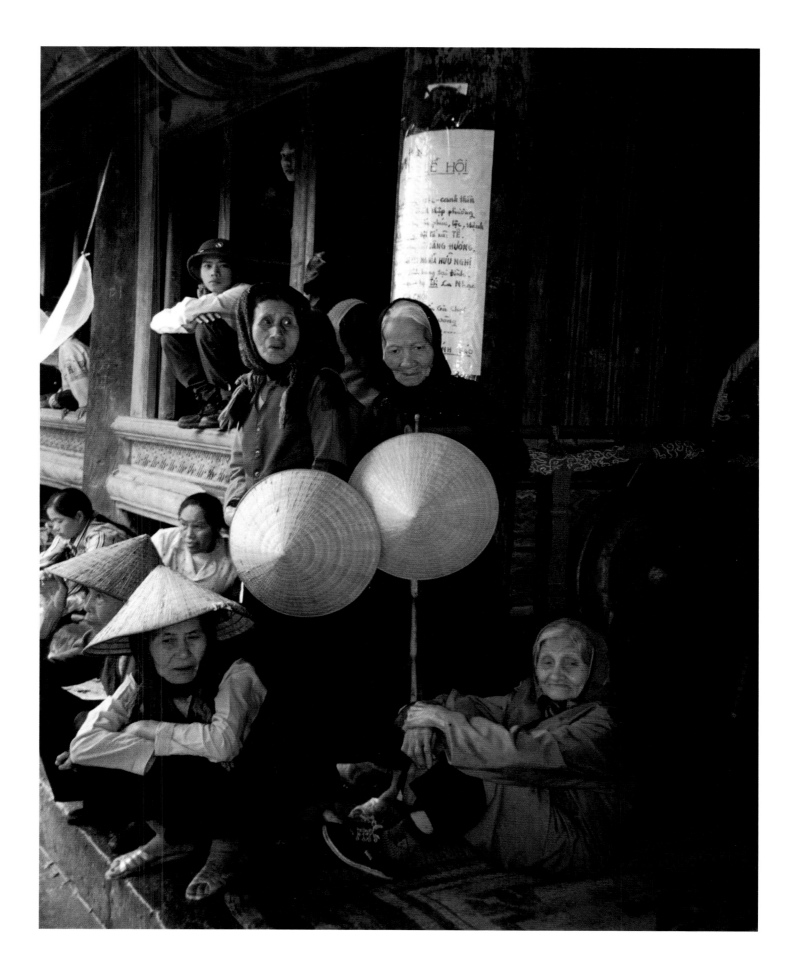

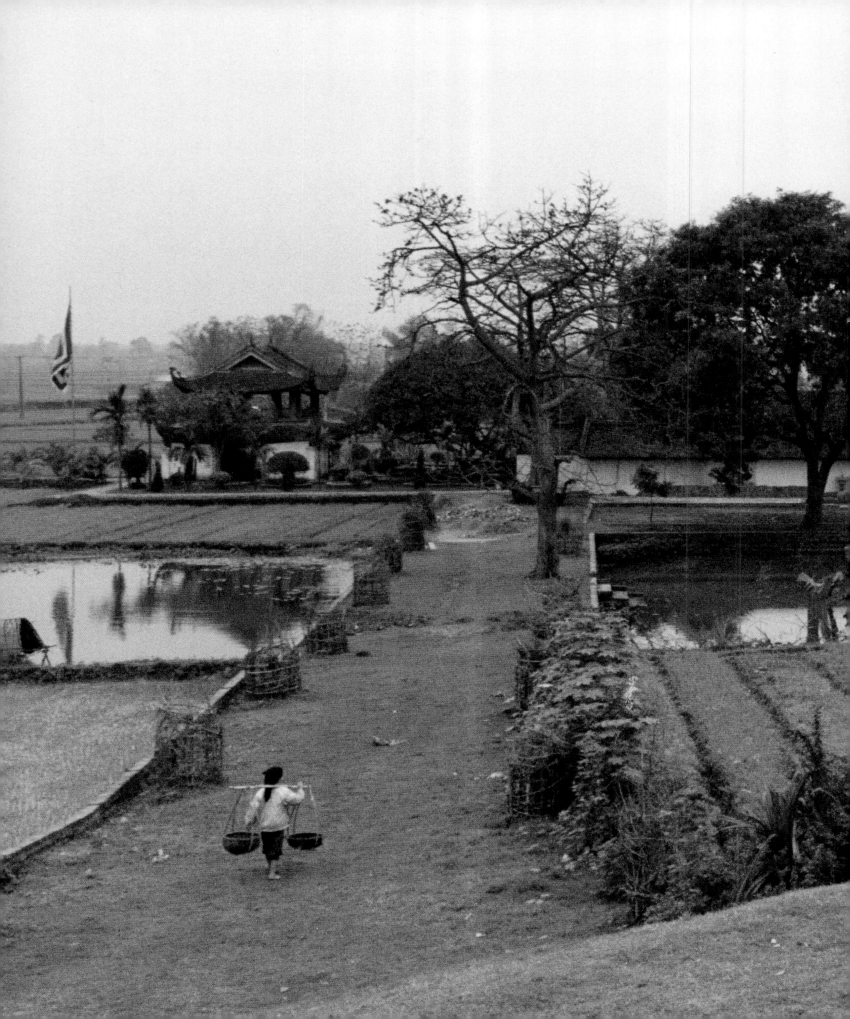

The head nun, aged ninety, at Dau Pagoda, lies in a courtyard hammock. She can read only large-type books. She is revered for both her advanced age and her exemplary life. Only a handful of nuns remain at this religious site nine miles east of Hanoi.

But Thap Pagoda as photographed from a high dike that looks out over the pagoda complex and down into Dinh To hamlet. The round five-story building on the far right is the Bao Nghiem tower, which contains the ashes of the first patriarch of the pagoda, Chuyet Chuyet, who died in 1644. The smaller octagonal Ton Duc tower holds the ashes of the Minh Hanh patriarch. The woman in yellow carrying two woven baskets suspended on a shoulder pole tends the fields and fish ponds that surround the pagoda.

An inner courtyard of But Thap Pagoda in the Tuan Thanh district of Bac Ninh Province, in northern Vietnam.

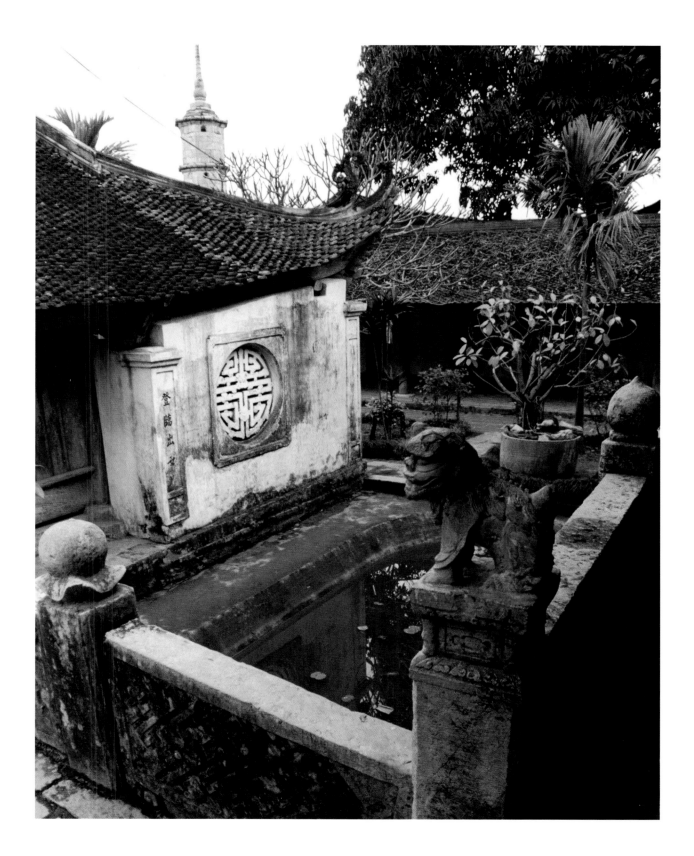

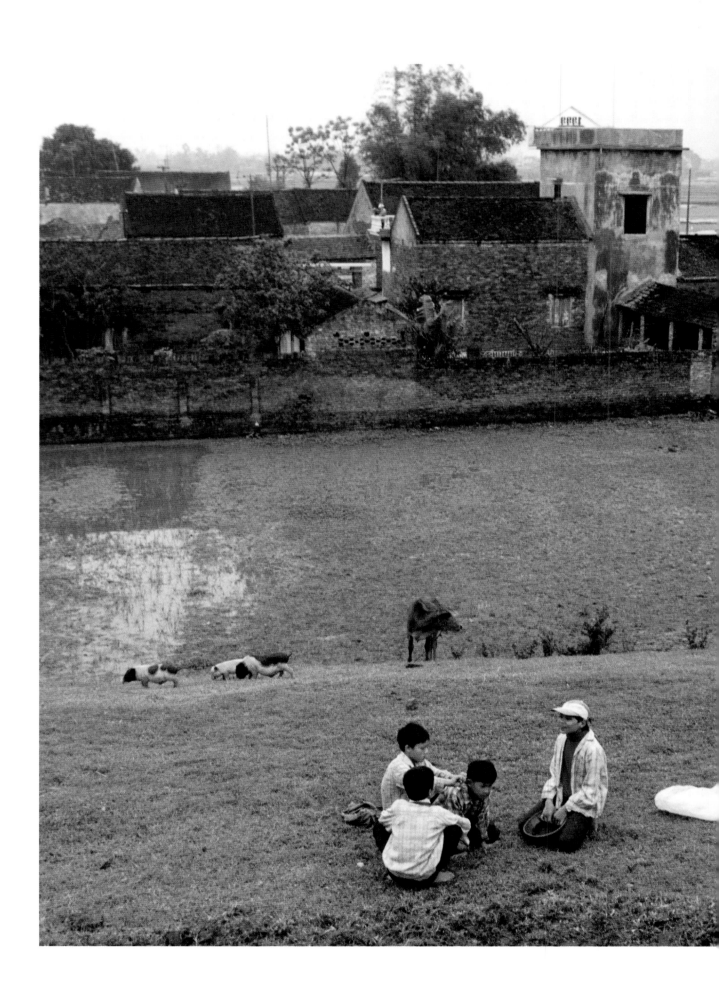

Adjacent to But Thap Pagoda, a wall around this tight cluster of houses separates the Red River Delta hamlet from its rice fields. Traditional Vietnamese communities were socially as well as physically enclosed environments. In compounds such as this, people live packed in, side by side, yet the winding lanes with high, curving walls protect the inhabitants from prying eyes. Privacy is highly valued. Front doors sometimes have eight-sided mirrors hung over the lintel. Bad spirits depart quickly when they see their reflected images.

But Thap hamlet and its rice fields are protected from the annual flooding of the nearby river by a huge dike. Most rice farmers in the Red River Delta grow two or three rice crops a year. Their lives are an endless continuum of plowing, planting, weeding, harvesting, and threshing. They do much of their work by hand. The economic future of these Vietnamese farmers is inextricably bound to the soil and the weather.

A sturdy bicycle is an essential element in family life.

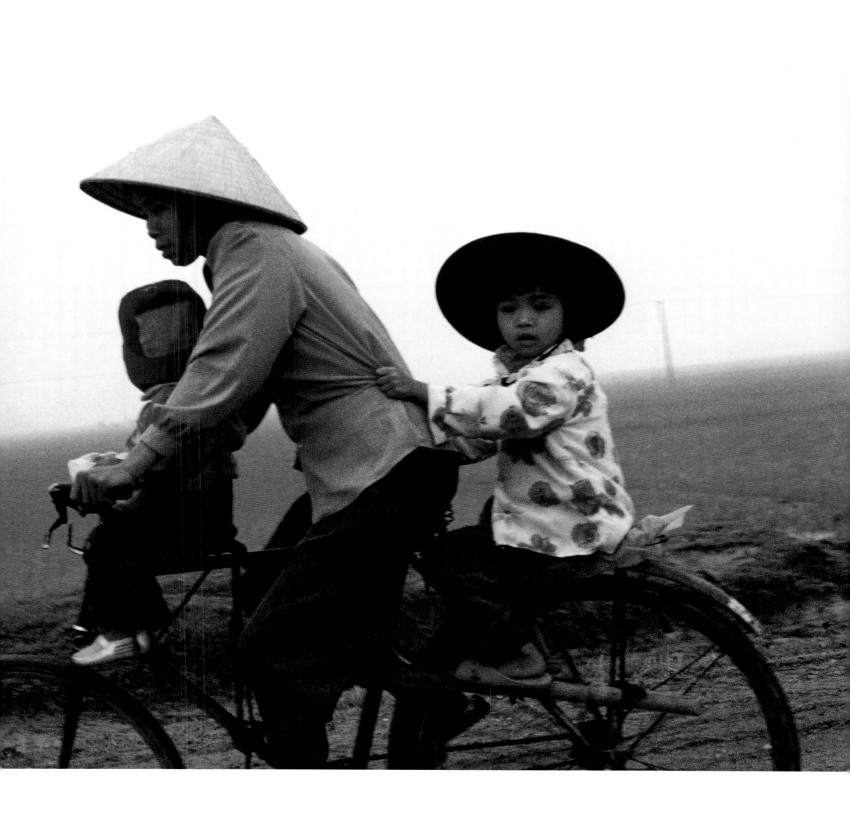

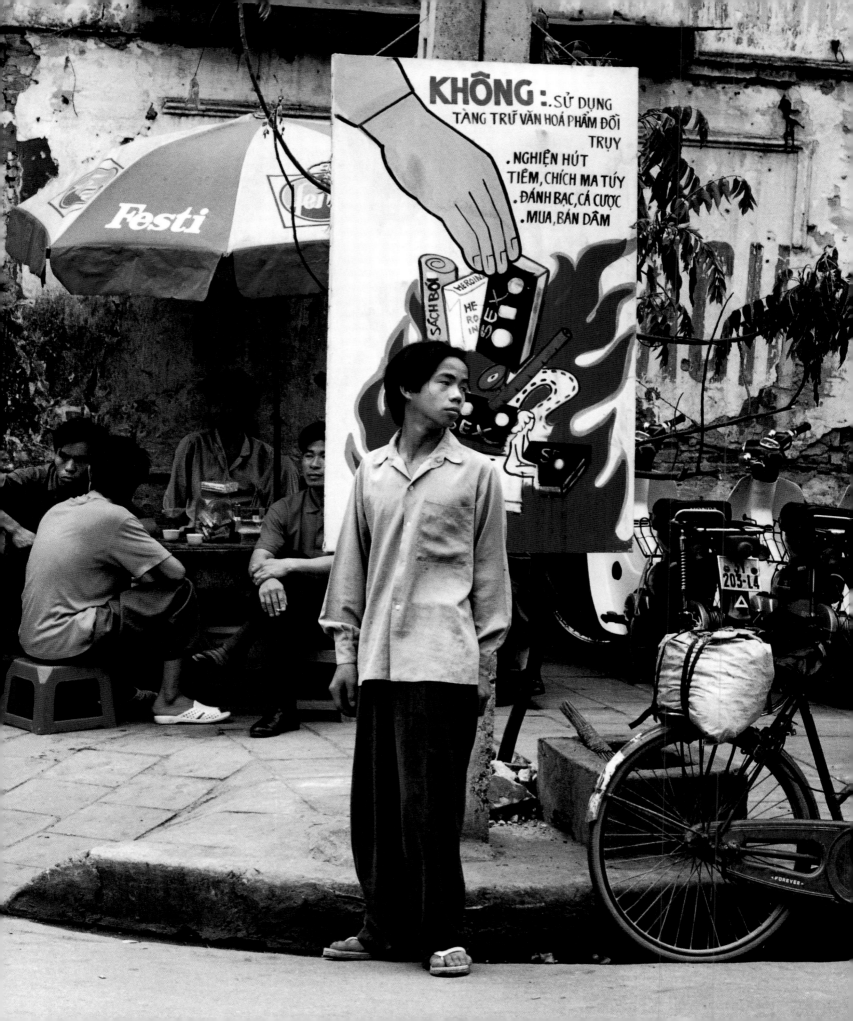

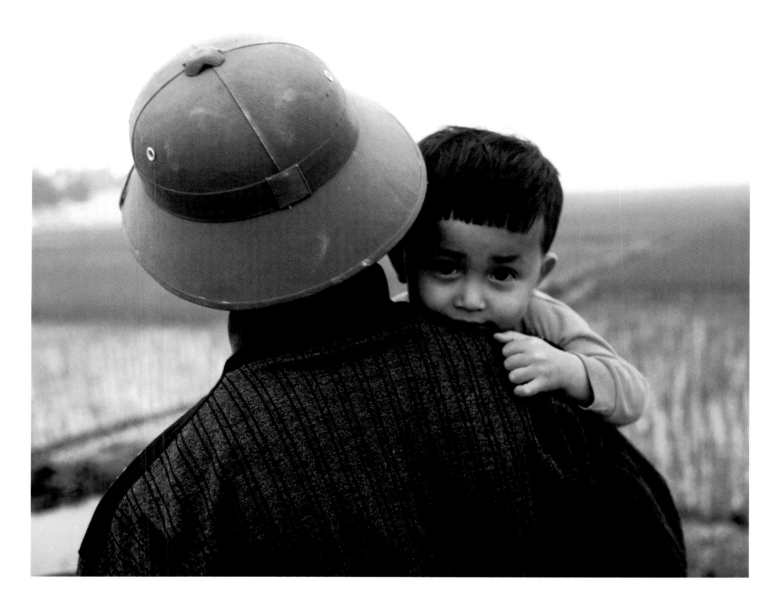

A street poster in Hanoi is part of a recent government campaign to "clean up" Vietnamese society. Along with billboards to increase public consciousness came a sudden enforcement of laws against "decadent culture": drug use, gambling, prostitution, violence, and pornography. Such corruption is considered an ideological enemy of the Communist Party and is sometimes blamed on Western and other outside "subversive" influences. The Vietnamese Ministry of Social Evils presides over the clean-up campaign.

Once used by the French in a white model, the pith helmet has been adopted by Vietnamese as government issue and a good hat.

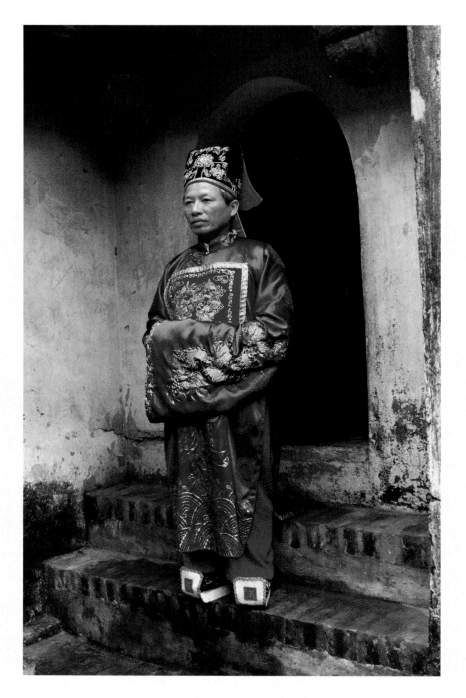

It is the festival day in the village. Full of pride and dignity, the chief official at the March festival in the northern Vietnamese village of Dinh Bang poses by the dinh, the local community house. He is expected to exercise moral leadership and to provide a positive influence for the citizens of the village by virtue of his exemplary life. It is said that this prominent citizen is both a happily married man and a loving father. Financially successful, he has a reputation for honesty. Because he is held in such high regard, he was chosen by the villagers to lead the ritual processions and prayers at this most celebrated annual event. This is the greatest honor that can be conferred on a family. The *Ong Dam*, as he is known, has paid for his own ceremonial robes, elaborately embroidered with golden dragons.

Attending her husband's funeral in Hanoi, this sorrowing wife is dressed in a white mourning robe and white head cover, which represent appropriate grief. She will follow the hearse to a country cemetery outside the city accompanied by family members and other mourners. After the burial all the bereaved will return to the house of the deceased for a mourning feast. The lettering on the wreath reads, "We bid farewell to the soul of the departed."

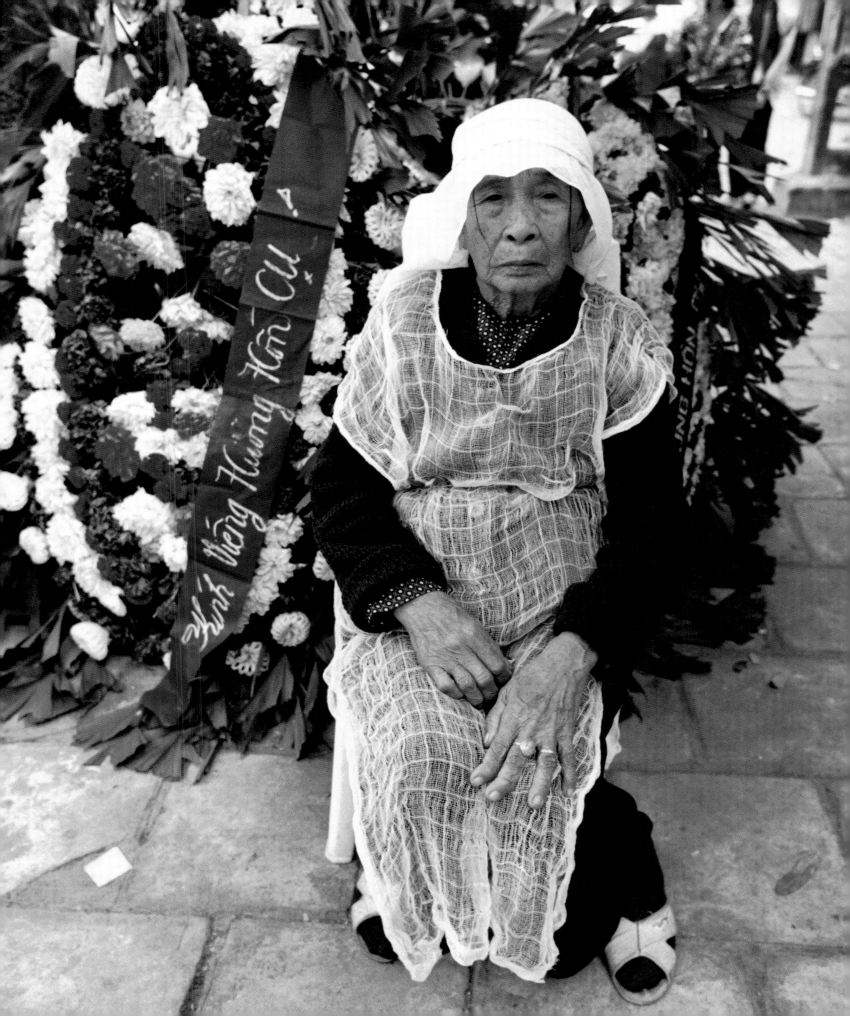

On Hanoi's Ga Hang Bac (Silversmith Street) gravestones are carved out of black marble. Ornamentation made of genuine gold dust is added later. Many of these memorial tablets, often picturing the deceased, are displayed on the altars of pagodas. Photographs are engraved on marble with a fine tool that makes thousands of tiny dots.

The marker at bottom left declares that this is the resting place of Mrs. Bui Thi Ai, 1906–1988. She died in the sixth month of the Year of the Dragon. Death anniversaries are always observed according to the lunar calendar.

Dressed in white, the widow and the sons and daughters of the deceased follow the hearse down a Hanoi street, weeping and touching the coffin as it is borne toward the cemetery. The top of the coffin carries lighted red candles placed there by grieving members of the family. This hearse bears the coffin of Mr. Dang Thai Oanh. On the way from the house to the cemetery the mourners drop small gold papers so that the spirit of the departed may find its way home.

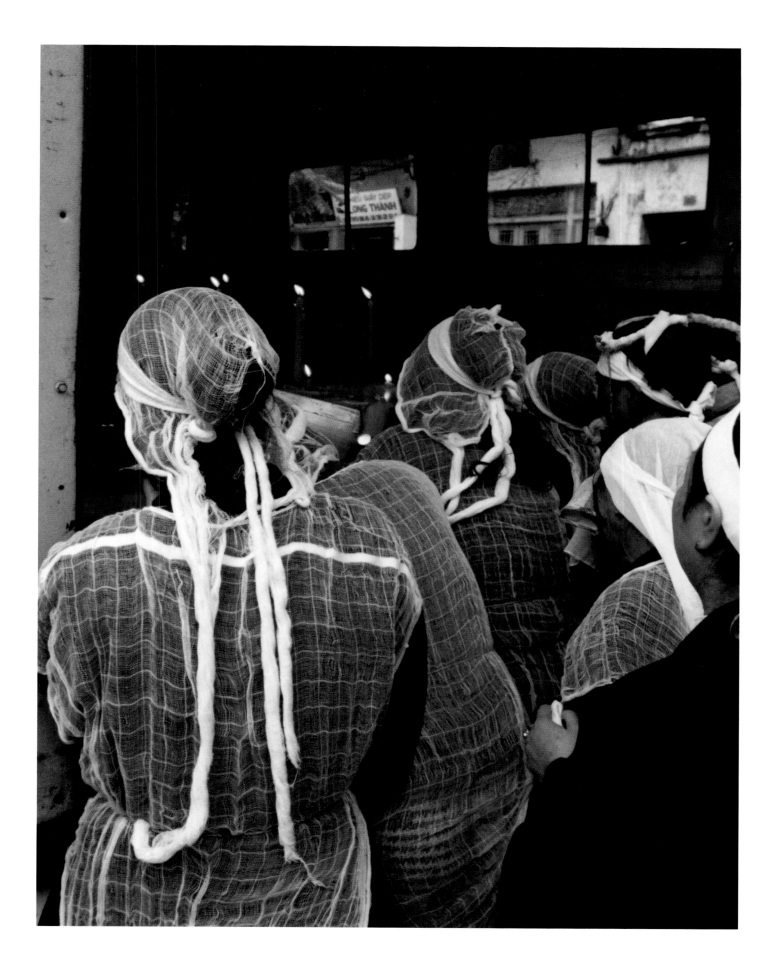

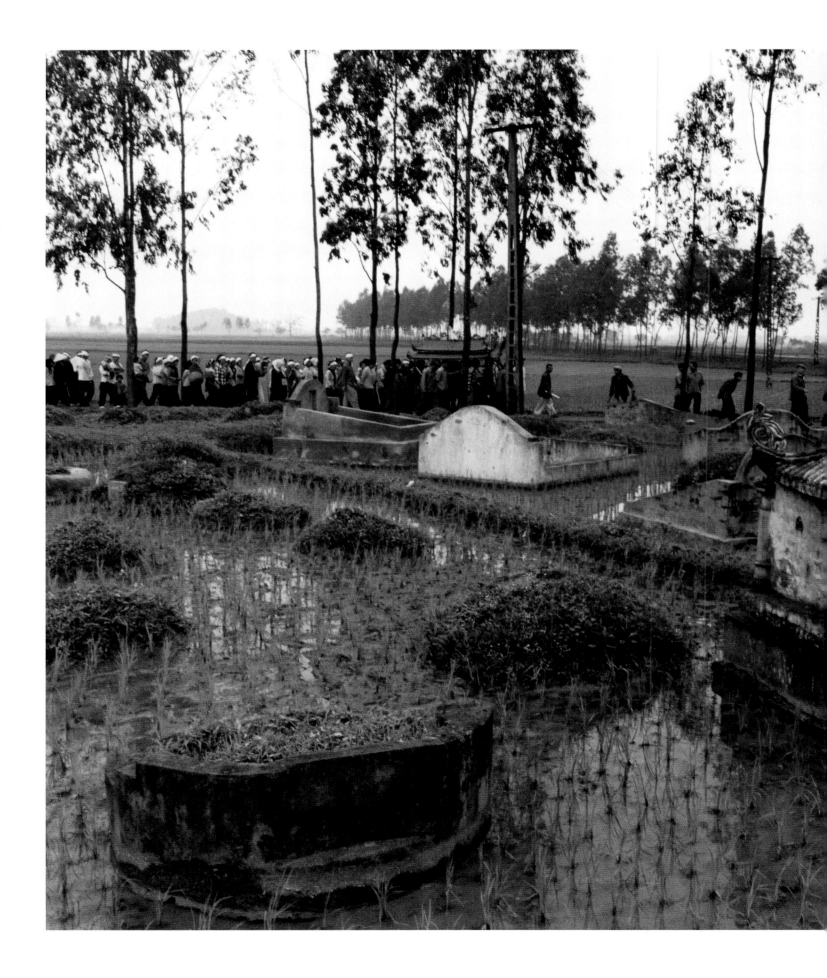

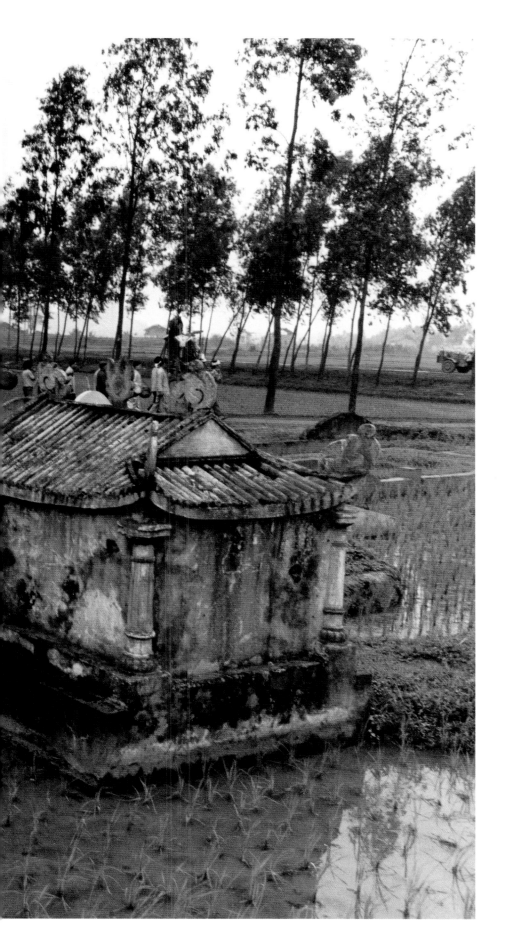

In rural areas many Vietnamese bury their dead in rice paddies just as they have done for centuries. One member of the family is obliged by tradition to continue to live in the area and to tend the graves of his ancestors. Because land for rice cultivation is scarce, this burial custom is controversial and opposed by government authorities.

After death the body is cleansed with rice alcohol, wrapped in a white cloth, and placed in a wooden coffin. The body remains at home for at least three days. During this period neighbors and relatives visit the family house to honor the memory of the deceased.

In preparation for this particular country burial, the body has been moved to the village pagoda at Phuong Cach village, in the Red River Delta, where the funeral procession will begin. Flags and banners borrowed from the pagoda lead the funeral cortege. As the procession passes, the solemn sound of gongs and drums echoes mournfully across the rice paddies.

Because white is the color of death and purity, mourners wear white headbands. The hearse, an elaborately decorated cart, is pushed along the road by family members. The shape of the roof mirrors the Chinese style of the upturned eaves in pagoda design.

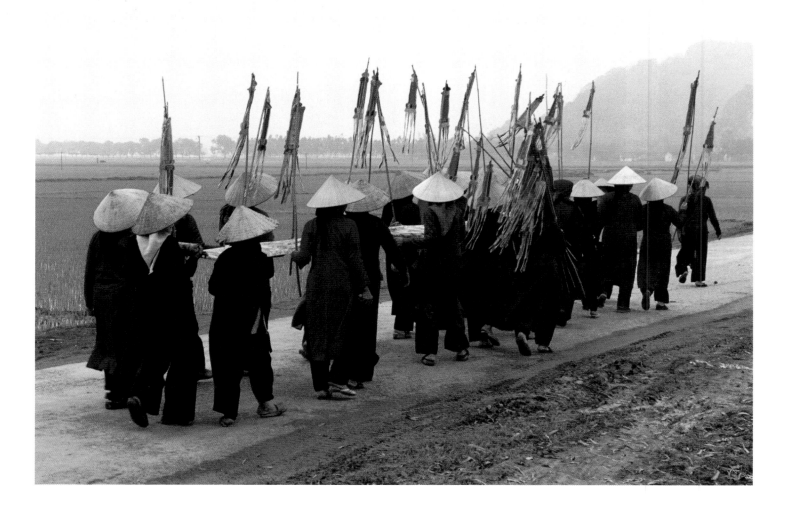

Flag bearers are followed by a large group of elderly women walking in pairs. Together they hold a thirty-foot scroll, which is covered with Buddhist scripture. Symbolically the scroll will ease the passage of the deceased from an earthly existence into the afterlife. Each woman in the procession also holds a torch, which, according to traditional beliefs, will illuminate the path of the deceased to the next stage of his existence.

On arrival at the burial spot the coffin is removed from the cart by five or six strong men and carried to the open grave.

Burial is in the rice paddies, and the exact site is often chosen according to *phong thuy*, or the practice of geomancy, which has recently regained popularity in Vietnam. In English *phong thuy* is translated as "wind and water." (The Chinese Mandarin name for the same practice is *feng shui*.)

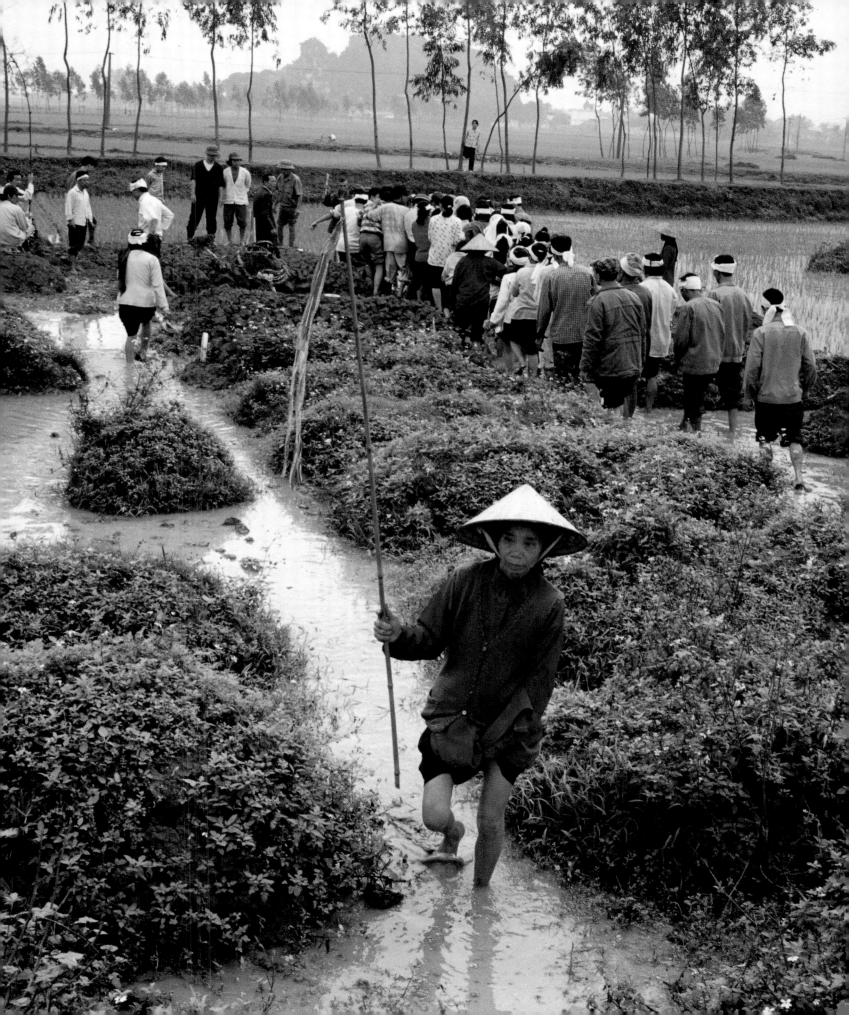

At his father's burial outside Phuong Cach village in Quoc Oai district, Ha Tay Province, Nguyen Duc Duc, one of two bereaved sons, holds a staff that represents obedience to his father. Staff in hand, the son walks backward from the house to the cemetery. Symbolically this action indicates that Nguyen Duc Duc wishes to delay the final farewell to his beloved father. Observance of death anniversaries is an integral part of ancestor worship. The third anniversary of a death marks the end of the formal period of mourning. In many rigidly traditional Vietnamese families, sons and daughters must refrain from marrying during this mourning period. If a parent becomes fatally ill, a young man and woman may even advance their wedding date so as to marry before the parent's death.

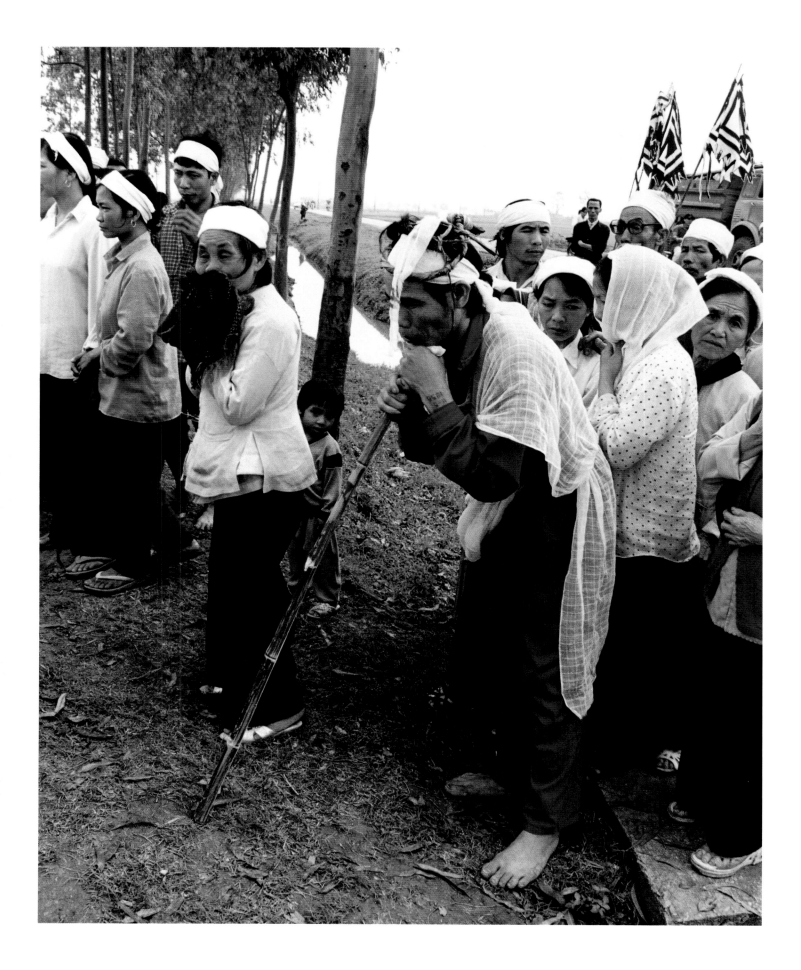

Burning paper money for departed souls means that the dead will be rich in their afterlife. Burning paper replicas of motorbikes means the deceased will ride motorbikes in heaven. Northern Vietnam has numerous cottage industries that manufacture paper products to be used for burnt offerings to memorialize the dead. Paper cell phones and paper CD players are new and popular items.

Most villages are known for one particular product or skill. Some villages specialize in the labor-intensive production of paper shoes, paper crowns, and paper money for ceremonial burning, others may make conical hats of bamboo or glazed clay pots. Villagers keep their unique knowledge and skills hidden from outsiders.

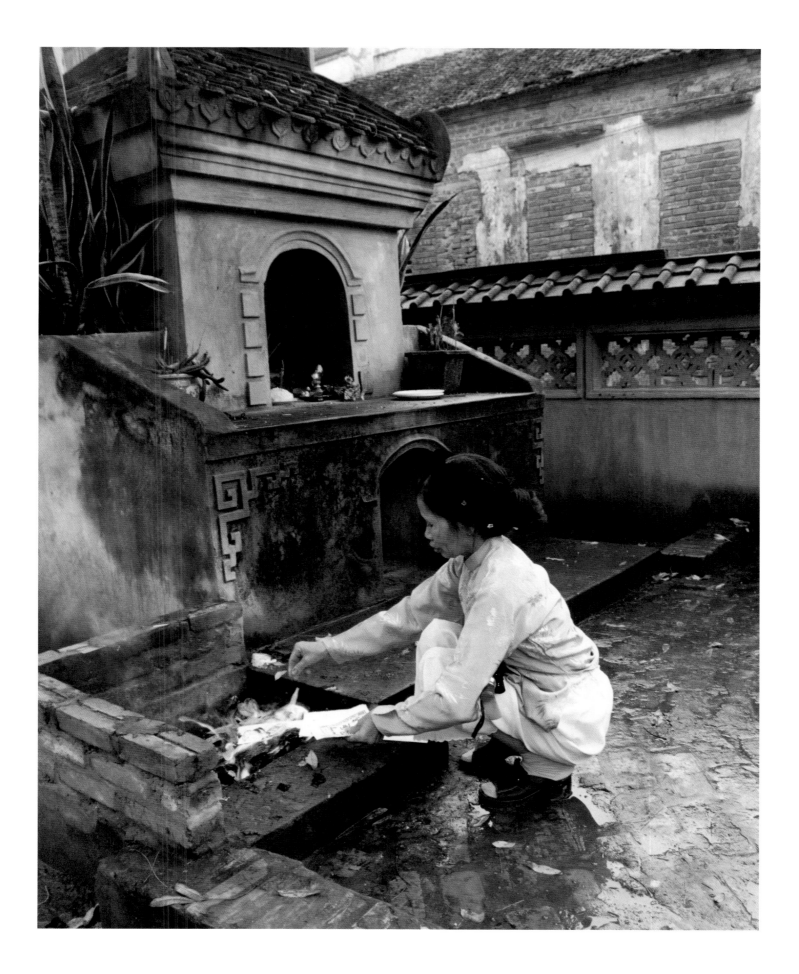

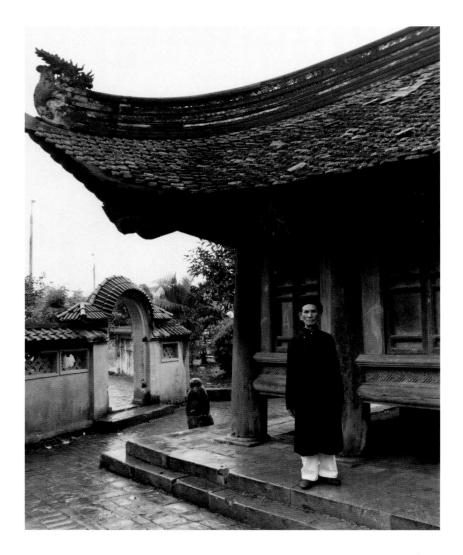

This style of hatband hearkens back to a generation free from the dictates of modern fashion. In Vietnam this type of hat is still worn for weddings and festivals. To complete his attire, an individual choosing this old-fashioned outfit often carries a furled umbrella and wears a floor-length robe.

This elderly gentleman is one of the oldest citizens of the northern village of Dinh Bang. The Chinese-style building behind him is the village dinh. The roof has sweeping upturned eaves and dragon peaks. For centuries the dinh has served as both the spiritual and political heart of Vietnam's villages.

Village elders at the Dinh Bang village festival. Participation as one of the principal officiants bestows enormous social status and prestige. The village is located twelve miles from Hanoi.

Clad in silken ceremonial robes, the participants venerate the genies of the mountains and the waters. During the ceremony the elders pray to the deities, asking them to protect the villagers of Dinh Bang from famine and illness, insects, and blights. They pray for good crops, for a peaceful and prosperous life, and for their brightest children to go to universities. Admission to universities is very competitive, and the process is especially difficult for young people educated in areas remote from Vietnam's major cities.

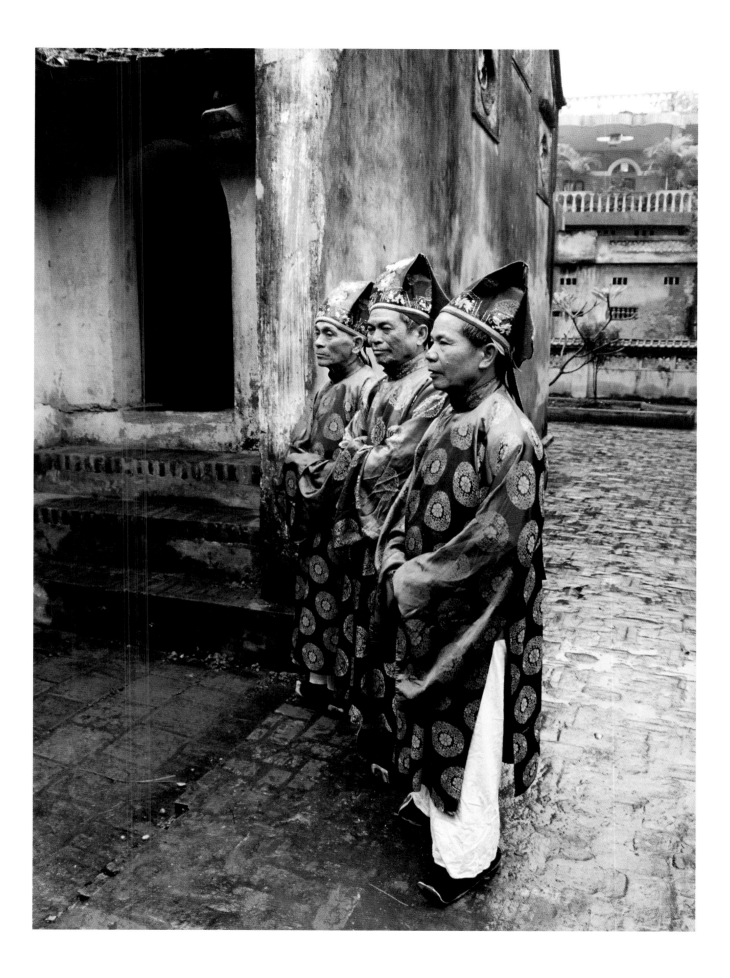

Near the town of Hoa Binh, children of the Zao tribe pose on the porch of a one-room school built by private contributions from Australia. Despite a new and spacious schoolhouse, it is difficult to attract teachers to this isolated region, where salaries are low and life is decidedly uneventful.

This tiny hamlet in Hoa Binh Province, three hours by car southwest of Hanoi, is inhabited by the Zao, one small group among the fifty-four ethnic minorities within the borders of Vietnam. The Vietnamese government prides itself on its generous and progressive attitudes toward all ethnic minorities, which make up more than 14 percent of the national legislature; this is 2 percent higher than would be called for by their actual percentage in the population.

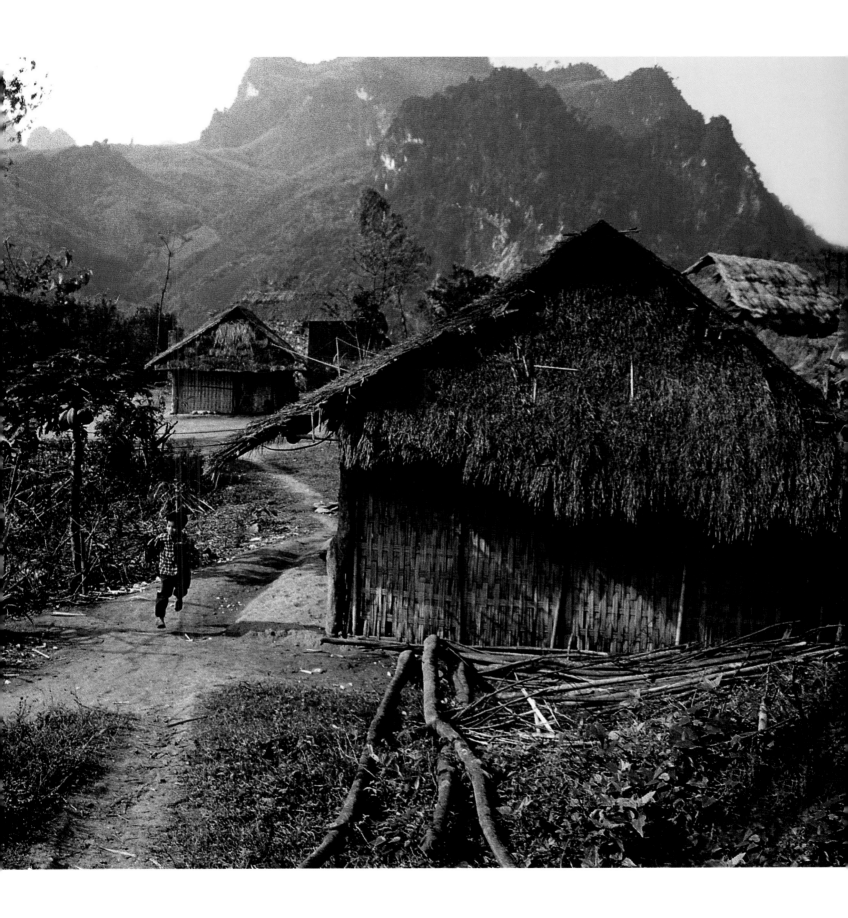

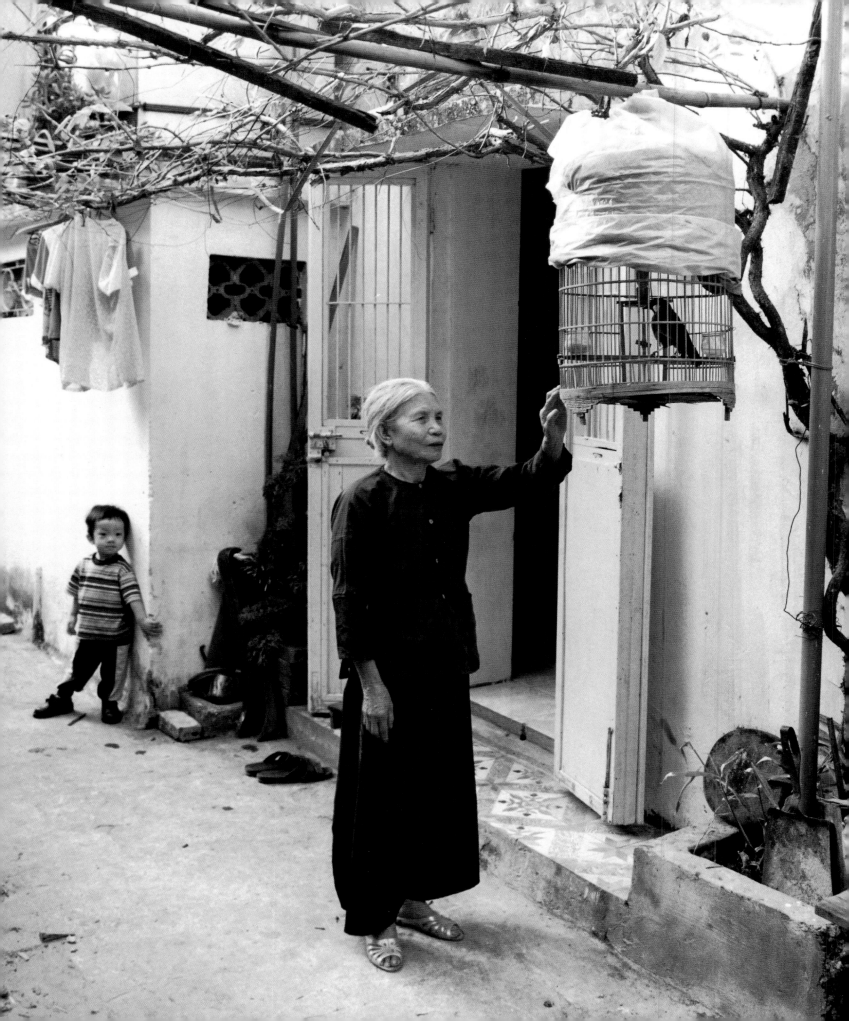

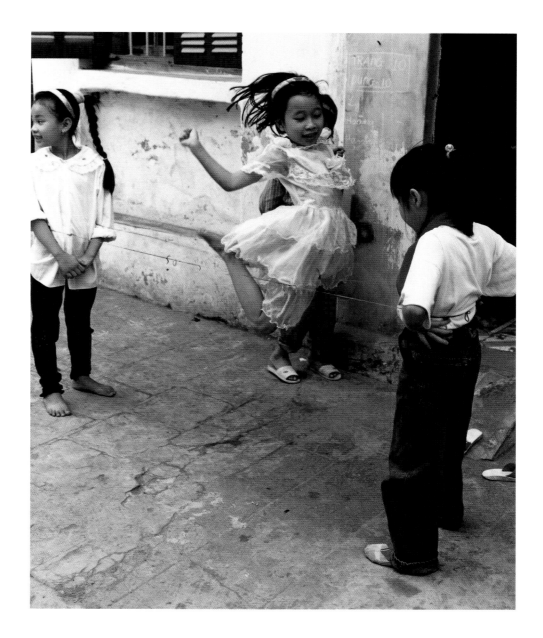

At 44 Hang Cot Street in overcrowded Hanoi, Ba Nguyen Thi, age eighty-one, visits a neighbor's pet. These sunny courtyards filled with plants and birds belie the fact that the living quarters for 90 percent of Hanoi's growing population border on the intolerable. Sanitation conditions are woefully inadequate. Seven or eight families often share a dark, tiny kitchen, and sometimes as many as thirty or forty people may have to share toilet facilities.

Both feet off the ground, she is flying! Joy suffuses the face of this ten-year-old girl. Street-corner high jumping is a favorite sport among boys and girls all over Vietnam. In many Vietnamese neighborhoods, one can see lengths of rope or string that are raised higher and higher as the young hopefuls train informally for the Olympics.

Central Vietnam

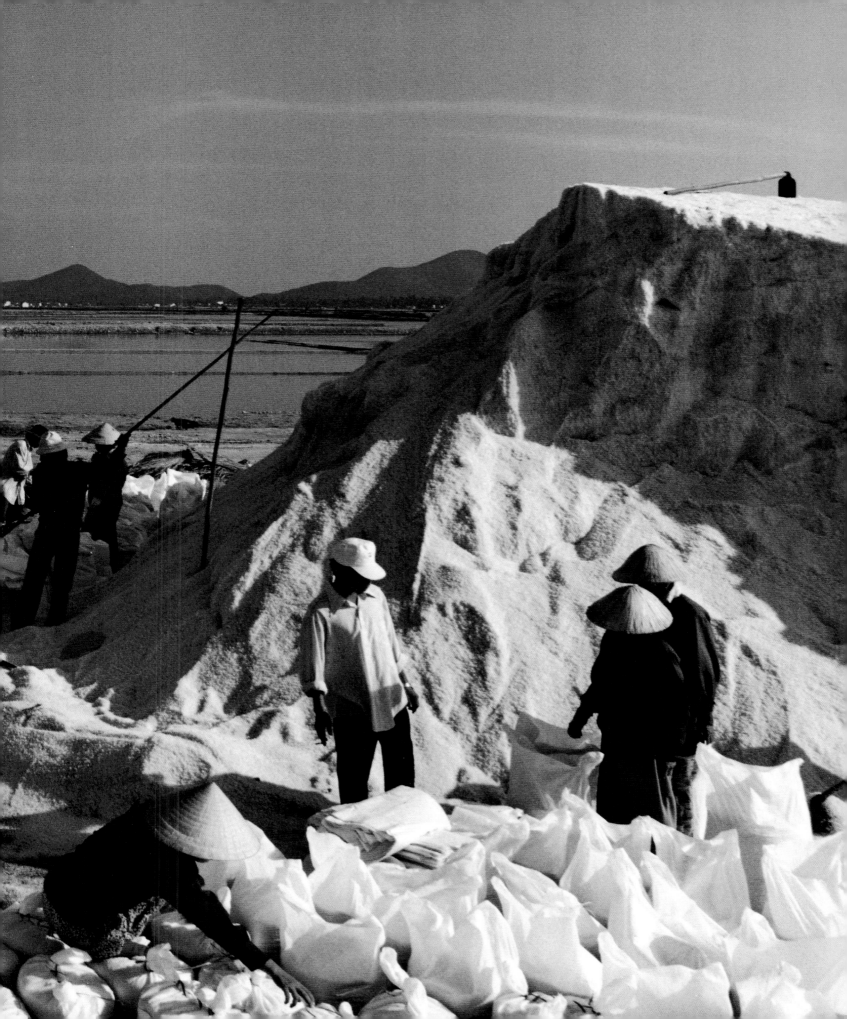

Hon Khoi salt works. The towering mountain of sea salt was built by the backbreaking toil of one hundred women who raked salt for 90 cents (U.S.) a day for four months. Each year from February through May the scorching sun evaporates water from the salt flats of Hon Khoi in central Vietnam, leaving large deposits of crisp, sparkling white crystals. In November, when a cargo ship docks at the tiny colonial port, the same workers return to fill thousands of 50-kilogram (110-pound) bags with the valuable commodity, which is then loaded onto trucks and transferred to a cargo ship. Considered to be of excellent quality, the salt will be sold all over Vietnam.

In Lang Co lagoon fishing village, at the foot of Hai Van Pass, between Hue and Da Nang, a satisfied smoker, who rolls her own, has no intention of giving up tobacco. Turquoise and purple plastic rain capes are to be found in small villages and markets throughout Vietnam.

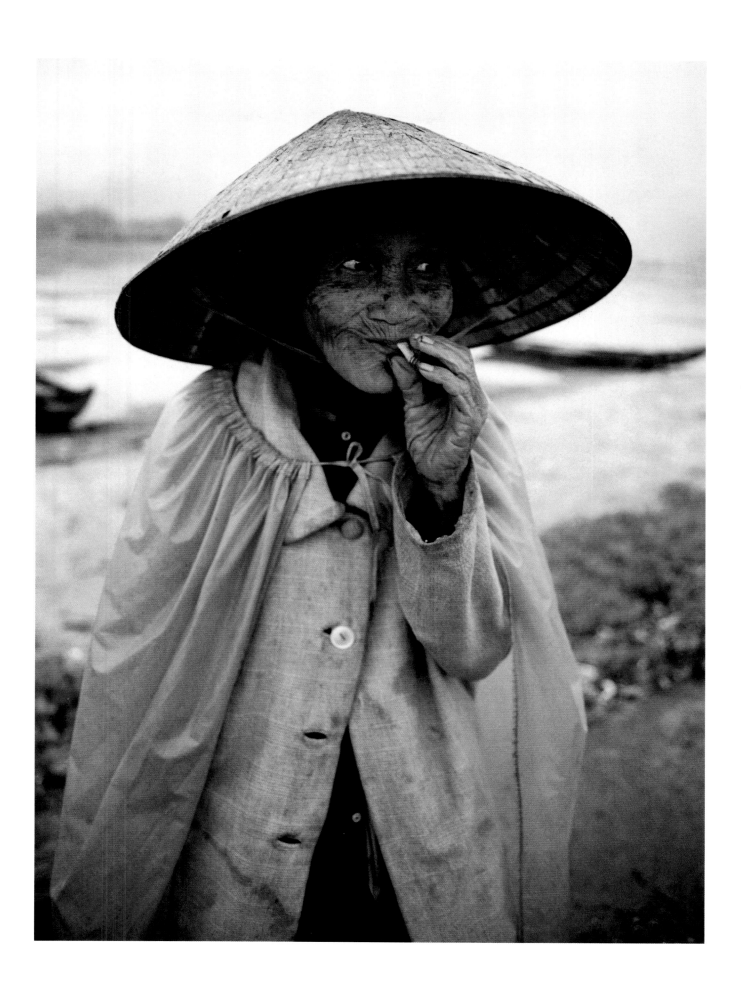

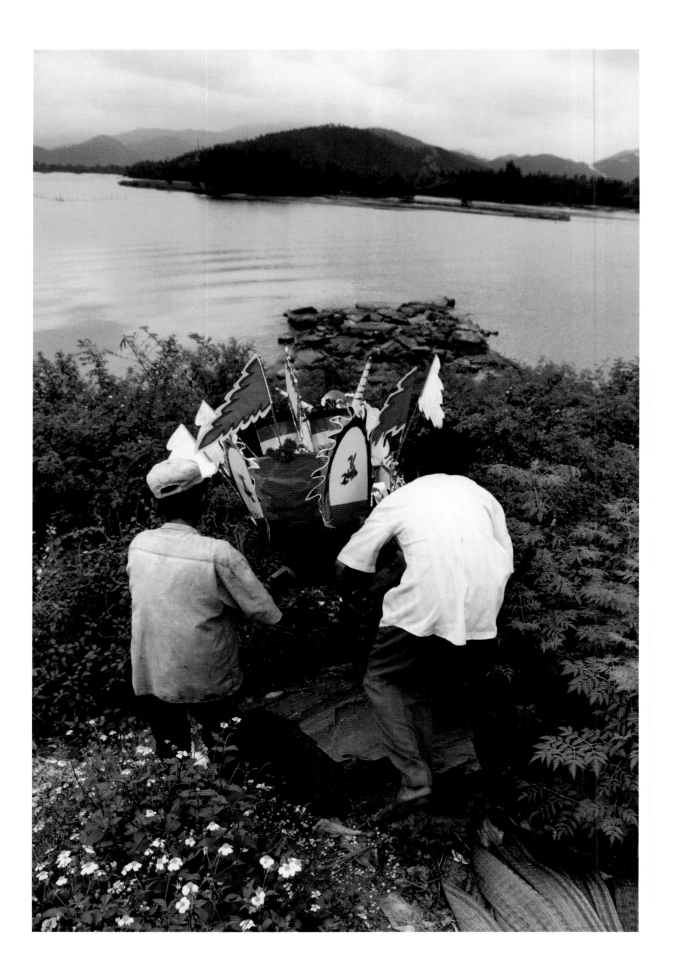

In March, a few weeks after the start of the lunar new year, a solemn religious ceremony takes place in a small fishing village at Can Hai along Highway 1 between Da Nang and Hue. A procession of fishermen marches along the shoulder of the road beating gongs and drums. Two lead fishermen carry a large paper dragon boat along the road and down a grassy hill. The boat will be launched from a rocky peninsula that juts out into Can Hai lagoon. The villagers pray for a good catch of fish and for calm seas, good weather, and abundance for all. Gentle winds and currents carry the boat into quiet lagoon waters, where it will be blessed by the deities of the oceans and the spirits of prosperity and bounty. Eventually the paper boat will disappear into the South China Sea.

Television aerials are a familiar sight in this floating village near Hon Khoi in central Vietnam. A favorite American television rerun is *Little House on the Prairie*. Each floating house has several small boats tied alongside. The little boats enable the house-holders to fish, go to market, and take their children ashore to attend school. The villagers are both fishermen and farmers. To supplement their income, some of the women work part of the year at the seasonally productive Hon Khoi salt works. Income in the fishing villages of central Vietnam rarely exceeds $200 (U.S.) per year. ➤

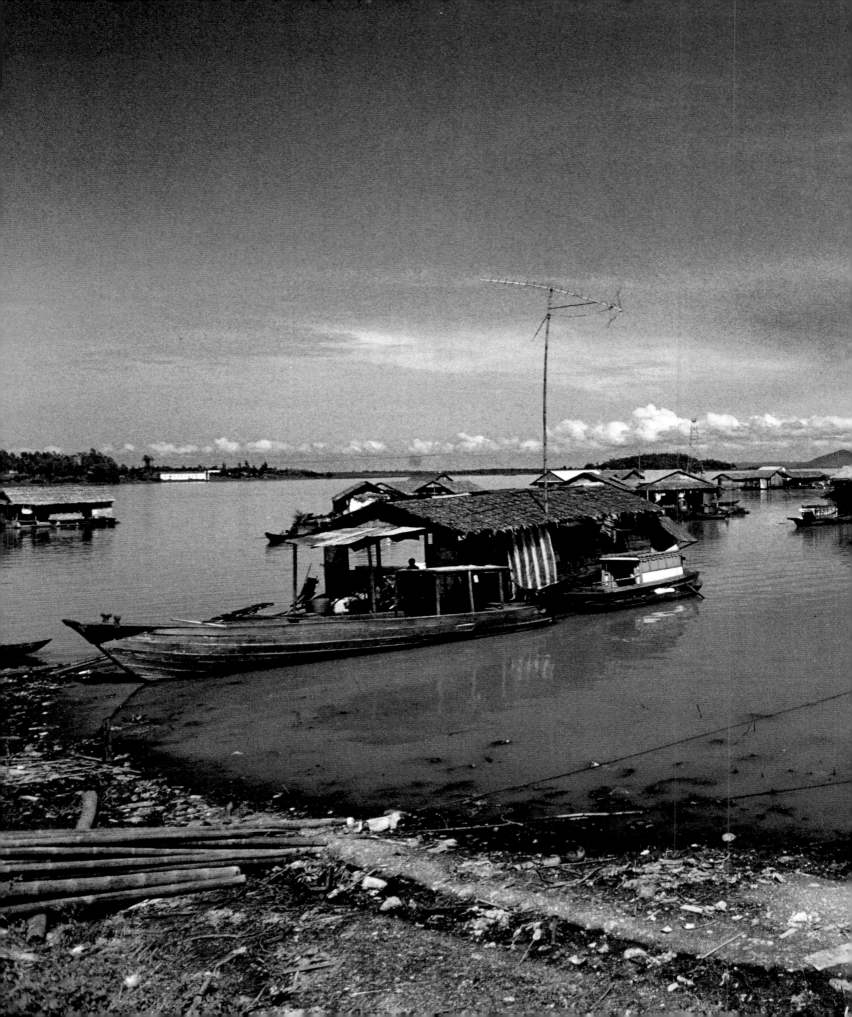

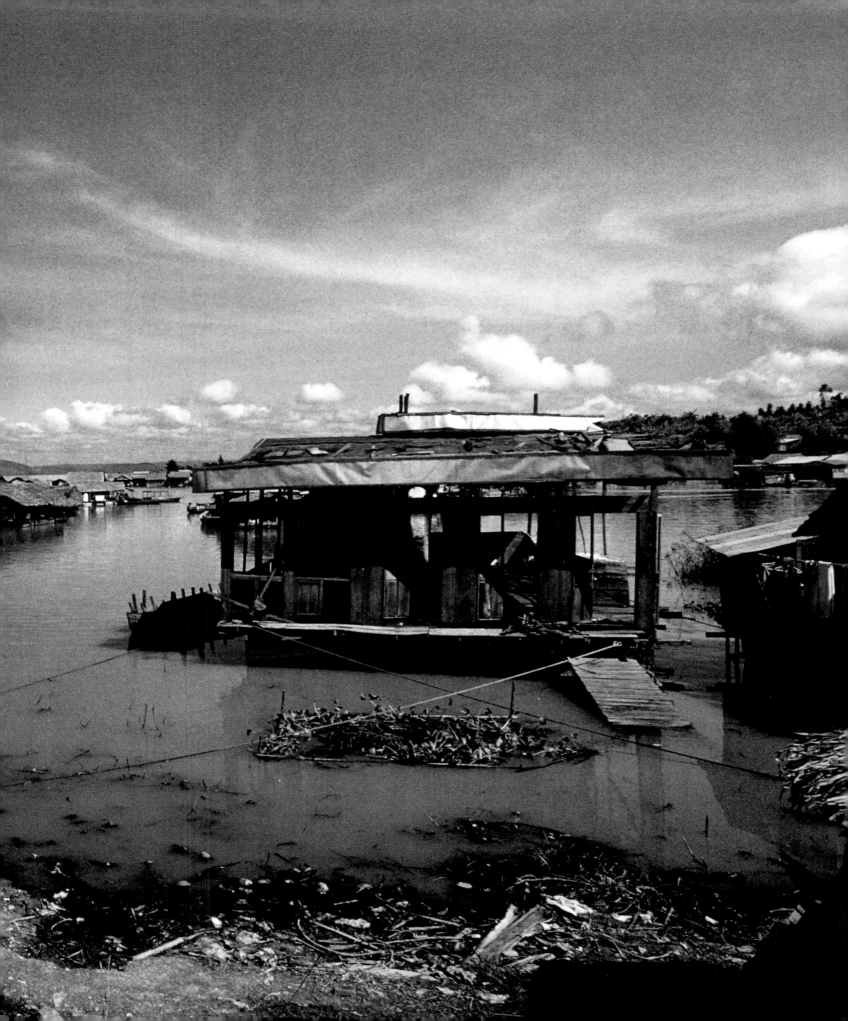

In Ban Mon village, twenty miles south of Hue, local children are engaged in their own version of kickball in the spacious courtyard of a village clan house. At the dinh, the traditional community center in Ban Mon, the first Communist Party cell in the Hue region was established in 1930.

In Hue, seemingly oblivious of his passenger, an elderly man spins along the bank on the north side of Truong Tien Bridge on his ancient Peugeot.

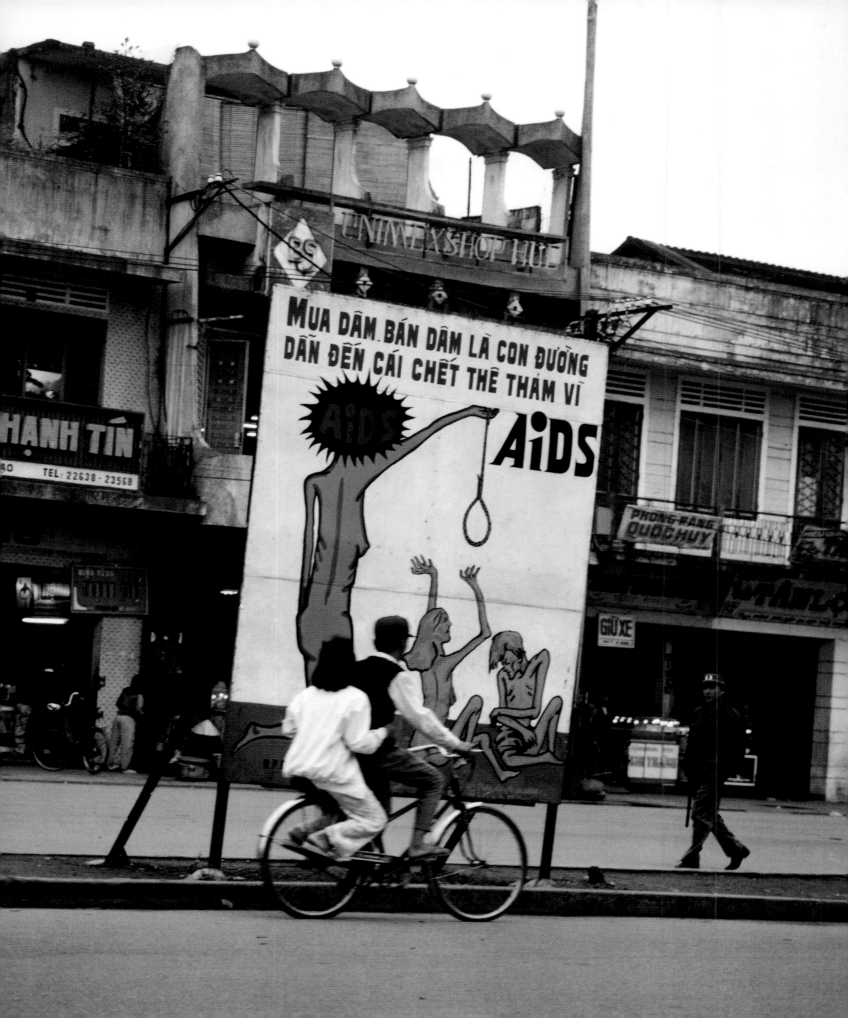

As part of a nationwide government campaign to disseminate health information, artists from municipalities across the land have been commissioned to design health and informational posters to encourage breast feeding, family planning, and immunizations and to fight the emerging scourge of AIDS, which is beginning to spread, especially in Ho Chi Minh City.

This propaganda poster in Hue is a relic of the 1980s, when the Soviet Union and Vietnam were staunch allies. It depicts a soldier, a nurse, a factory worker, and an engineer all unified in their struggle for economic progress. Behind them stand both a bridge and a factory whose stacks belch smoke. The Soviet and Vietnamese flags billowing forth together were symbols of pride and solidarity until the Russians pulled out most of their economic support in the late 1980s.

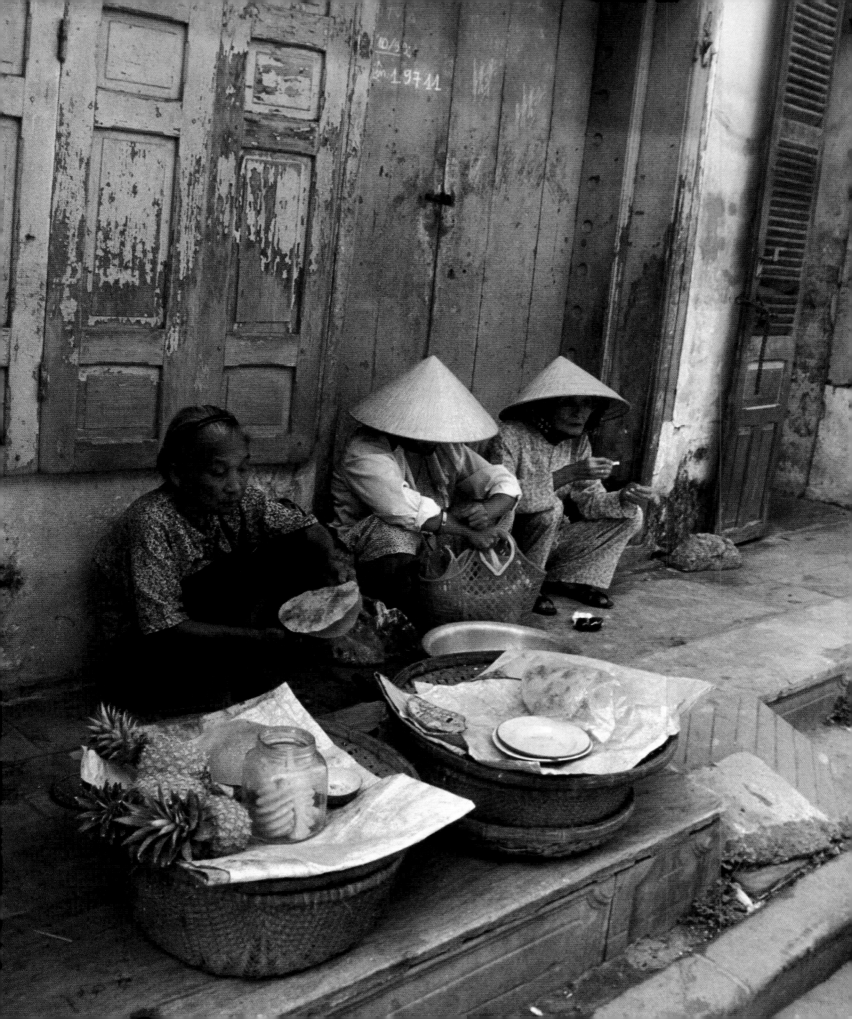

Three elderly women selling food in the central Vietnamese coastal town of Hoi An. As a consequence of the country's long years of war, the older generation in Vietnam has a much greater number of women than men.

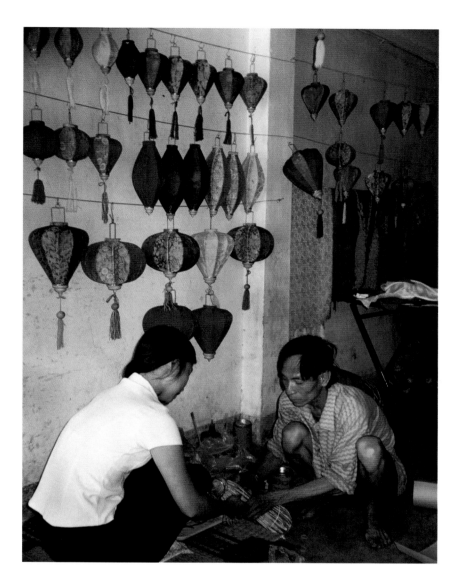

A booming cottage industry produces these delicate handmade silk lanterns. They are created by the meticulous labor of eighteen families in the riverside town of Hoi An, south of Da Nang. The art of lantern making has been actively revived in the last five years due to an increase in tourism.

The custom of hanging lanterns reaches far back into the history of both Vietnam and China. For special festivals the Hoi An town council encourages citizens to turn off all other lights and hang lanterns in front of their houses. On the fourteenth night of the second lunar month the ancient streets are illuminated only by the warm light of colored lanterns.

Untouched by American bombers, Hoi An contains an important collection of architectural treasures, particularly wooden buildings from the seventeenth, eighteenth, and nineteenth centuries. It was once a major trading port on the South China Sea coast of central Vietnam.

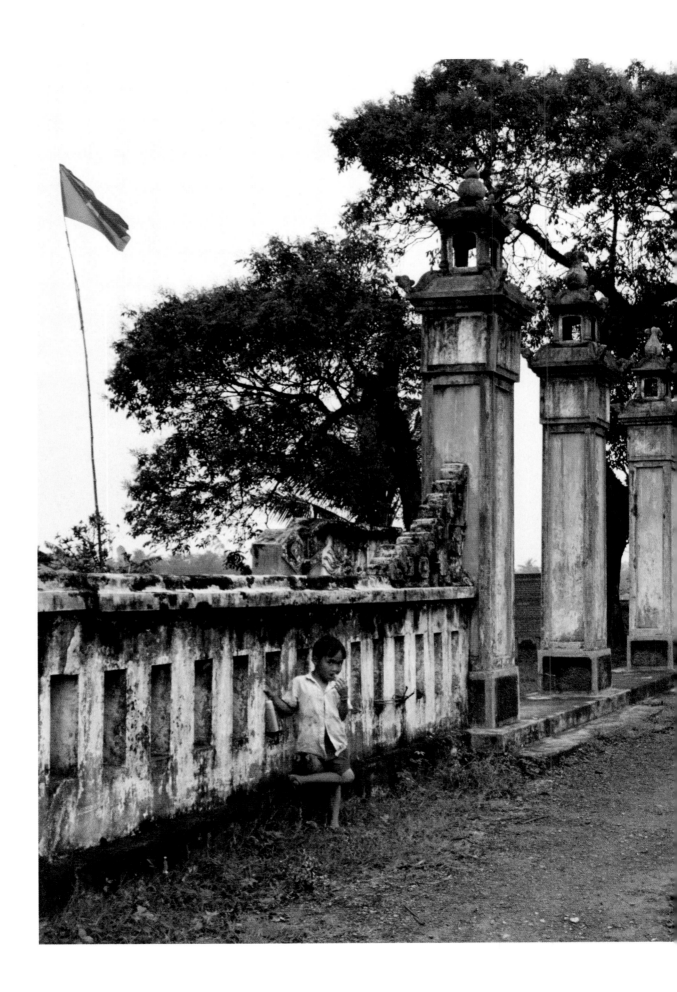

A harvester of bamboo passes the gate of a clan house complex near Ban Mon village, Phu Loc district, central Vietnam.

In Vietnam clans are made up of descendants of kinsmen evolving through the father's paternal bloodline. Lineage halls are built (always in a traditional Chinese-type architectural style) to honor ancestors going back several generations. Lineage halls are still being built today in northern and central Vietnam.

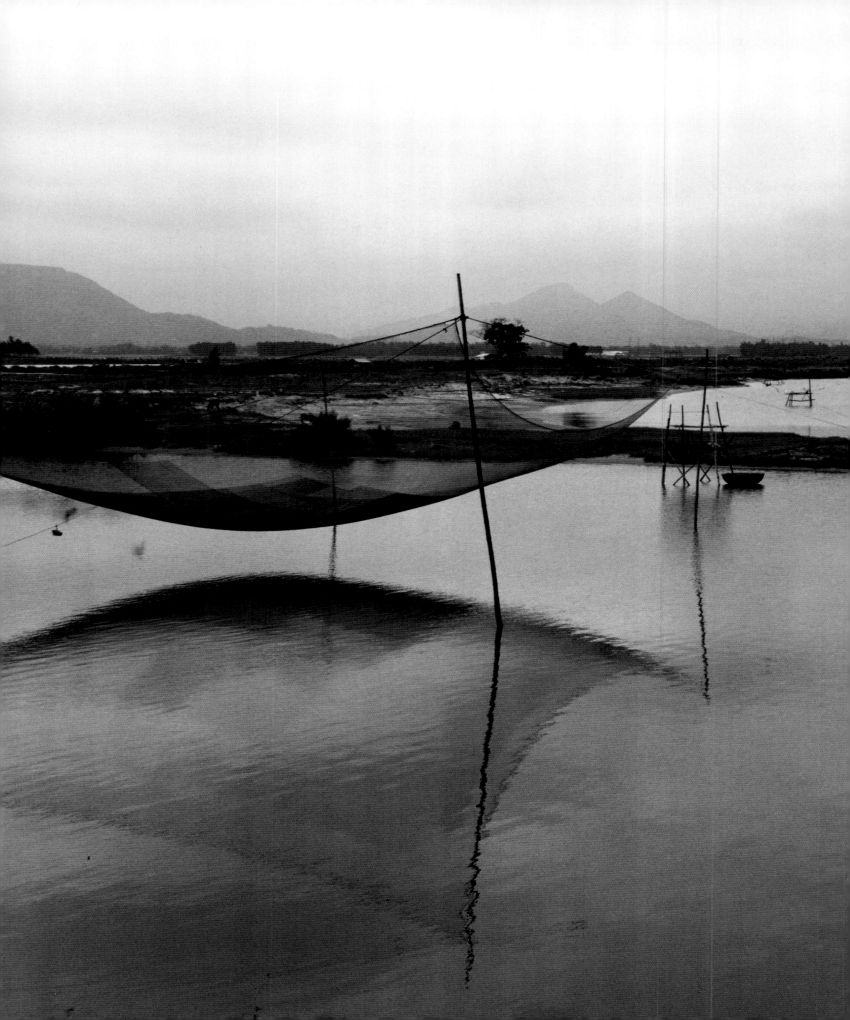

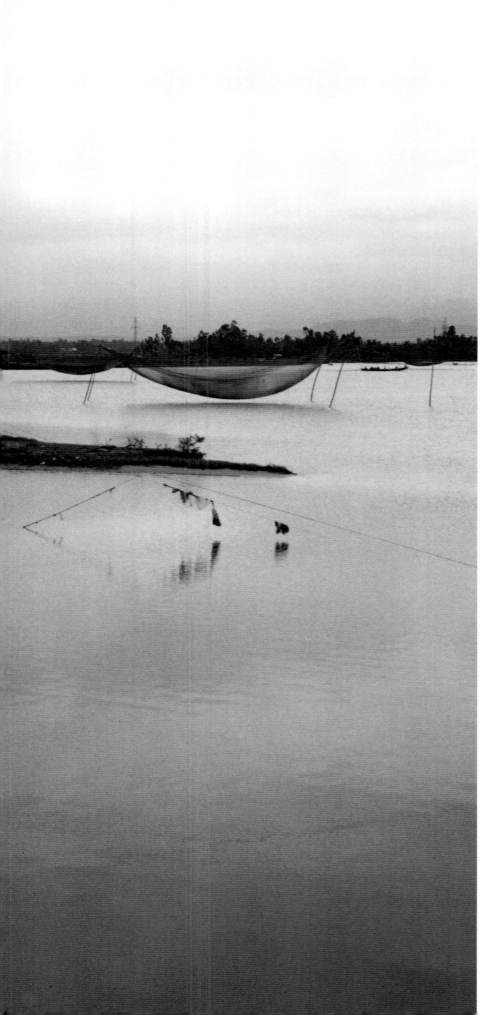

Fishing with giant nets made of nylon and bamboo can provide a meager supplementary income for rice farmers. The tide runs into the narrow river near Nam O Bridge. The net is controlled by a man who perches on a tiny bamboo stand. His wife will come out in a round woven basket boat to collect the catch of small freshwater fish.

Nam O Bridge is eleven miles north of Da Nang near Red Beach II, where the first U.S. marines landed in Vietnam, on March 8, 1965.

Nha Trang is the capital of Khanh Hoa Province. The beaches edging this section of the South China Sea attract ordinary Vietnamese tourists and wealthy Vietnamese businessmen, who own elegant resort homes along the coast.

Shown moored in Nha Trang harbor is a fishing fleet of trawlers and junks whose painted eyes protect them against sea serpents. The fishermen bring in profitable catches of lobsters, prawns, scallops, and mackerel. ➤

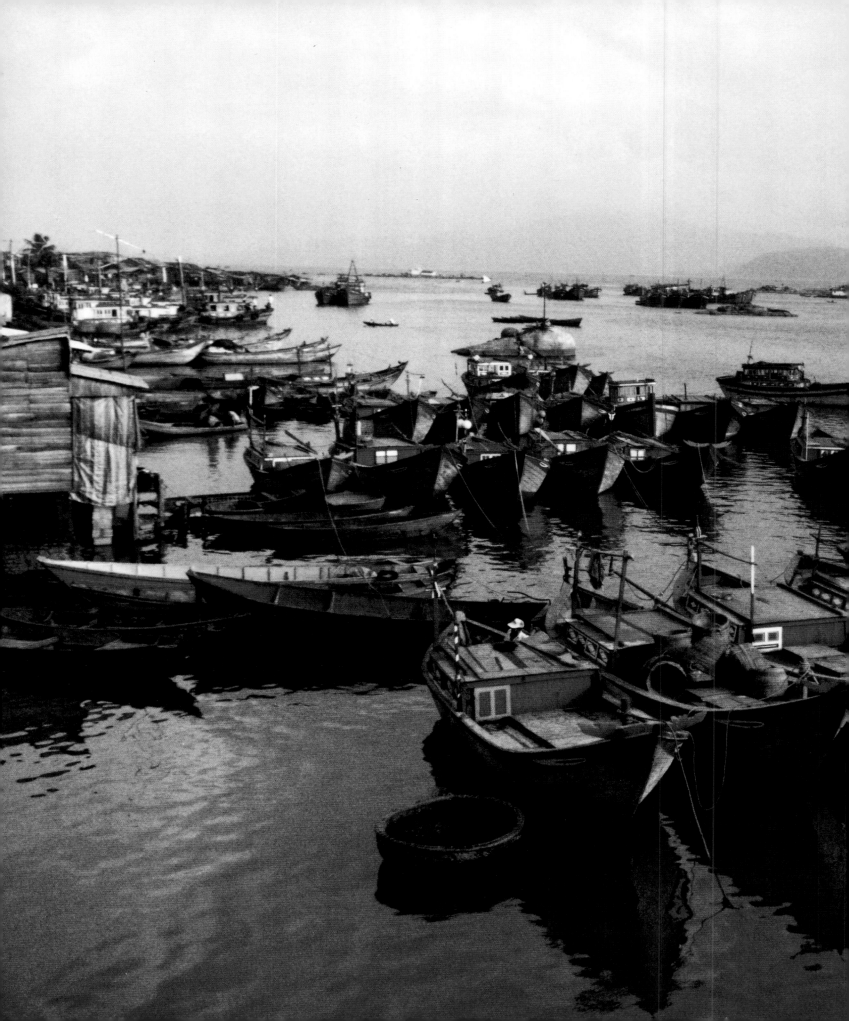

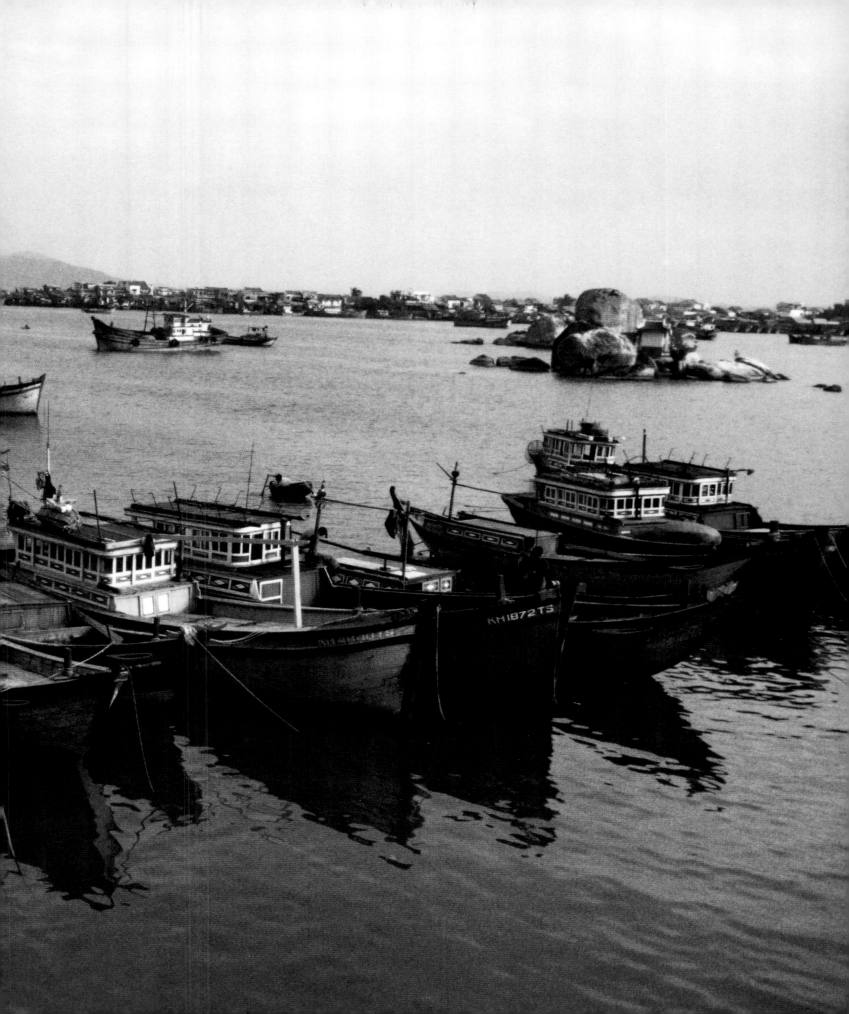

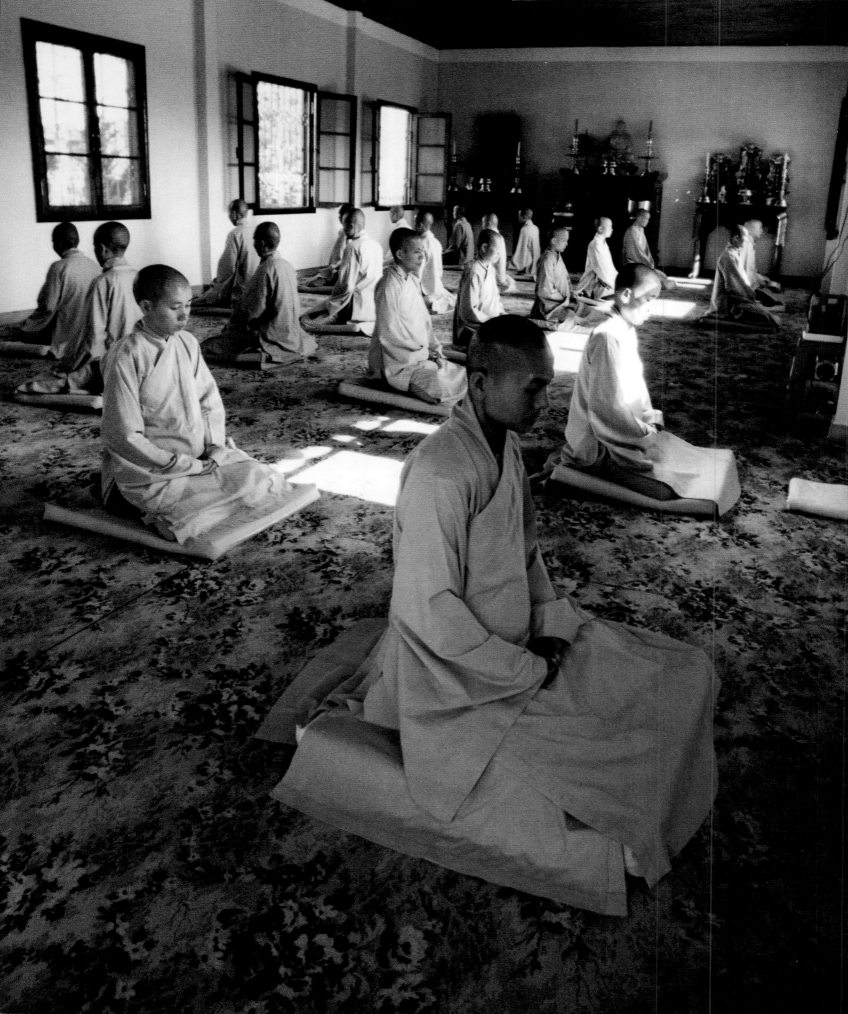

Outside Dalat, a hill town in Vietnam's Central Highlands, at the Zen Institute of Truc Lam, forty Buddhist nuns meditate for a total of six hours a day, two hours at a time, legs crossed, eyes closed, never moving.

During this, their second meditation period, the warm afternoon sun washes over them, but they must concentrate solely on their inner consciousness. The motto of the nunnery is "Look back into the self." Between meditations the nuns work in the flower and vegetable gardens, prepare food, and pray.

Buddhist nuns take vows of commitment to their faith and to their monastic community. These nuns will never travel into the outside world. Their boundaries are here. Visits from family members are allowed but are limited to thirty minutes, twice a year.

At the Tu Hieu Pagoda, north of Hue, young monks in training can be identified as novices by their gray robes as well as by their partially shaved heads. Hair signifies the link with earthly life. Adult monks who have renounced the world are completely shaved. Monks still undergoing the training process retain the option of returning to life with their families.

More than seventy monks live at the Tu Hieu Pagoda. *Tu* means "compassion," *hieu* means "filial piety." The pagoda is widely known as a teaching center of distinction and excellence and was once the home base of the well-known monk Thich Nhat Hanh, who lives and teaches in France. The scholarly monks study the teachings of the Buddha, Buddhist philosophy, and the history of Buddhism in Vietnam and abroad. In addition they learn English, mathematics, and other subjects taught in secular schools. The barefoot monks ceremonially proceed to the central altar of the monastery, offering prayers before assembling in the dining hall for their midday meal.

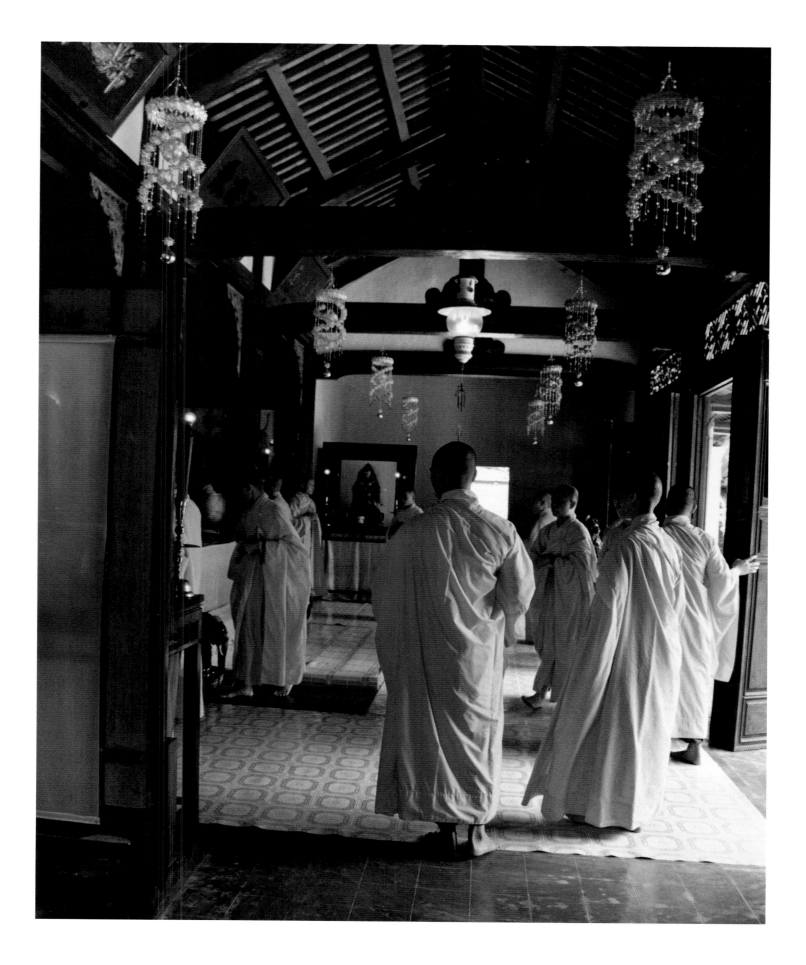

One of four Po Klong Garai Cham towers, near Phan Rang–Thap Cham, Ninh Thuan Province. Not far from the south central seacoast, these brick towers were built at the end of the thirteenth century as Hindu temples. The kingdom of Champa flourished from the second to the fifteenth centuries in central Vietnam.

The Cham are still an ethnic minority recognized by the Vietnamese government. According to the 1989 census, there were ninety-nine thousand Cham in Vietnam. Their settlements are scattered along the central coastal plain south of Da Nang.

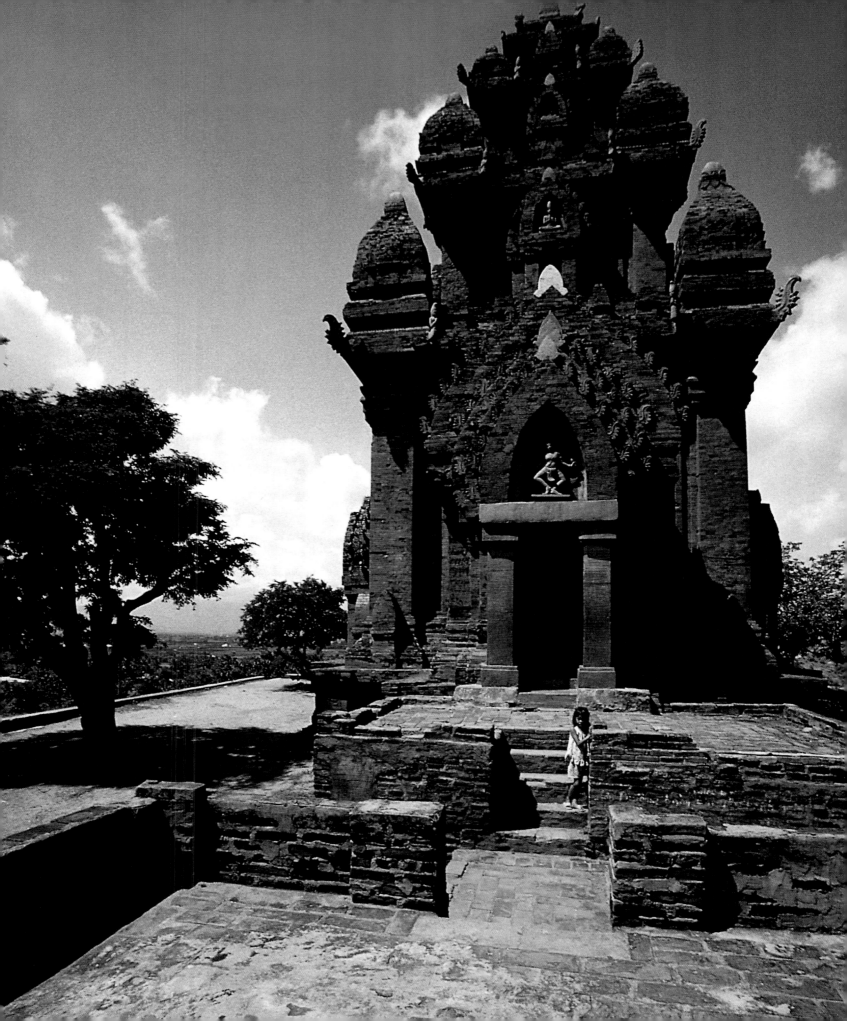

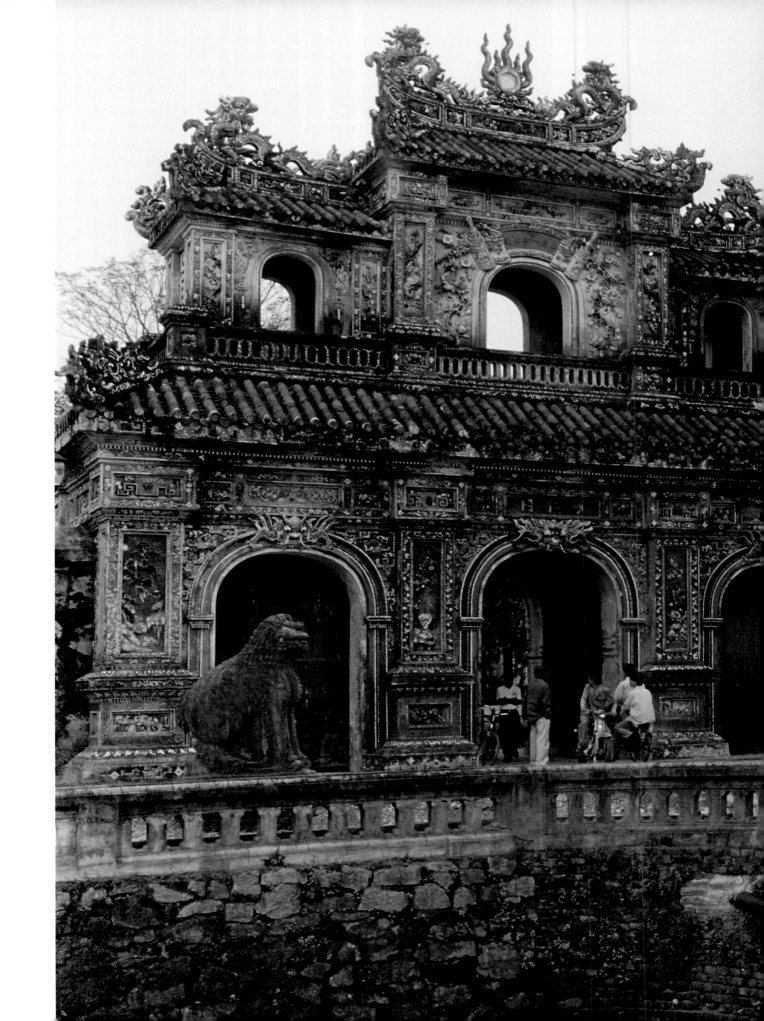

The eastern access to Hue's imperial city, the Hien Nhon Gate of the Nguyen dynasty was built in 1803. It is the most beautiful entrance to the palace complex. The gate, which survived the American war, is decorated with elaborate mosaics of glass and porcelain and flamboyant dragons inlaid with jade. On the left a solemn stone lion protects the gate from marauders.

The South

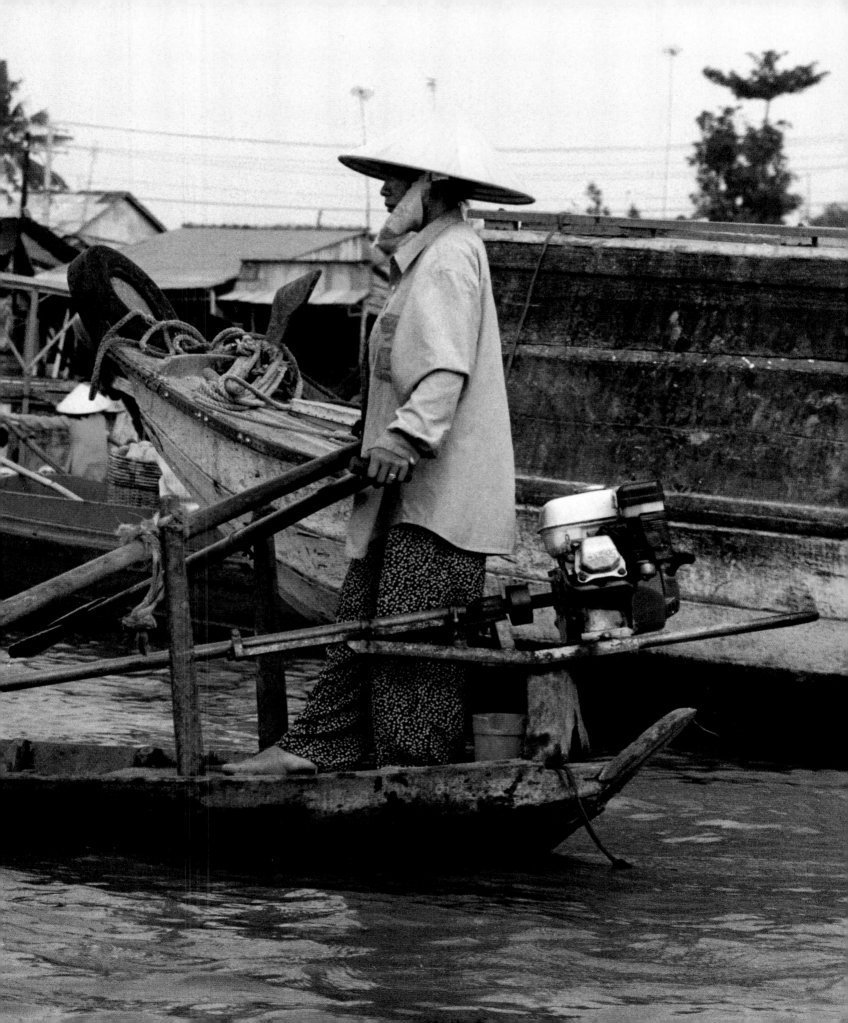

Cai Rang floating market, in Can Tho, is the largest in the Mekong Delta. To get the freshest produce it is important to arrive at Cai Rang market by 6 A.M. Boats loaded with melons, bananas, and coconuts jockey for prime space as the boatmen maneuver in and out of jumbled water traffic. Fresh baguettes and steaming hot tea are sold by separate vendors to supply customers and salespeople with a satisfying breakfast.

In the larger cities the government has permitted the Coca-Cola Company to advertise at bus stops and other urban gathering spots. A strong relationship with foreign companies will bring in capital from abroad. Foreign businesses must open an office in Hanoi before they are allowed to establish headquarters in Ho Chi Minh City, the country's business hub. Until recently all overseas business firms had to have a Vietnamese partner and had to be officially registered as joint ventures.

Pedicures cost no more than 50 cents (U.S.) in a beauty parlor near the O Mon district market of Vinh Long Province, in the Mekong Delta. This shop in such a small community becomes the center of news, gossip, and social interaction. The clients study photographs of Western models in order to be up-to-date on new trends in hair styles.

On Ho Chi Minh City's Cholon canal, thousands of families live crowded together at the water's edge. Some occupy the houseboats, whose brightly painted eyes protect them from the spirits of the sea. Others inhabit the adjacent shanties. In this Chinese community, the people live by trading and commerce.

After the American war many wealthy ethnic Chinese fled to Singapore or to Taiwan to escape having their property confiscated and their businesses crippled by the policies of the new Communist government. But since then many have returned, and today they are fueling the economic growth of the city.

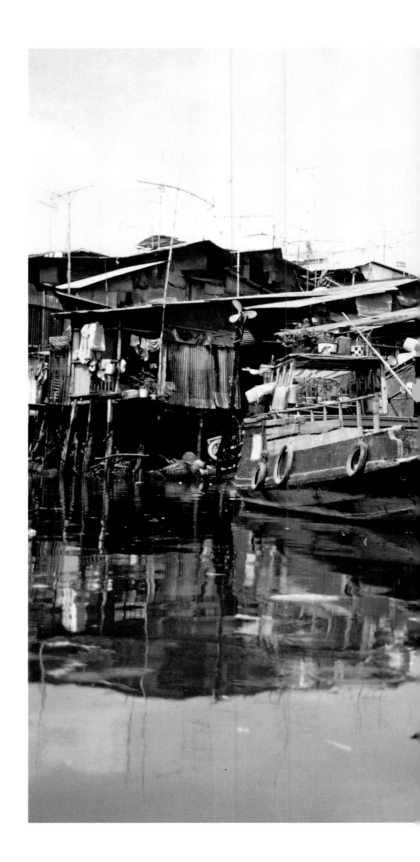

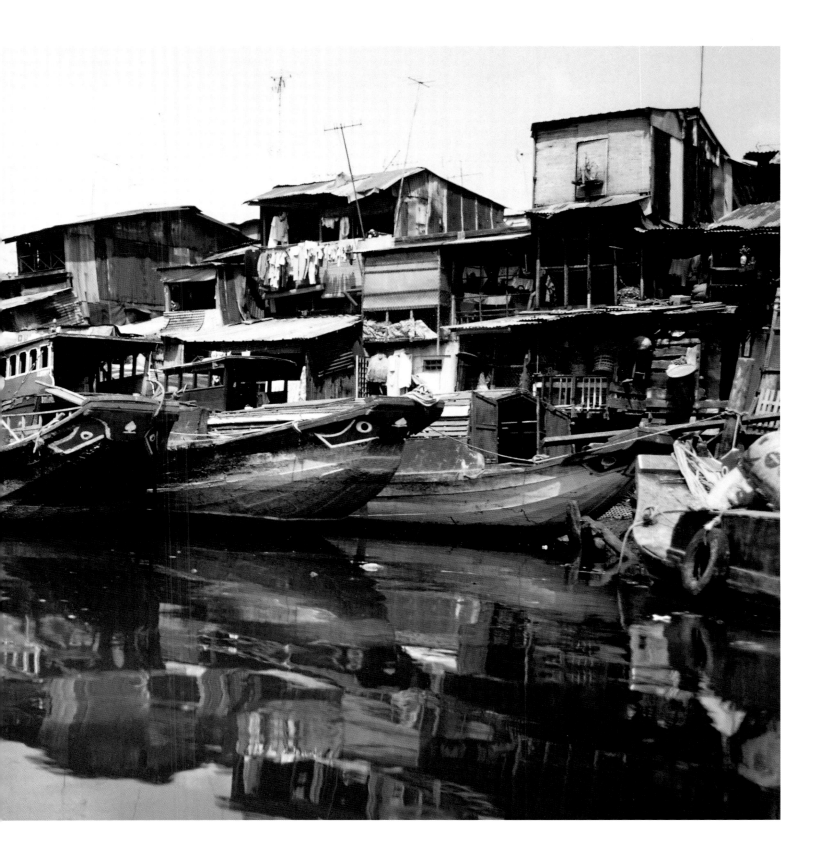

A young sugar cane seller plies her trade as she travels south on the My Thuan ferry in the Mekong Delta. The ferry connects Tien Giang Province with Vinh Long Province.

Schoolchildren in the hamlet of Binh Hoa A in the O Mon district of the Mekong Delta. It is costly to attend a "free" public school in Vietnam. The state's contribution is limited to buildings, teachers, and instruction manuals. Families who cannot afford notebooks, textbooks, uniforms, and other school necessities must often take their children out of school. Even a mysterious "construction fee" is sometimes exacted from parents. When a choice is necessary, girls are more likely to be the ones who must stay at home. The literacy rate among elementary school age girls is 6 percent lower than that for boys. Teachers' salaries are low and the quality of instruction is often poor. Nevertheless, the nation's educational policies are relatively successful. Today, 91 percent of the population over age sixteen is literate, compared with 88 percent in 1989.

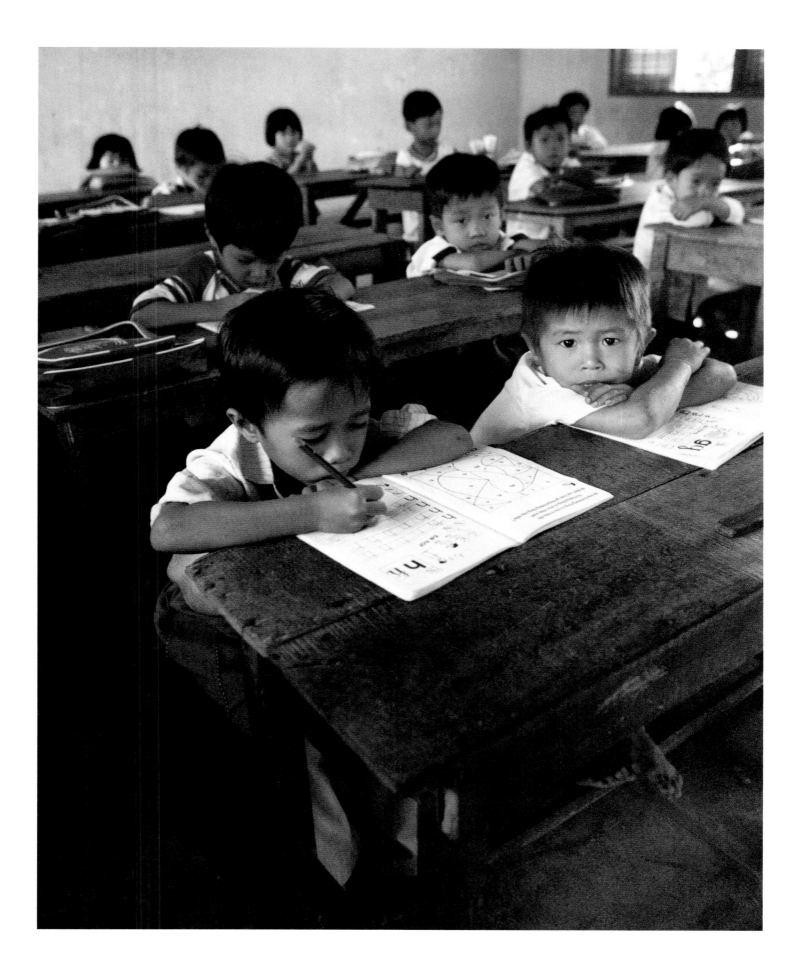

A young schoolgirl looks up from her copybook. Her family sells produce at a large market in the Mekong city of Can Tho. While she studies, her little sister sleeps suspended in a hammock overhead. Children whose families can afford the cost of school take education seriously.

Because more than 1.5 million children enter the school system each year the government can no longer afford to provide universal free education.

In Cholon, Ho Chi Minh City's bustling Chinatown, Mr. Phong owns a small barber and beauty shop (*hot toc*). The sign advertises haircutting, hairdressing, curling, dyeing, washing, and drying. Cholon was settled in the latter part of the eighteenth century by Chinese merchants. The word means "big market." A successful and financially active Hoa populace (Vietnamese of Chinese origin) fills the crowded area of town, energetically selling a wide variety of products, from cell phones to pineapples to silk yard goods. Shop signs all over Cholon are written in both Vietnamese and Chinese. Cholon has a population of half a million Hoas. Their children attend Vietnamese public schools, but they also go to special classes where they are tutored in written Chinese and Chinese culture.

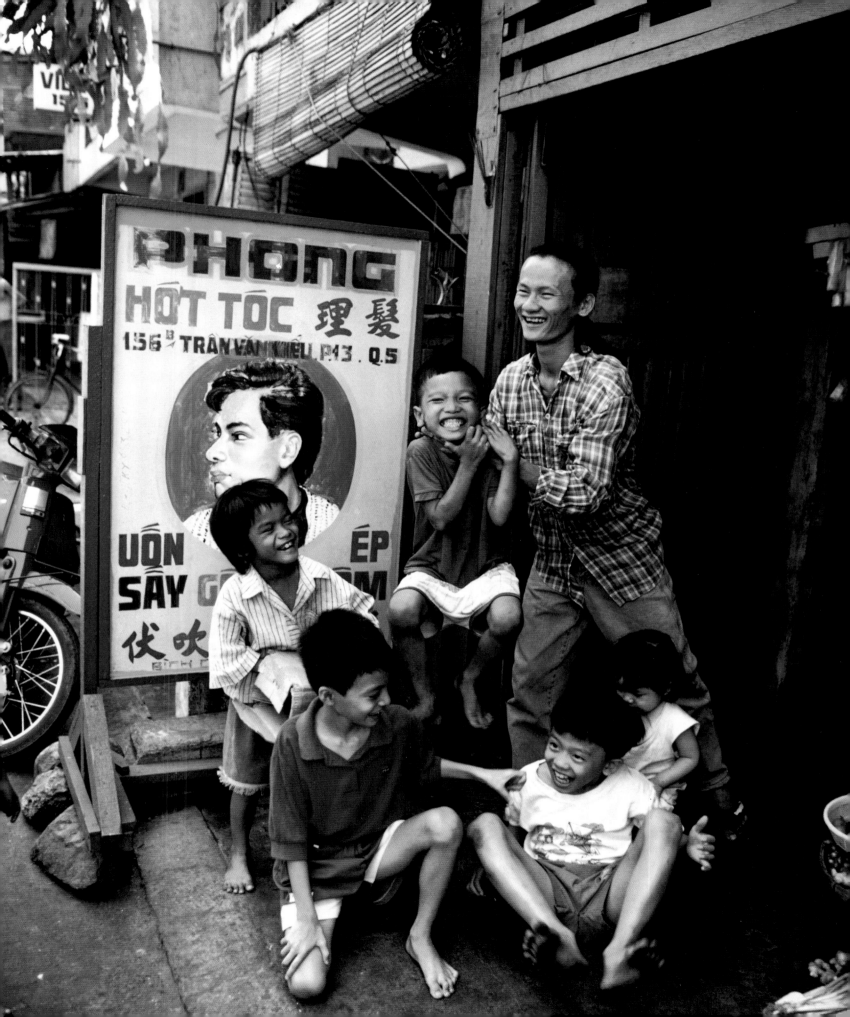

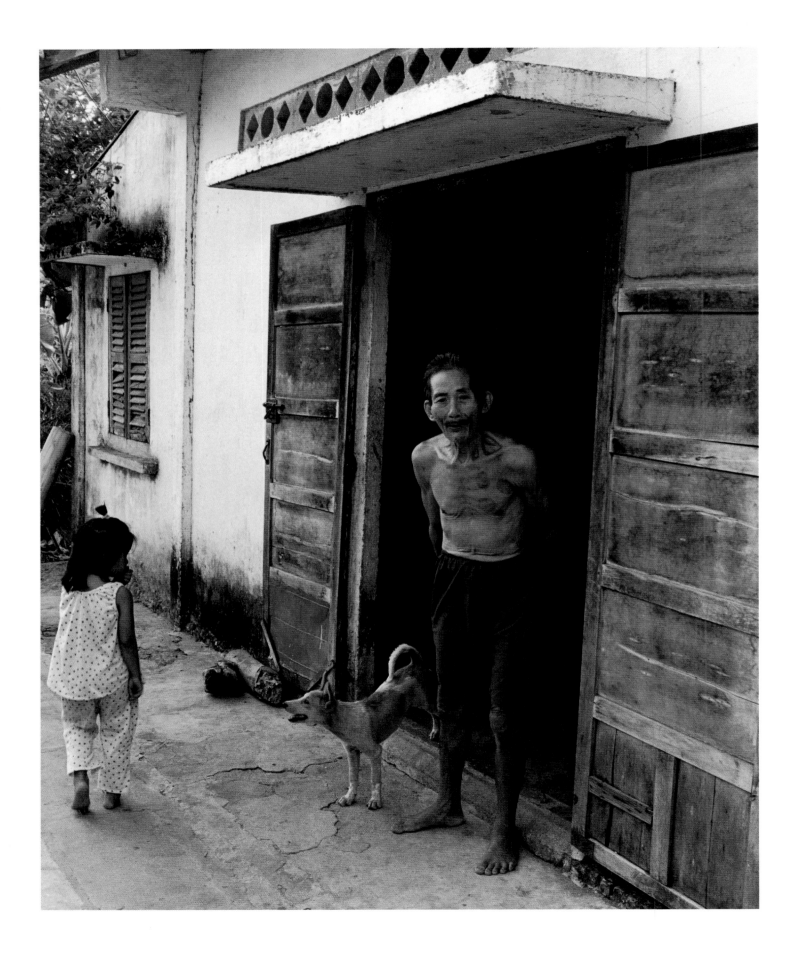

An old man who lives in Binh Hoa A hamlet, in the Mekong Delta, near the city of Can Tho. In Vietnam, life expectancy is about sixty-eight years.

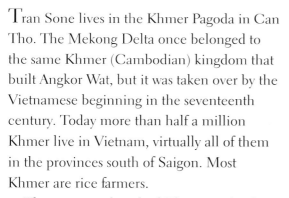

Tran Sone lives in the Khmer Pagoda in Can Tho. The Mekong Delta once belonged to the same Khmer (Cambodian) kingdom that built Angkor Wat, but it was taken over by the Vietnamese beginning in the seventeenth century. Today more than half a million Khmer live in Vietnam, virtually all of them in the provinces south of Saigon. Most Khmer are rice farmers.

There are two hundred Khmer in the Can Tho area. Because local Khmer children are educated at Vietnamese schools, as generations pass they tend to forget the language and traditions of their ancestors. Each Saturday a few Khmer children come to the pagoda to be tutored by the Khmer monks.

The stone window behind the monk depicts the eight paths necessary to overcome suffering according to the Khmer tradition of Theravada Buddhism.

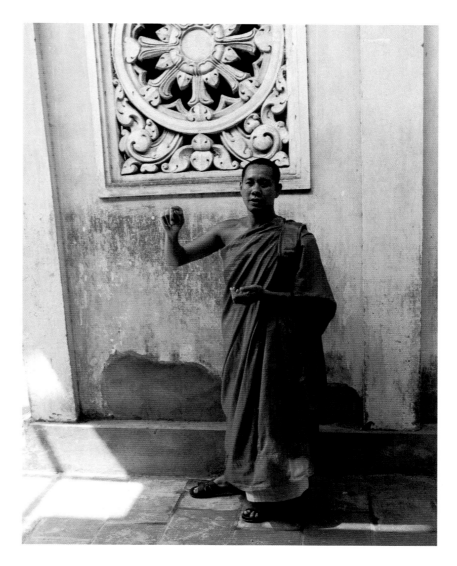

The house and rice fields of Mr. Phan Van Hoang are located in the hamlet of Binh Hoa A, in the Mekong Delta. By Vietnamese standards Mr. Hoang is well-to-do. He is a good farmer and hardworking. He owns one *mau* of land (nine-tenths of an acre), given to him by his father. He and his wife and two children own a new, airy house with several rooms. By Western standards, life for this family is not so easy. They have no indoor plumbing and the wife washes dishes in the stream next to the house.

Sharing a bike, two teenage schoolgirls ride home to the hamlet of Bin Hoa A from their junior high school in Phouc Thoi, several miles away. The red neckerchief signifies membership in the Young Pioneers, a socialist youth group. The girls find it hilarious to see foreigners in their neighborhood.

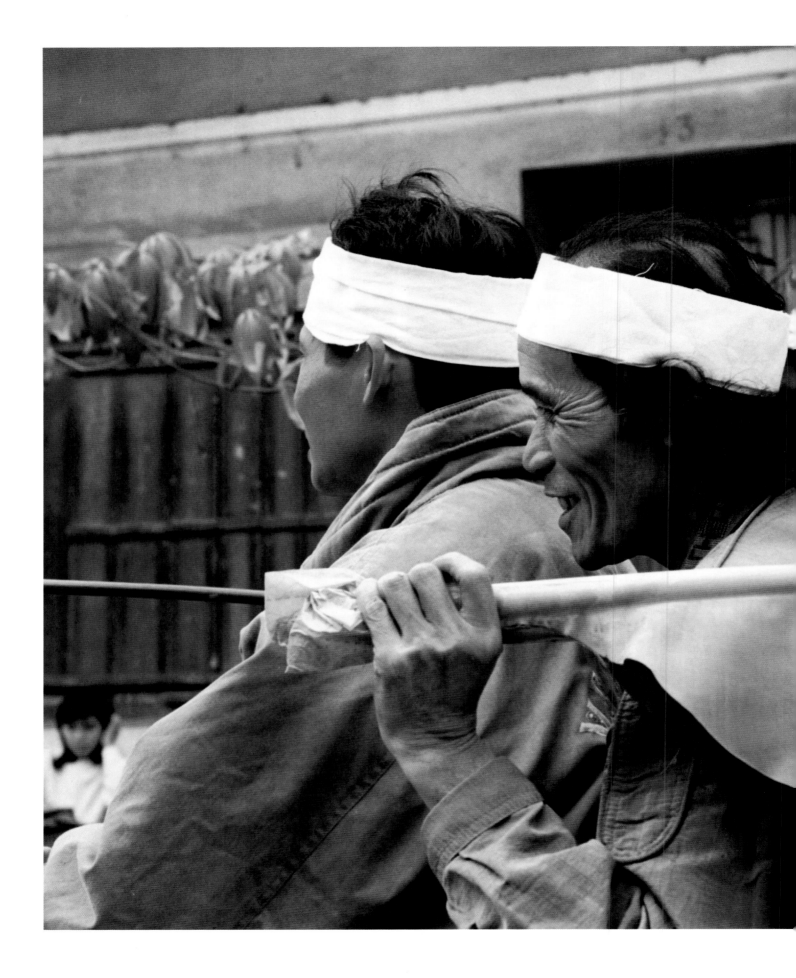

Two brothers, their heads girded in white bands signifying mourning, race their motorbike through the Saigon streets. They are grasping huge banana fronds and are on their way to their father's funeral, which will be held in the countryside, about twelve miles outside the city.

The sign on the building in the background advertises the repairing and overhauling of motorcycles, and it promises the work to be durable and technically guaranteed.

In Cholon, Ho Chi Minh City's populous Chinese quarter, a funeral steeped in ancient tradition takes place in a vast funeral hall owned and administered by the Chinese Buddhist community.

Robed in white, the four grieving children of the deceased kneel before their father's bier. His photograph is prominently displayed on the altar. The headbands made of straw signify submission and helplessness before the esteemed parent. Facing the magnitude of a parent's death, everything must be stripped down to the essence of life.

Three lacquered roast pigs (not shown) and bowls of apples are placed on the altar. After the father's burial, the offerings will form part of a celebratory funeral feast. ➤

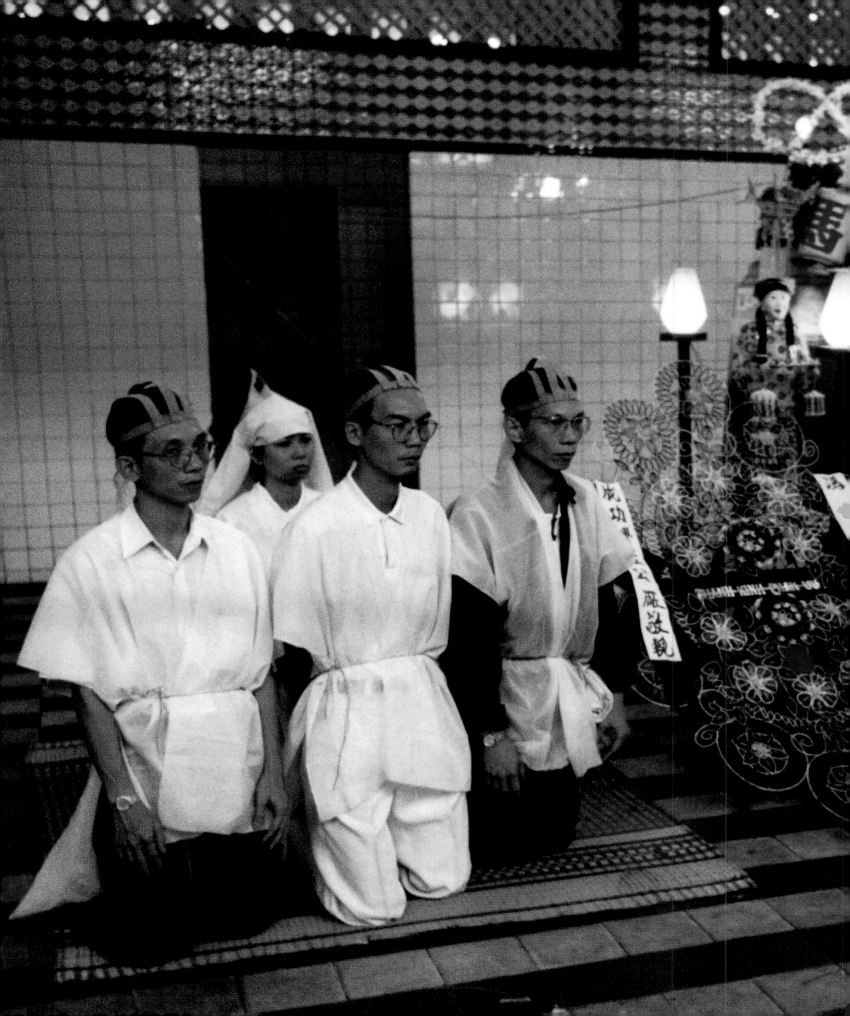

Throughout the Mekong Delta, farming families who live along the hundreds of small rivers can do their shopping by patronizing the melon man or the freshwater fisherman. These vendors, who work from small boats, stop in front of the houses of their regular customers. In the O Mon district of Vinh Long Province the countryside is crisscrossed by hundreds of waterways. Agriculture, particularly rice farming, continues to be the primary way of life because the Mekong Delta is ideal for rice growing. It is the granary of Vietnam and the reason Vietnam is the third largest rice exporter in the world.

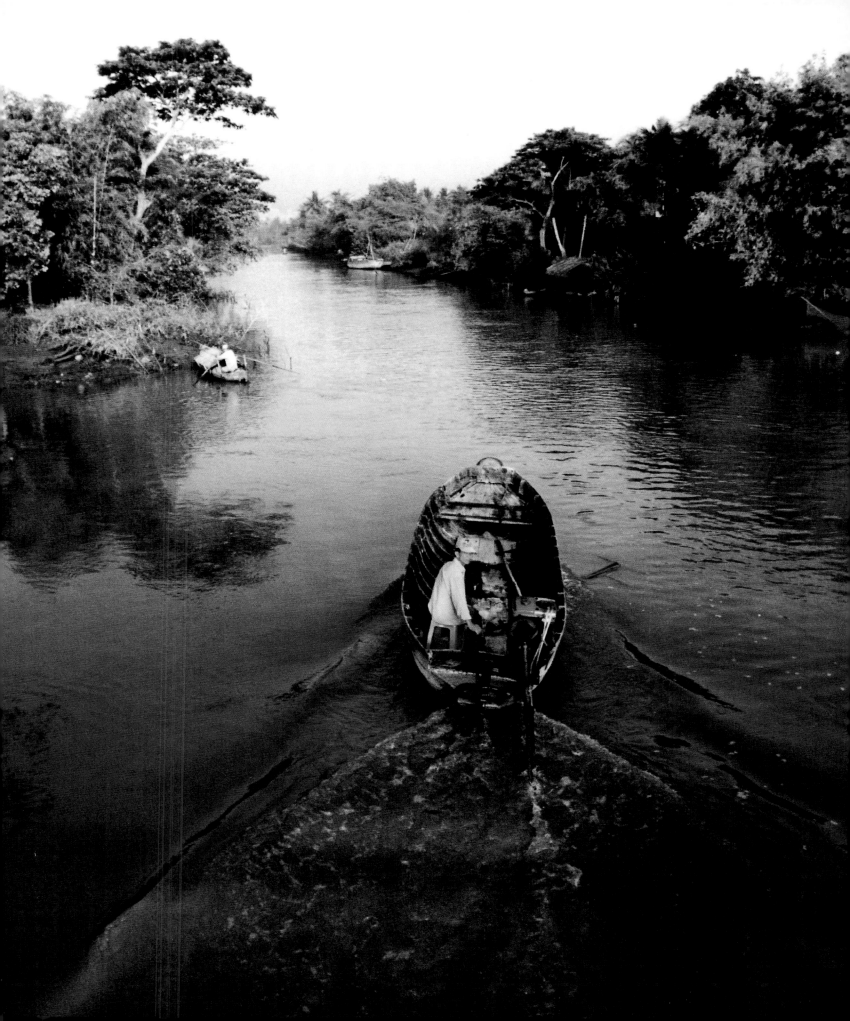

The exuberantly designed Vinh Trang Pagoda is in My Tho, a city in the upper Mekong Delta. The pagoda, built in 1849 by a monk from Hue, is, like all Vietnamese pagodas, Mahayana Buddhist. The builders of the pagoda allowed their imaginations free rein in their choice of ornamentation. The colors and the elaborate "wedding cake" turrets, finials, and columns are immensely popular with Vietnamese tourists and pilgrims. Contributions from busloads of visitors support many of the smaller pagodas in Tien Giang Province.

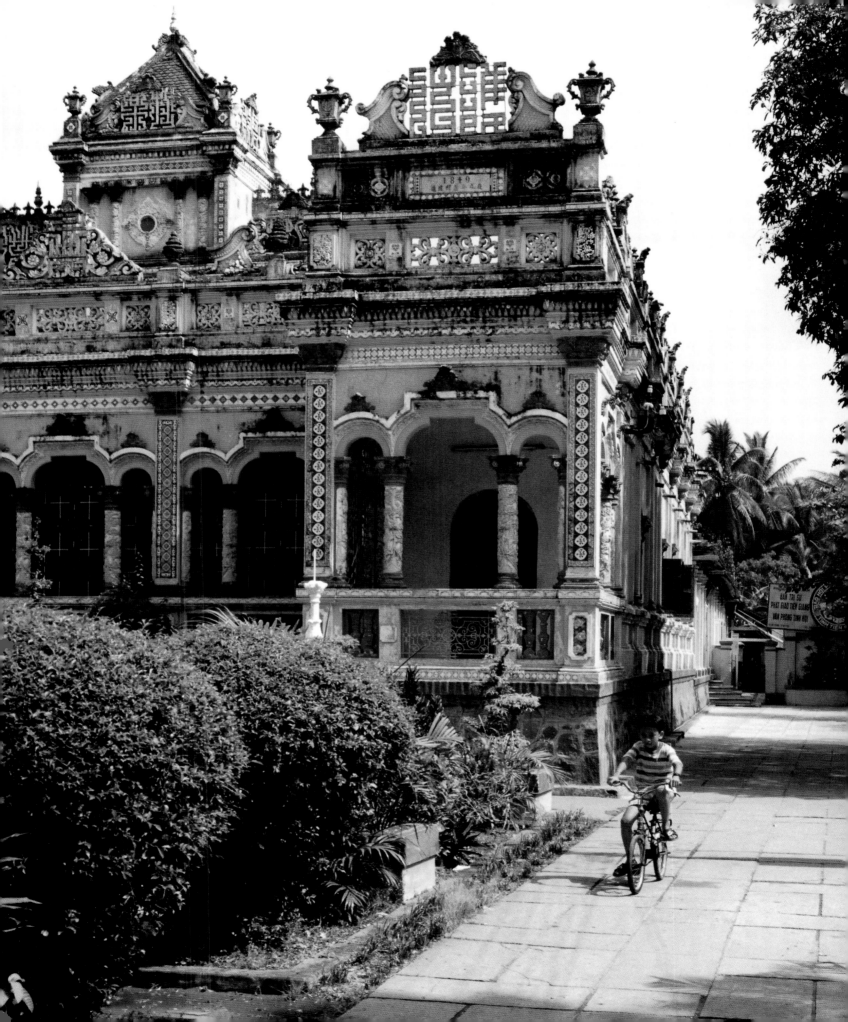

The wrought-iron lotus motif at the Vinh Trang Pagoda, thirty miles south of Ho Chi Minh City, repeats a theme familiar in Buddhist art. The lotus is a symbol of purity because it grows out of mud yet remains undefiled. In this manner, too, the Buddha was born into this world but attained enlightenment and Nirvana. Images of Buddha seated on a sacred lotus are found throughout Asia. In reverence for their master, Buddhist nuns and monks assume the lotus position when meditating.

On his way to morning prayers, a resident monk at the Vinh Trang Pagoda passes through a covered arcade. His saffron robe blends with the vivid hues of the pagoda walls. Outside stretches a lush tropical garden planted with palms, bamboo, and oleander.

Note the deer antlers on the right. The deer is believed by both Chinese and Vietnamese to live to a very great age, and thus it has become an emblem of long life. Antlers are thought to have magical properties for increasing sexual potency. They sell for as much as $250 (U.S.) a pair in the international markets of the Far East.

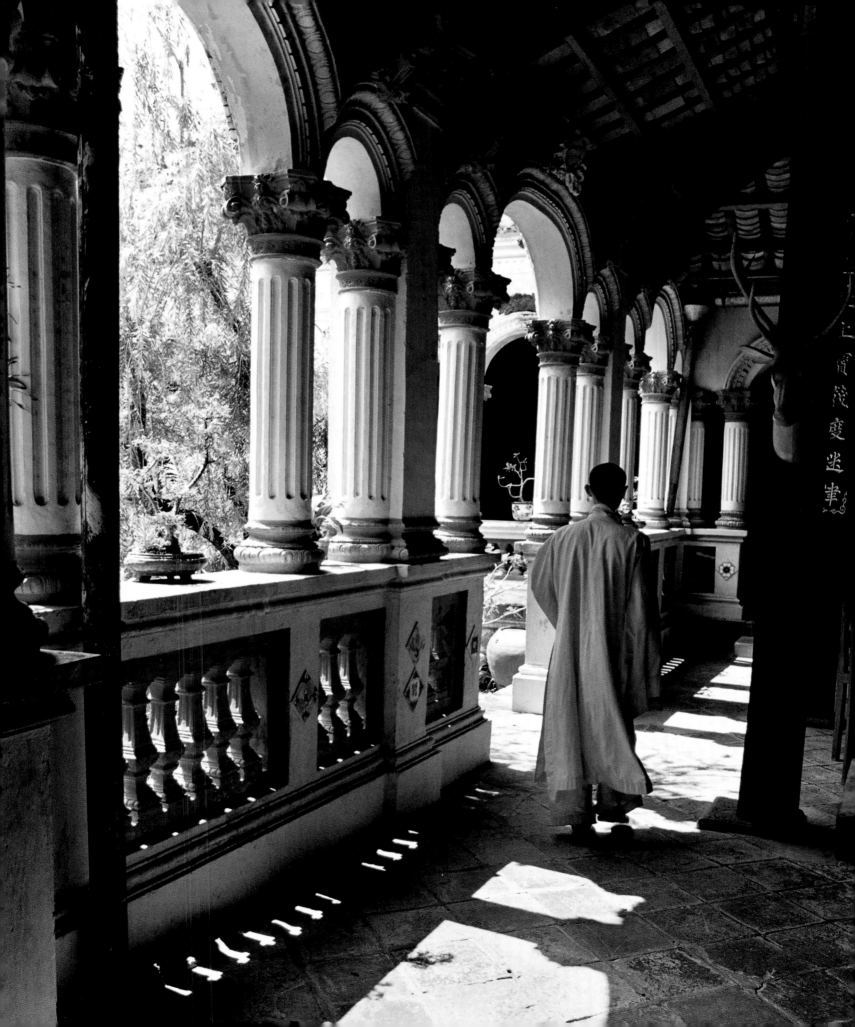

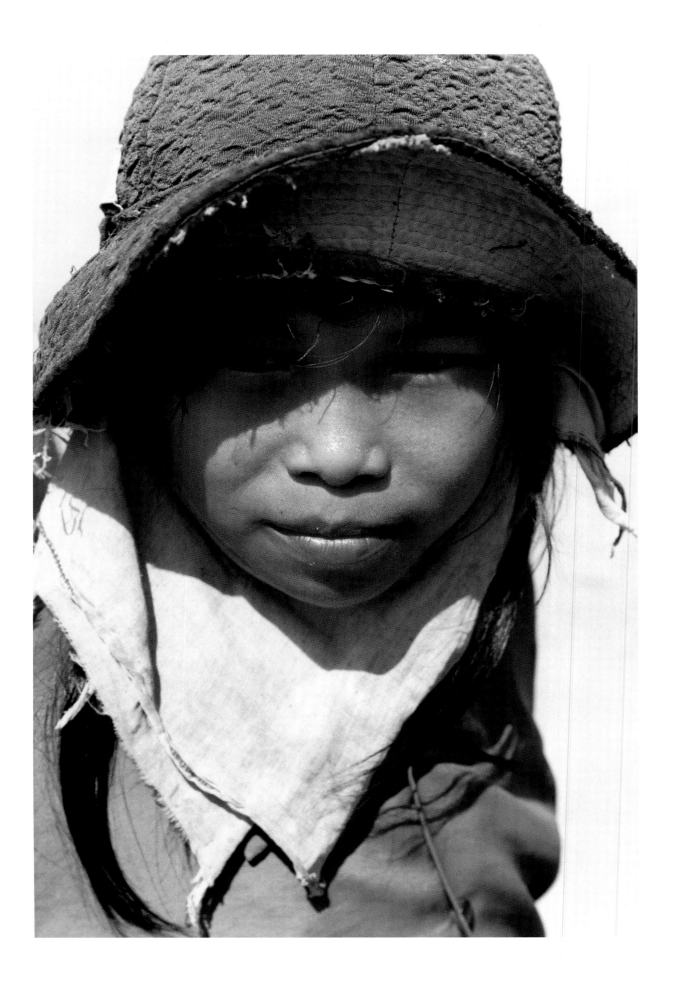

Chronology

7TH–3RD CENTURY B.C. Bronze Age Dong Son culture in the Red River Delta. The legendary Hung kings rule the kingdom of Van Lang.

257 B.C. King Au Duong conquers Van Lang and establishes the kingdom of Au Lac, with its capital at Co Loa (near present-day Hanoi).

111 B.C.–A.D. 938 Chinese rule over the Red River Delta, punctuated by numerous revolts.

A.D. 40–43 The Trung sisters lead a rebellion against China; the revolt is put down and the Han dynasty makes the Red River Delta a province of China, Giao Chau.

938 A Vietnamese warlord expels the forces of the T'ang dynasty from the delta.

1010 Ly Thai Tho unifies the country, establishes the kingdom of Dai Viet (Vietnam) with its capital in Thang Long (Hanoi), founds the Ly dynasty.

1010–1225 Ly dynasty.

1077 The Ly dynasty repels an invasion by the Chinese Sung dynasty.

1225–1400 Tran dynasty.

1257, 1284, 1287 The Tran repulse three invasions by the Mongol Yuan dynasty of China, founded by Kublai Khan.

1407–27 Occupation of Vietnam by the Chinese Ming dynasty.

1427 Le Loi and his strategist, Nguyen Trai, drive the Chinese out of Vietnam.

1428–1788 Le dynasty.

1471 The Le dynasty conquers the kingdom of Champa, forms military colonies, and begins the Vietnamese March to the South.

1620–1788 De facto partition of the country between the Trinh lords in the north and the Nguyen in the south.

Vietnamese settlers move into the Mekong Delta; the Nguyen gradually annex all territories north of the Bassac River.

The French establish Catholic missions in Vietnam. Alexandre de Rhodes, a Jesuit, transliterates Vietnamese into the Latin alphabet. (In the twentieth century this system, known as *quoc ngu*, will become the written language of Vietnam.)

1771–1802 Tay Son rebellion and reunification of the country.

1802–1945 Nguyen dynasty, capital in Hue.

1813 Vietnamese invasion of Cambodia; leads to the total annexation of the Mekong Delta.

1858 French forces land at Da Nang in the hopes of taking Hue; thrown back, they attack and take Saigon in 1859 and then move out across the Mekong Delta.

1867 Southern Vietnam becomes the French colony of Cochinchina.

1885 Having taken Hue, French make central Vietnam the protectorate of Annam and the north the protectorate of Tonkin.

1885–1945 French colonial rule. Resistance to the French in parts of the north and center continues until 1913.

1930 Creation of the Indochinese Communist Party; anti-French rebellions break out in Vietnam and are suppressed.

1941 Japanese troops arrive; Vietnam becomes a French-administered possession of Japan.

Ho Chi Minh creates the Viet Minh, unifying nationalist and Communist groups; establishes a base at Pac Bo in the mountains of northern Vietnam and begins a guerrilla war against the Japanese.

1945 In March the Japanese take control from the Vichy French regime in Vietnam; in August, after the Japanese surrender and before the Allies can occupy Vietnam, Viet Minh forces move into Hanoi and Ho Chi Minh proclaims the establishment of the Democratic Republic of Vietnam (DRV).

1946 Negotiations between the DRV and the French government eventually break down, and the French occupy the country again. Ho Chi Minh and his forces withdraw from Hanoi and begin a new guerrilla war.

1946–54 The Franco-Vietnamese war.

1954 French surrender to Viet Minh forces at Dien Bien Phu. At the Geneva Conference, at which Great Britain, the United States, China, and the Soviet Union are participants, the DRV and France agree to a cease-fire and to a temporary division of the country into two regroupment zones on either side of the seventeenth parallel. The Final Declaration of the conference, stating that nationwide elections will be held in 1956 to reunify country, goes unsigned because of U.S. opposition. The United States begins an effort to create a government in Saigon to resist a Communist takeover of the south. With U.S. help Ngo Dinh Diem, a Catholic from the north, assumes control in Saigon.

1954–56 Land reform program under way in Democratic Republic of Vietnam (north of the seventeenth parallel).

1955 South of the seventeenth parallel, Ngo Dinh Diem refuses to hold nationwide elections and begins a military campaign against the former Viet Minh and all other dissidents. He establishes the Republic of Vietnam (RVN) and the United States sends military advisers to build and train its army (ARVN).

1958 Collectivization program begins in North Vietnam.

1960 Anti-Diem groups in South Vietnam create the National Liberation Front (the Viet Cong).

1963 Buddhist protests against the Diem regime; coup d'etat by a military junta.

1965–75 The American war.

1965 By this time the Saigon government has virtually dissolved, and the Viet Cong control most of the countryside below the seventeenth parallel. U.S. bombing of North Vietnam begins, and the first American troops land in Da Nang to

help the Saigon government defeat the Viet Cong.

1968 Viet Cong launches Tet Offensive. By now there are half a million American troops in Vietnam. The offensive is a military defeat for the Viet Cong, but because the Viet Cong and North Vietnamese troops manage to take over most of the cities and towns of South Vietnam for a period of time, it is a psychological defeat for the United States. President Lyndon B. Johnson decides not to seek a second term and begins peace negotiations with the DRV.

1969 U.S. troop withdrawals begin under President Richard Nixon.

1973 The Paris Peace Conference ends with an agreement providing for a cease-fire, the return of U.S. prisoners of war, and the withdrawal of remaining U.S. troops from Vietnam. The last U.S. troops leave March 29, but the cease-fire does not hold.

1975 North Vietnamese troops march unopposed into Saigon on April 30.

1976 The reunified country becomes the Socialist Republic of Vietnam (SRV), with its capital in Hanoi.

1976–79 The SRV puts tens of thousands of southerners into reeducation camps, confiscates the property of ethnic Chinese merchants and many others; it attempts to collectivize the land and to create a socialist economy in the south.

1978 Attacked by the Khmer Rouge, Vietnam invades Cambodia and drives Pol Pot's forces from Phnom Penh. Vietnamese forces remain in Cambodia waging war with Khmer Rouge guerrillas until 1989.

1979 China invades Vietnam and withdraws after a seventeen-day war.

1981 Introduction of the household contract system in agriculture.

1986 The government adopts a sweeping economic reform program known as *doi moi*, or renovation.

1988 Further agricultural reforms.

1989 Soviet bloc economic support drastically reduced after fall of Berlin Wall.

1995 Diplomatic relations are restored between the United States and Vietnam.

1997 The United States and Vietnam exchange ambassadors.

1999 Vietnam and the United States conclude an agreement normalizing trade between them.

Acknowledgments

I am deeply indebted to Desaix Anderson, the first U.S. diplomatic representative to Hanoi, who went as chargé d'affaires in 1995. Desaix introduced me to artists and to other Vietnamese citizens throughout Hanoi who helped develop my knowledge of the world of Vietnam.

Dr. Neil Jamieson has been invaluable over the past five years in giving me both anthropological and practical advice. He and his wife, Ginny, kindly invited me to their house in Virginia, where I stayed for several days. They reviewed slides and photographs with me and helped me to understand the culture of the country.

My thanks to Corlies Smith, editor par excellence, who has been reviewing captions of Vietnamese photographs for me since 1996. Without the loyalty, the intelligence, and the dedication of Adrienne Cannella, Patricia Maddi, and all the other superb staff at 200 West 57th Street — Elaine Kursch, Bruce Slater, Curtis Conway, Paulina Gonzalez, and Danielle Viscosi — there would be no book. Adrienne and Pat stayed late many nights and put in many extra hours typing, revising, and organizing photographs and written materials. I am forever grateful to them all. Patrick Scudder at Modernage Photographic Labs has been a terrific help with his keen eye and excellent judgment.

My deep appreciation to Terry Hackford, at Little, Brown / Bulfinch, a warm, intelligent, and subtle woman who I am certain is one of the world's wisest and most gracious editors. I feel fortunate to count her among my friends. My thanks to Laura Lindgren and Celia Fuller, our excellent book designers, who can see to the heart of a logistical problem in the twinkling of an eye and whose taste and discretion I admire and value. I am grateful for the support and perseverance of our gifted agent, Robert Lescher. The keen eye and swift judgment of Peggy Leith Anderson made her copyediting a pleasure. The visually sensitive eyes of Allison Kolbeck were essential to this project.

My thanks to Guy Horner and Michael Bressler, who have skillfully and efficiently hung my Vietnamese photographic exhibitions, and to Eli Haislip of Bamboo Tours, who has been of enormous help in planning all my journeys to Vietnam and has aided me with communications problems. My appreciation to Daphne Hawkes, who first

went with me to Vietnam in 1966. My thanks and love to my good friends Judy and Leslie Gelb for editing captions at Blue Shutters and for their affectionate encouragement. I am deeply appreciative to my very dear friend Kemp Battle for his unflagging support. I am grateful as well to Walter Lippincott for his enthusiastic early interest in this book and to Professor Robert Fagles, who helped send me on my way.

Frances FitzGerald, my coauthor, traveling companion, and friend, is a woman of the highest ideals whom I admire deeply. She was never irritable, even in the most humid and tiring conditions, and was always open-minded and enthusiastic about sharing this project. Frances accompanied me with a sense of humor and flexibility of spirit, yet with the unflagging determination of a journalist. She has been my constant inspiration.

My husband, Theodore Cross, saw me off on my first Vietnamese journey with a certain trepidation, but his love and encouragement, keen and unfailing intelligence, and patient support have enabled me to complete this work. I am forever grateful to this remarkable and loving man.

— Mary Cross

In the first place, my thanks go to my Vietnamese friends and colleagues, living and dead, who patiently helped me to gain some insight into their culture — and my own.

Second, I owe a great deal to those who read the text of this book in manuscript: the historian Robert K. Brigham of Vassar, who gave me the benefit of his great expertise on Vietnam, and the anthropologist Susan Harding of the University of California at Santa Cruz, who provided a trenchant critique of my approach. Neither should be blamed for any remaining faults in this text.

Bob Lescher deserves credit for finding the perfect publisher for this book. I am grateful to him, as always.

Terry Hackford at Bulfinch Press has all my thanks for her support and her skill as an editor. So, too, does Peggy Leith Anderson, who copyedited the text.

Above all, I am grateful to Mary Cross, who conceived this project and who overcame serious obstacles to see it to completion. She is gallantry itself and an inspiration to all who know her. She is also a great traveling companion: indefatigable, endlessly curious, a perfectionist in her work, and at the same time considerate and generous to a fault. I have learned a great deal from her while enjoying her company, and I am proud to count her as a friend.

— Frances FitzGerald

Index